I0235947

IMAGES
of America

TAMPA BAY'S
GULF BEACHES

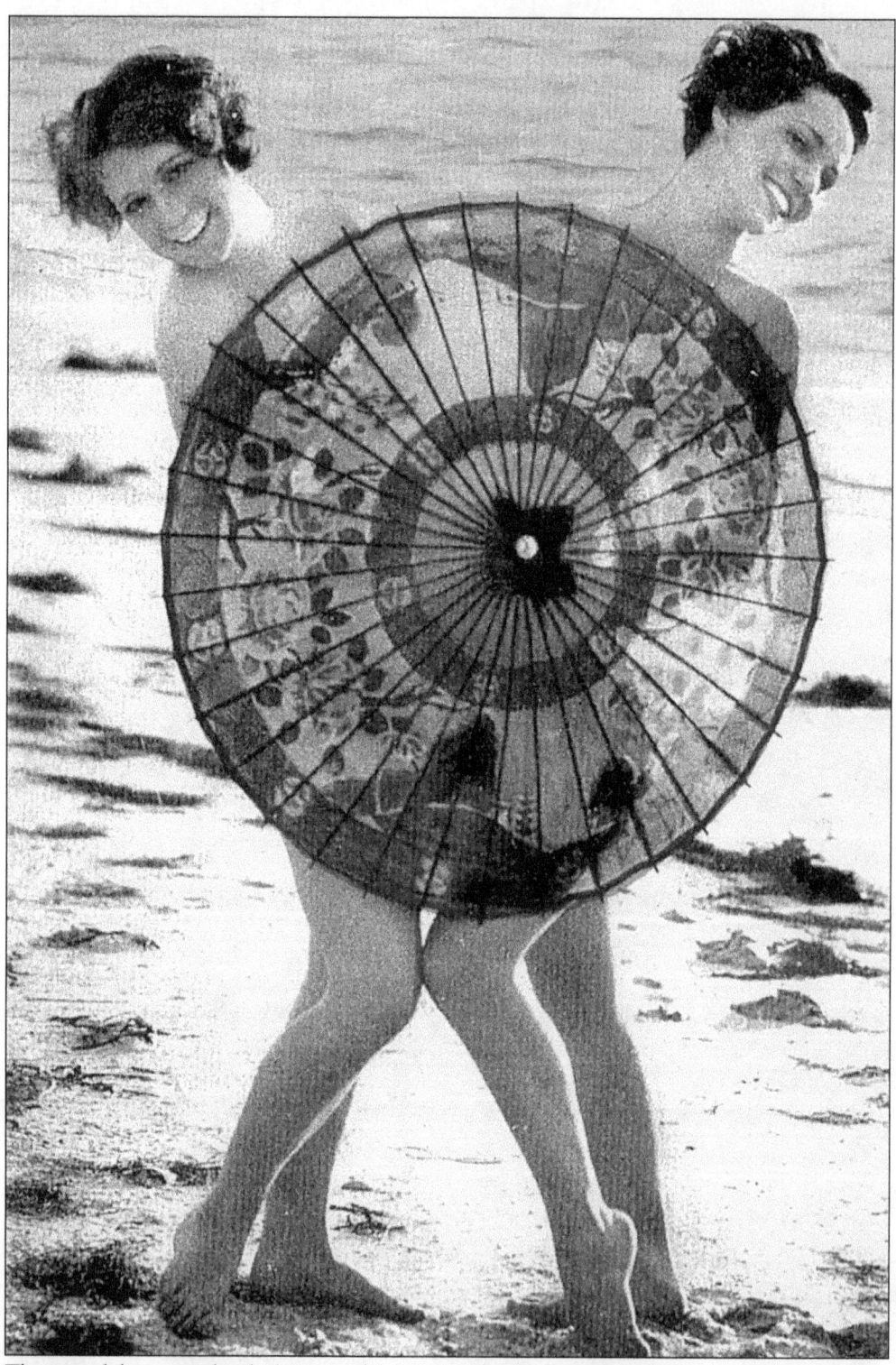

These models, covered only (apparently) by an umbrella, helped publicize the Gulf Beaches as a place for fun and relaxation.

IMAGES
of America

Tampa Bay's
Gulf Beaches

R. Wayne Ayers

ARCADIA
PUBLISHING

Copyright © 2002 by R. Wayne Ayers
ISBN 978-1-5316-0984-9

Published by Arcadia Publishing
Charleston, South Carolina

Library of Congress Catalog Card Number: 2002105524

For all general information contact Arcadia Publishing at:
Telephone 843-853-2070
Fax 843-853-0044
E-mail sales@arcadiapublishing.com
For customer service and orders:
Toll-Free 1-888-313-2665

Visit us on the Internet at www.arcadiapublishing.com

To my wife Nancy—my teammate and soulmate on this project, and loving partner through life's brief storms and long beach walks.

CONTENTS

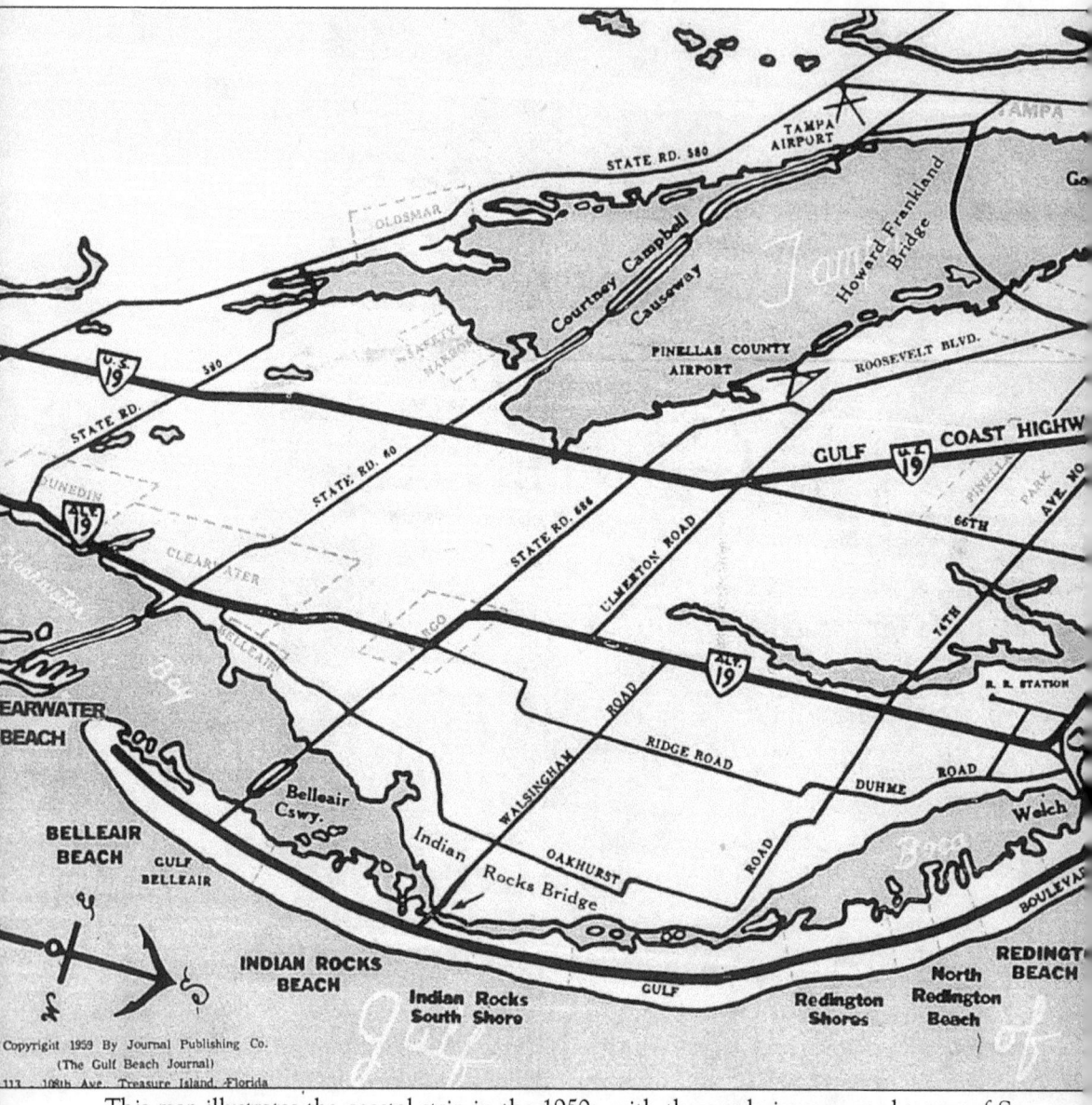

Copyright 1959 By Journal Publishing Co.
(The Gulf Beach Journal)
113 108th Ave. Treasure Island, Florida

This map illustrates the coastal strip in the 1950s, with the newly incorporated towns of St. Petersburg Beach, Treasure Island, Madeira Beach, the Redingtons, and Belleair Beach resulting from the post-war development boom.

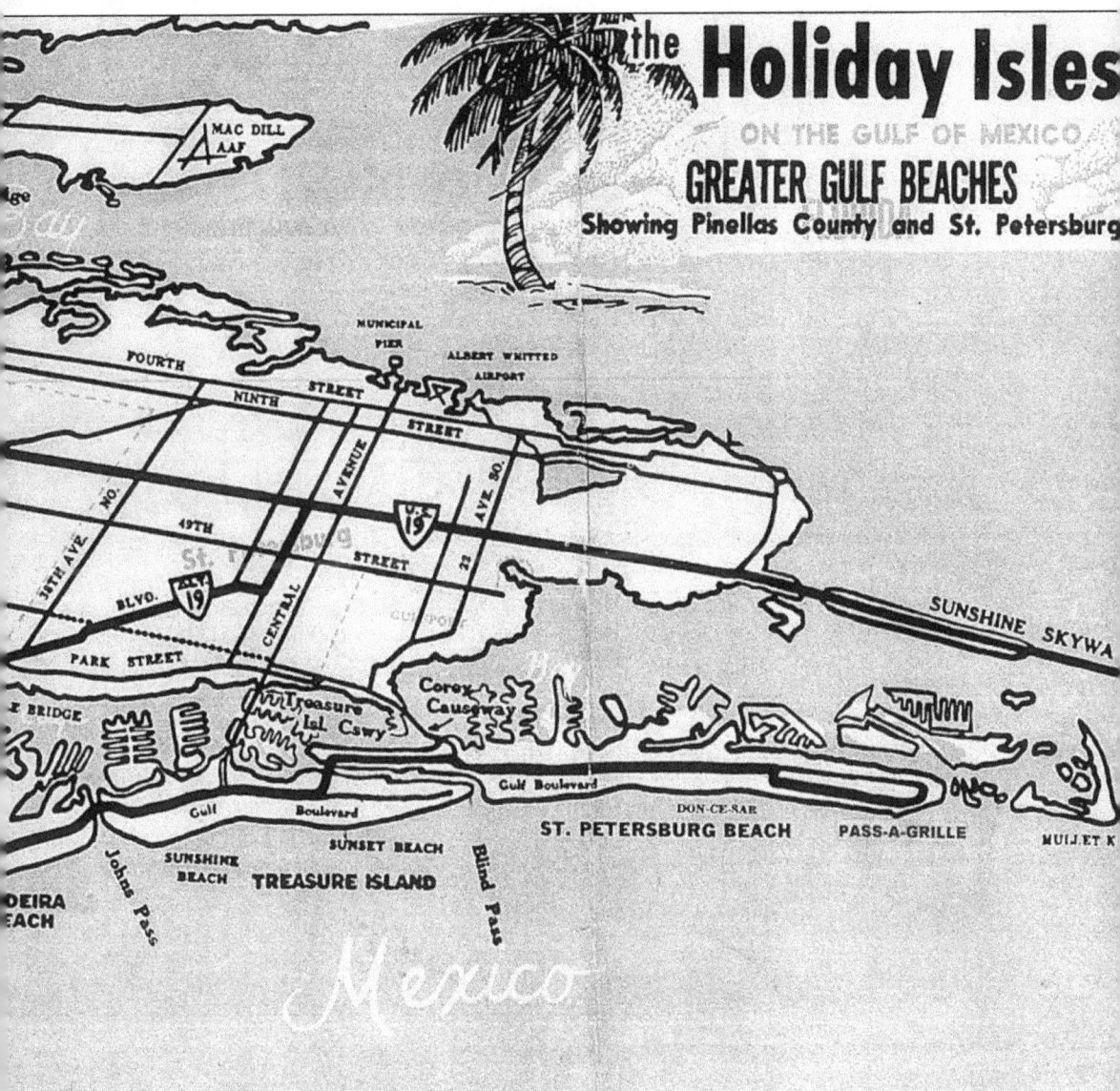

the **Holiday Isles**
ON THE GULF OF MEXICO
GREATER GULF BEACHES
Showing Pinellas County and St. Petersburg

7

ACKNOWLEDGMENTS

The author wishes to express his appreciation for the generous support given by the Pinellas County Historical Museum Heritage Village, Jan Luth (director); the Indian Rocks Beach Historical Society, John Robinson (president); and the St. Petersburg Museum of History, Mathias Bergendahl (executive director).

I especially wish to thank the following people: Don Ivey, curator of collections at Heritage Village-Pinellas County Historical Museum; Barbara Baker Smith, first volunteer coordinator and organizer of the Gulf Beaches Historical Museum and historian for Pass-a-Grille Beach Community Church and Pass-a-Grille Woman's Club; Ann Wikoff, archivist at St. Petersburg Museum of History; and Dennis Rhodes, volunteer archivist.

The author consulted a number of sources in writing the introductory sections and captions for this book. The following books were especially helpful and highly recommended to anyone desiring a more in-depth look at the history of specific beach communities:

Hurley, Frank T. Jr. *Surf, Sand, & Post Card Sunsets: A History of Pass-a-Grille and the Gulf Beaches*. Printed by Precision Litho Service, Inc., 1977, 1989.

Indian Rocks Beach Area Historical Society. *Indian Rocks: A Pictorial History*. Great Outdoors Publishing Company, 1980, 1985, 1994, 1999.

Board, Prudy Taylor and Colcord, Esther B. *The Belleview Mido Resort Hotel: A Century of Hospitality*. The Donning Company, 1996.

Kennedy, Margery and Waltz, Doris. *Pass-a-Grille: A Patchwork Collection of Memories*. Macon Graphics, Inc., 1981.

Lenfestey, Hatty. *An Elegant Frontier: Florida's Plant System Hotels*. The Henry B. Plant Museum, 1999 (booklet).

Sanders, Michael L. *Clearwater: A Pictorial History*. The Donning Company, 1983, 1997, 2000.

INTRODUCTION

The beach. To Tampa Bay area residents and tourists, the name brings visions of surf and sand, luxury condominiums and hotels, restaurants and shops, traffic . . . and expensive beachfront real estate. Wall-to-wall development interspersed with a few jealously preserved green spaces.

Today's Gulf Beaches are the place people want to be, and they are willing to pay ever-higher prices for the privilege. It is surprising then to visit the Gulf Beaches nearly a century ago—at a time when St. Petersburg was booming as a tourist mecca and real estate speculation was rampant—and find a virtual wilderness visited mainly by fishermen and adventurous bathers and sightseers.

While Tampa and St. Petersburg were settled in the 1800s, there was not even a bridge to the beaches until nearly 1920. And extensive development of the coast did not get underway until after World War II.

The beaches were considered a pleasant excursion at best, a palmetto-and-mosquito-infested wasteland at worst. People saw the beach as something to be visited and viewed only at arm's length. With a few notable exceptions, accommodations were built on the mainland side of Boca Ciega Bay, and excursionists were ferried over to the beach for outings and relaxation.

Pass-a-Grille, the first and only real town on the beaches, was an arduous journey from the mainland until the bridge was built in 1919. Most visitors took the streetcar to Gulfport and then the ferry over to Pass-a-Grille. Nevertheless, Pass-a-Grille was the West Coast's leading beach resort during the early 1900s, sporting several first-class hotels—notably the Lizotte, Mason, and Pass-a-Grille hotels—and a casino for entertainment and recreation.

While tourists tended to shy away from the beaches in favor of mainland activities and attractions, sportsmen soon discovered the abundance of fish and marine life in the Gulf waters and took up the challenge of landing tarpon and other sport fish available for the taking. Lodgings catering to sport fishermen soon began opening up along the beach, and fishing guides, like the legendary George Roberts, acquired boats and built a thriving business taking well-heeled visitors out to the best fishing spots. The bounties of the sea soon became known to "landlubbers," and shore dinners at Pass-a-Grille fish house restaurants soon became a popular tourist excursion.

Located further up the beach, Indian Rocks was the other major settlement during the early 1900s. As with Pass-a-Grille, visitors were ferried across Boca Ciega Bay to the beach, and the main accommodations were on the mainland side of the bay. Most visitors arrived aboard the excursion train from Tampa, and early Indian Rocks was referred to as "Tampa's Playground."

Tourists stayed at the Indian Rocks Lodge or the small but plush (25-room) Indian Beach Hotel that featured a private streetcar for guests to the Indian Rocks Beach railroad station.

Though a large fire in 1912 destroyed most of the community, the building of hotels, tourism, and settlements continued, with visitors drawn by the cool Gulf breezes and pastoral setting. A narrow, rickety bridge replaced the ferry in 1916, and, although badly suited for automobile traffic, it spurred development on both sides of the bay and spawned the cottage community along the beach.

Clearwater Beach, during the early era, was largely an adjunct to the growth of Clearwater, giving residents a nearby beach retreat. Tourist activity during that era centered on the elegant Hotel Belleview (today's Belleview Biltmore) in nearby Belleair, a huge rambling hotel constructed in 1888 by railroad magnate H.B. Plant as part of his "Plant System" of integrated rail/hotel links. As in other areas along the shore, tourists shied away from beach proximity, and the Belleview was considered a beach resort although it was on the mainland side of Clearwater Bay. The huge hotel, considered the largest wooden structure in the world, featured luxurious accommodations, extensively manicured grounds, a golf course, and fine dining, and has been a favorite haunt of society's rich and famous throughout the years.

Development of Clearwater Beach began with the construction of the wooden bridge, referred to as the Rickety Bridge because of its warped surface, in 1917. That same year, the first significant development began with construction of the Clearwater Beach Hotel.

Bridges to the mainland at Pass-a-Grille, Indian Rocks, and Clearwater Beach constructed in the late teens helped facilitate growth along the beach. However, the boom of the 1920s, which brought rampant growth to St. Petersburg, had only a ripple effect on shoreline property.

During the 1920s and 1930s, people began to view the beach as a diversion. A place to visit rather than just a sight to see. Surf bathing became a common activity, and bathing dress moved from the Victorian "don't show the ankles" bloomers to one-piece bathing suits similar to some of the outfits of today—though less revealing. Casinos, featuring ballroom dancing to swing bands of the era, became widely patronized. Bathhouses and pavilions were common along the beach. Visitors in this era considered the Gulf Beaches a pleasant place to get away and overnight stays began to appeal to the more adventuresome.

Probably the most significant beachfront development of the period was construction of the spectacular Don CeSar Hotel at Pass-a-Grille in 1926. Like the Belleview at Clearwater, the Don CeSar was another "no expenses spared" property which brought the rich and famous to the Gulf shores. Completion of the Welch Causeway from the mainland to Madeira Beach made the mid-key area of Madeira, Treasure Island, and Redington more accessible to tourists, but growth was still modest, consisting mostly of cottages and a few mom-and-pop-style tourist courts.

Completion of the rambling Tides Hotel on Redington Beach in 1939 was the first major construction along the beaches since 1926.

The true "boom era" for the beaches was the period following World War II, when world-traveled servicemen returned to their homes and, aided by a booming economy, improved roads, and a new generation of automobiles, took their families on the road. This period saw the opening up of tourism to the masses and the beginning of the motel era along the beaches. Travel was no longer a struggle, vacations became common for all classes of people, and the beach came a destination—a place people traveled to and planned to stay awhile. The clearing of jungle areas and paving of major roads took away the unpleasantries associated with the beach, and the cool Gulf breezes and sparkling waters offered a pleasant alternative to the hot cities during the warmer months when most families traveled.

Consequently the Gulf Beaches, from St. Petersburg Beach (which broke off from Pass-a-Grille as a separate community) to Clearwater Beach, experienced a construction boom. The largely undeveloped areas of Treasure Island, Redington Beach, and Madeira were filled in during the late 1940s and 1950s with classy motels, restaurants, and tourist attractions. It was the age of the auto tourist and US 41 and 19 brought them down. The now-easy bridge accesses

from the mainland and between the keys made it a breeze to traverse the beaches in search of the right lodgings. In the early 1950s, streamlined motels with swimming pools and air conditioning competed for the tourist dollar as the older wood frame and grand hotels largely fell by the wayside. The Don CeSar, after serving the military during the war, housed government offices and the big hotels at Indian Rocks and Pass-a-Grille passed into oblivion.

The jungle along the beach disappeared, except for a few green spots, into a wall-to-wall sea of motels and cleared lots waiting to be developed. Only along the northern fringes of the beach area, at Sand Key (which eventually succumbed to condominiums), and Indian Rocks where a cottage atmosphere prevailed, and at Pass-a-Grille, was any of the Old Florida left.

Today, the Gulf Beaches are a pleasant mixture of high and low-rise condominiums, and residential development interspersed with old and new motels. Each community has its unique imprints, with Pass-a-Grille maintaining its early-1900s look, Treasure Island and Madeira Beach retaining much 1950s kitsch, Indian Rocks a mixture of cottages and small condominiums, and previously undeveloped areas like Sand Key and Belleair Beach populated with classy condominiums. It is an eclectic mix, diverse in style and income, and still a fascinating place to explore and live.

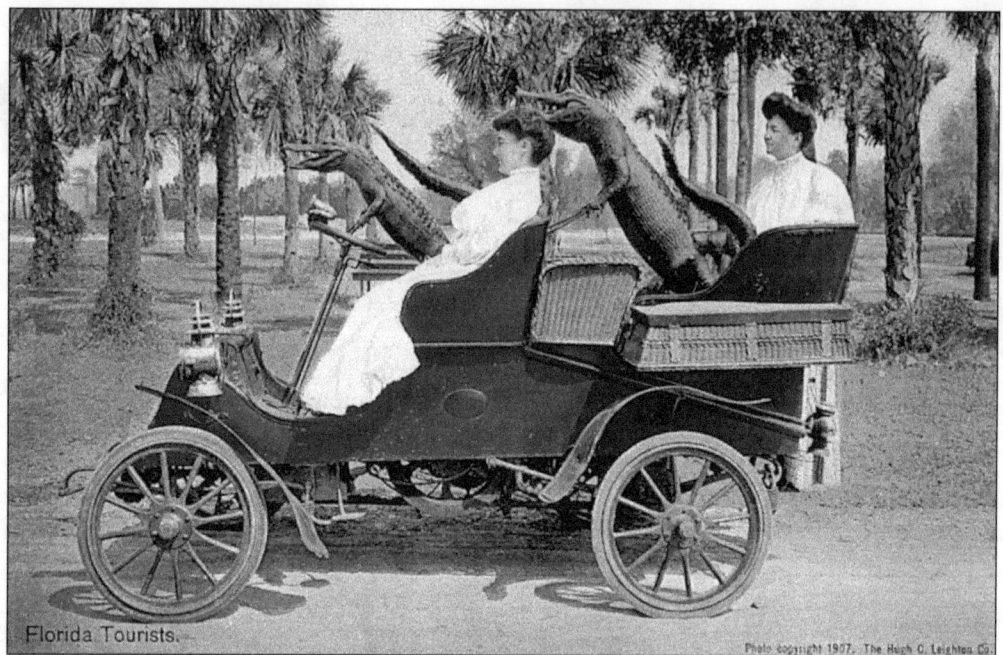

Off to the beach . . . The alligator was a big attraction to early Florida tourists and this card announces, "He has waked up, wears an expansive smile, goes motoring and is attentive to the ladies."

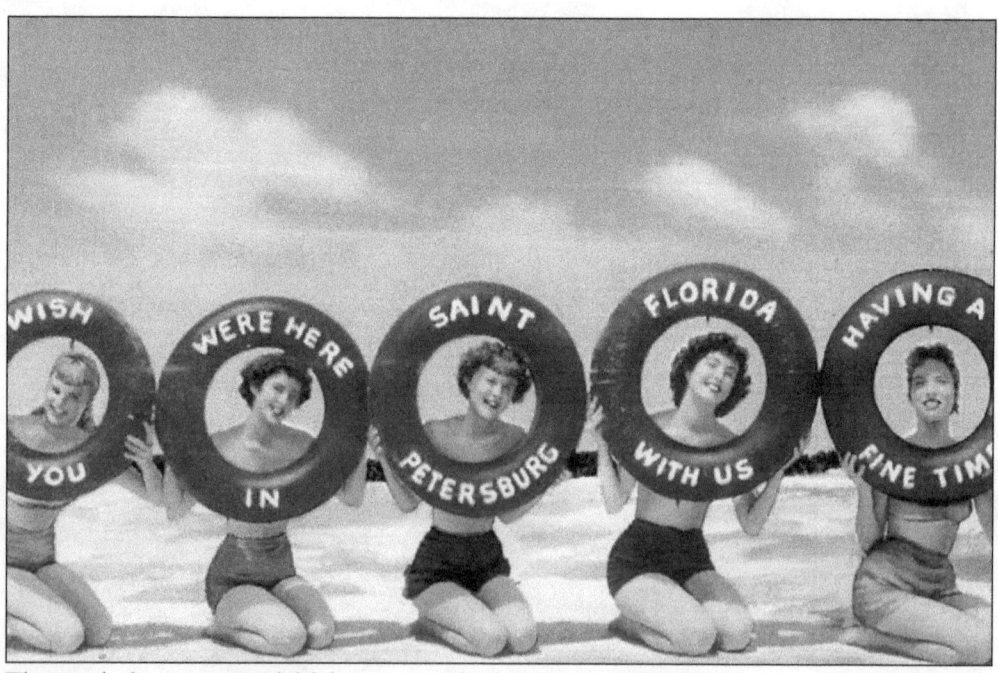

This card, featuring youthful beauties with their inner tubes teasingly positioned, enticed visitors to come to the beach for a "fine time."

One

THE BEACH
AS A CURIOSITY
LATE 1800s–EARLY 1900s

The turn of the 20th century was the "age of discovery" for the beaches as a tourist attraction. During this period, the beach was viewed largely as a curiosity by visitors who ventured over from the mainland for sightseeing and perhaps a walk or a dip in the beach. Sportsmen discovered the plentiful fish populations and deep-sea fishing boat excursions, with a stay at one of the early beachside or "floating" hotels becoming common.

Still, except for settlement at Pass-a-Grille and a few cottages at Indian Rocks, the beachfront remained largely uninhabited during this time. Even most beach services were located on the mainland side of Boca Ciega Bay, and those hardy and adventurous souls who wished to venture to the beach were ferried over on crude wooden platforms.

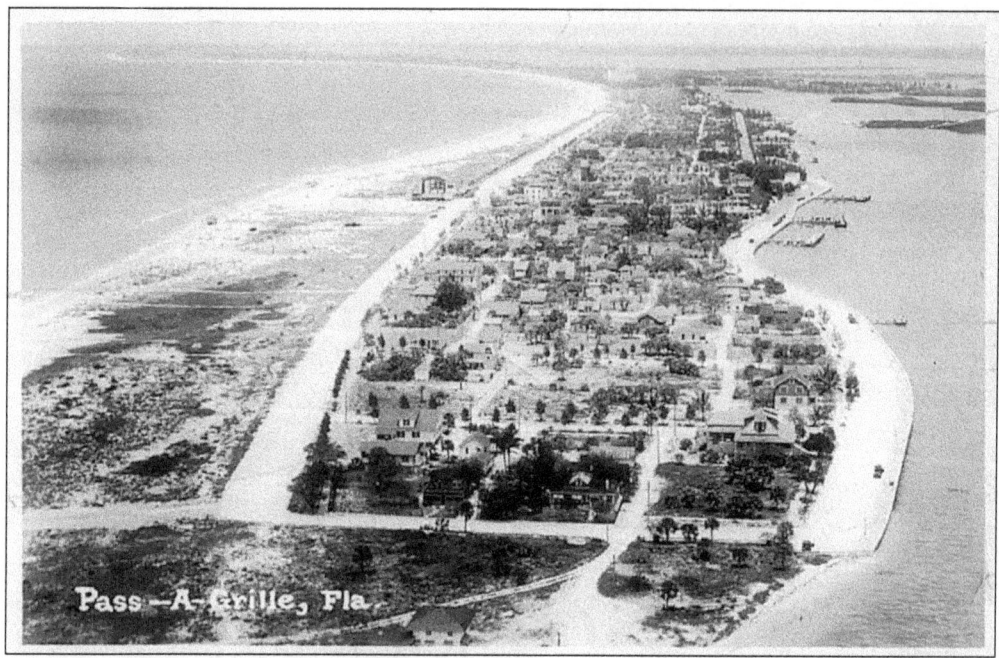

The town of Pass-a-Grille, shown here in an early aerial view, was the first real settlement on the beach. The area was first settled in 1884 by Capt. Zephaniah Phillips from Ohio, a Union veteran of the Civil War. The name is believed to be of French origin, "La Passe-aux-Grillards" or "Pass of the Grillers," derived from the fact that the area was frequented by pirates, fisherman, smugglers, and other adventurers who often came ashore to cook (or grill) their meals.

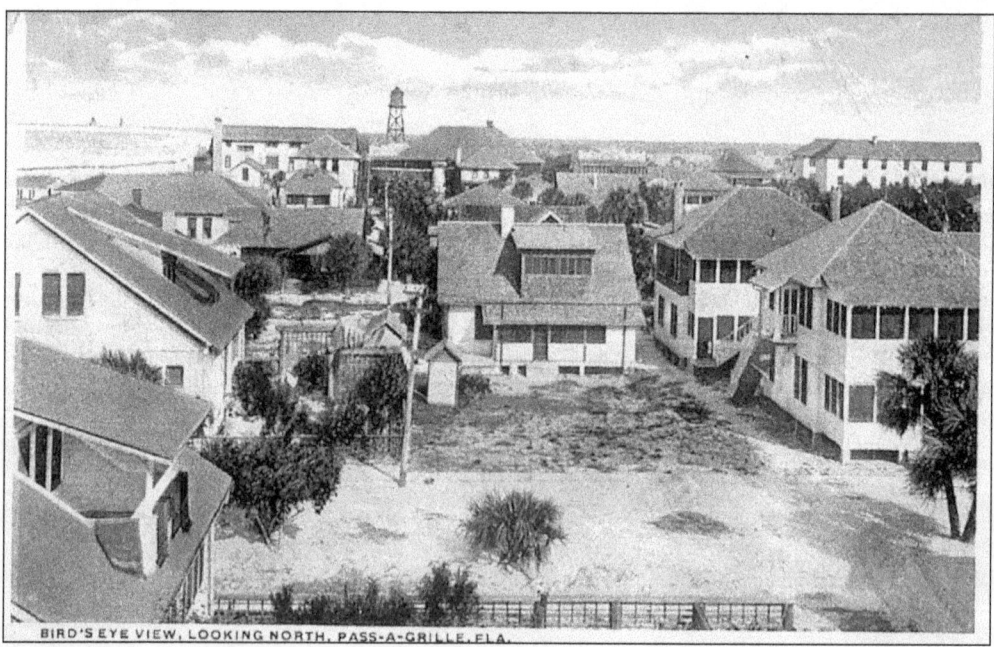

By the mid-1910s, Pass-a-Grille sported a thriving downtown, several first-class wooden hotels, and a number of cottages featuring screened-in porches to catch the cooling Gulf breezes.

14

Pass-a-Grille in the early 1900s was a thriving community, featuring a main street (Oleander Avenue, now Eighth Avenue) lined with substantial two-story buildings. At the left is the Buckeye Inn, built in 1912 by John Wesley Bonfield. The small structure in the middle on the Bay is the ticket office of the Favorite Steamer Line.

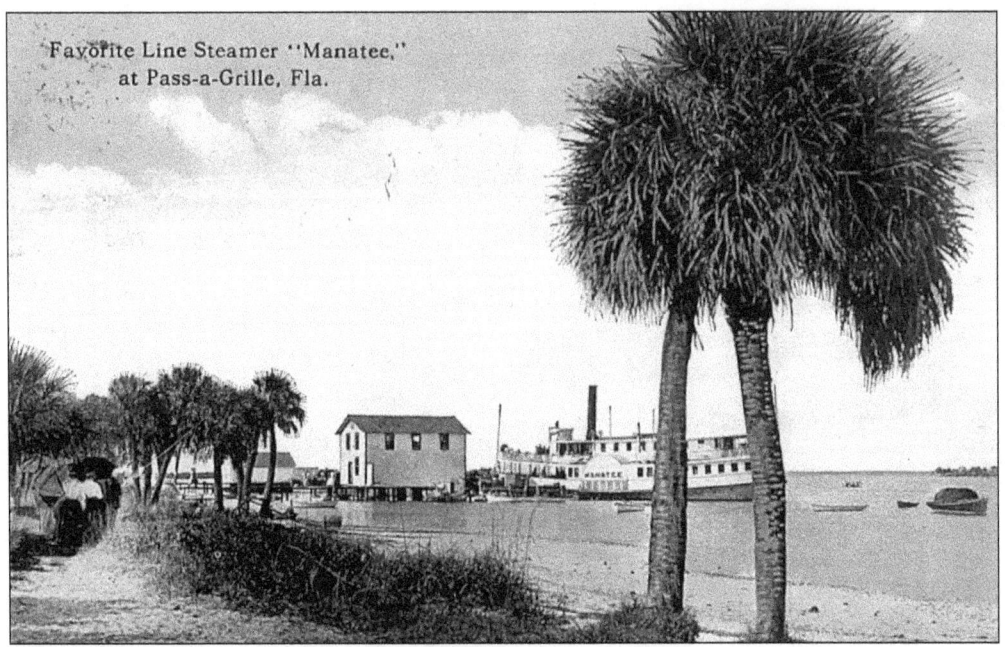

Favorite Line Steamer "Manatee," at Pass-a-Grille, Fla.

Before the coming of the bridge to the mainland in 1919, Pass-a-Grille enjoyed frequent steamboat service from St. Petersburg, Tampa, and Gulfport. The steamer *Manatee*, one of the Favorite Line boats, is shown here boarding passengers at the Merry Dock. The structure in the foreground, built by Joseph E. Merry, housed the first store on the Gulf Beaches.

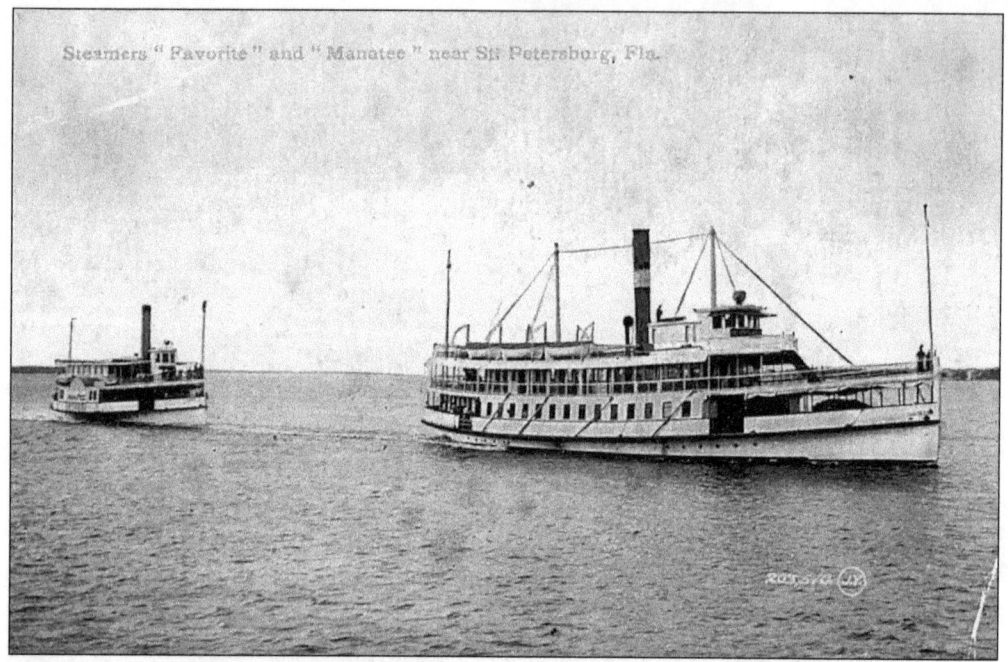

The steamship *Favorite*, on the right, flagship boat of the Favorite Line, is shown here with the *Manatee* steaming toward Pass-a-Grille from St. Petersburg.

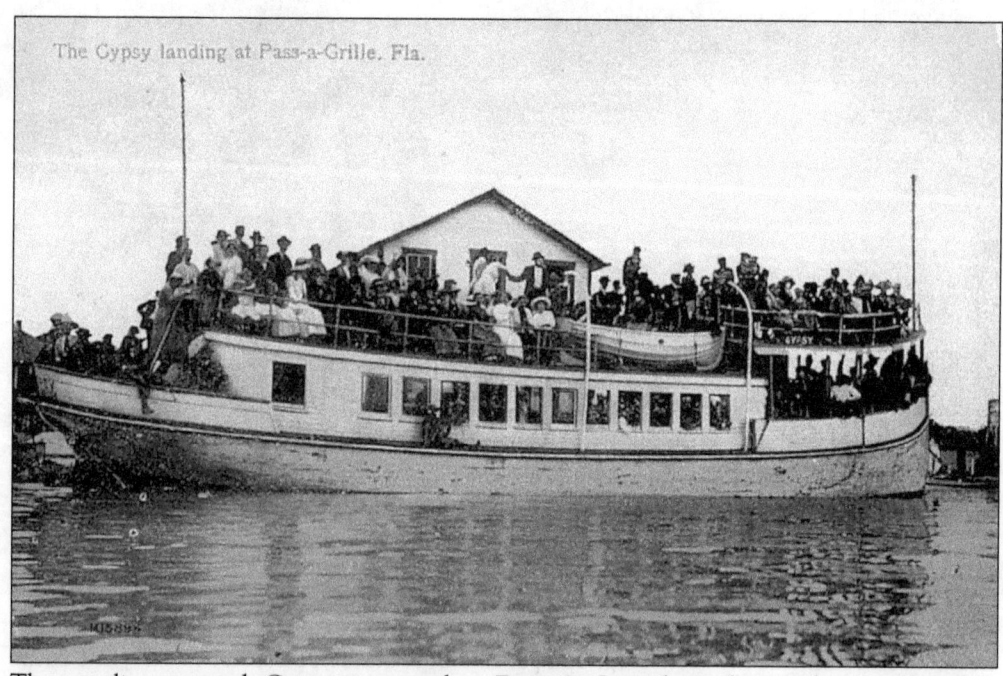

The gasoline-powered *Gypsy* was another Favorite Line boat frequently seen in early Pass-a-Grille.

Steamship and rail routes along with early beach settlements are shown in this *c.* 1913 Pinellas County map. Note the Favorite Line from St. Petersburg to Pass-a-Grille and Long Key.

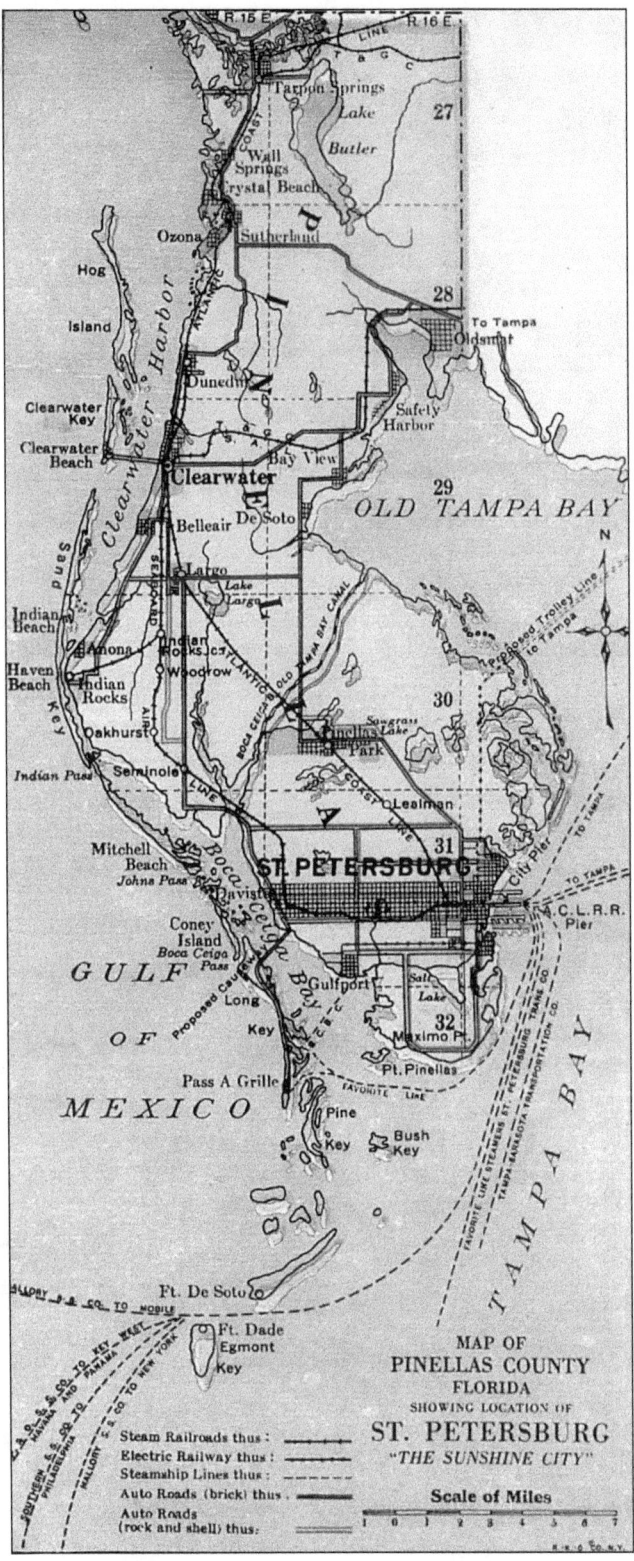

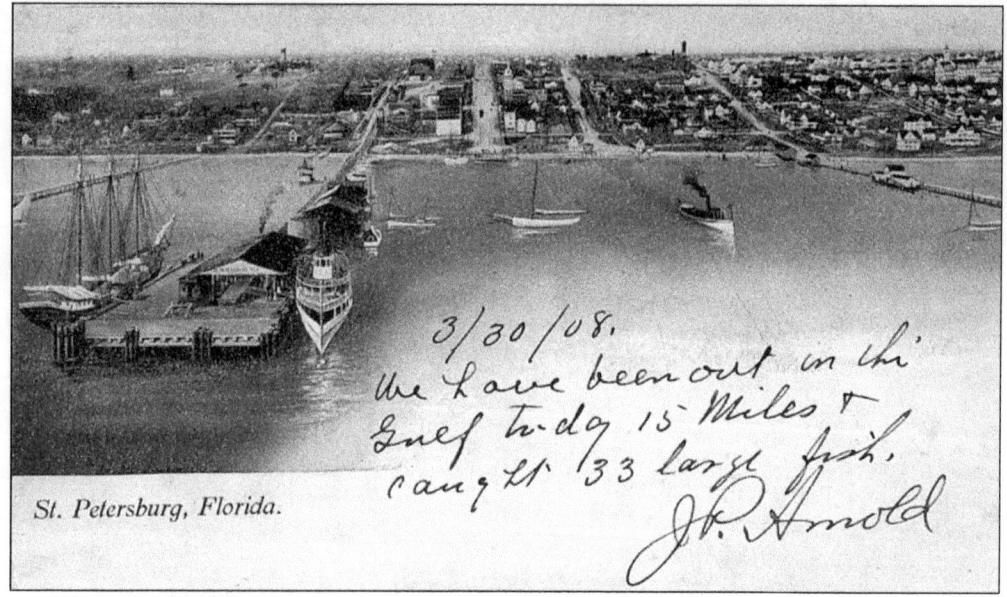

St. Petersburg, Florida.

3/30/08.
We have been out in the
Gulf today 15 Miles &
caught 33 large fish.
JR. Arnold

This 1908 postcard, showing the steamboat dock at St. Petersburg and postmarked from that city, proclaims, "We have been out in the Gulf today 15 miles & caught 33 large fish."

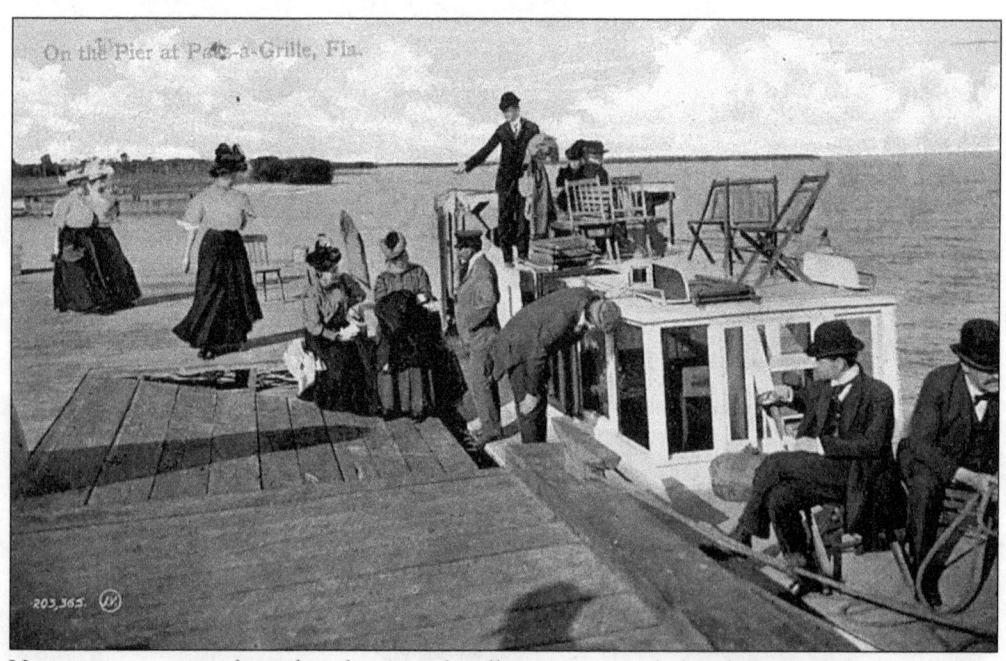

On the Pier at Pass-a-Grille, Fla.

Victorian passengers dressed to the nines for all occasions, including boat excursions.

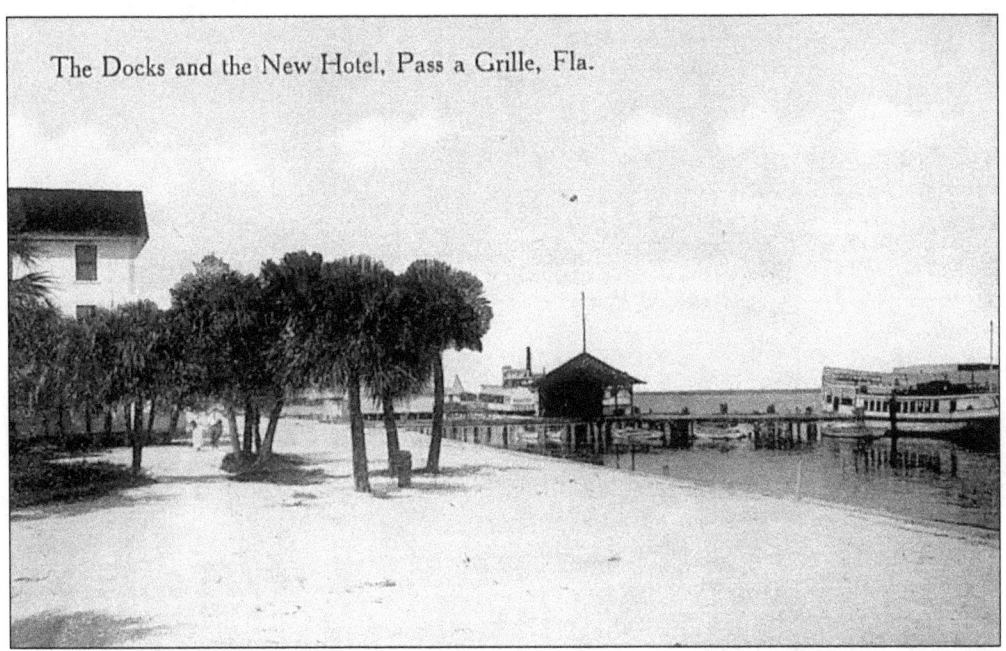

The Docks and the New Hotel, Pass a Grille, Fla.

Hotels sprang up near the docks in early Pass-a-Grille to serve the arriving boatloads of visitors.

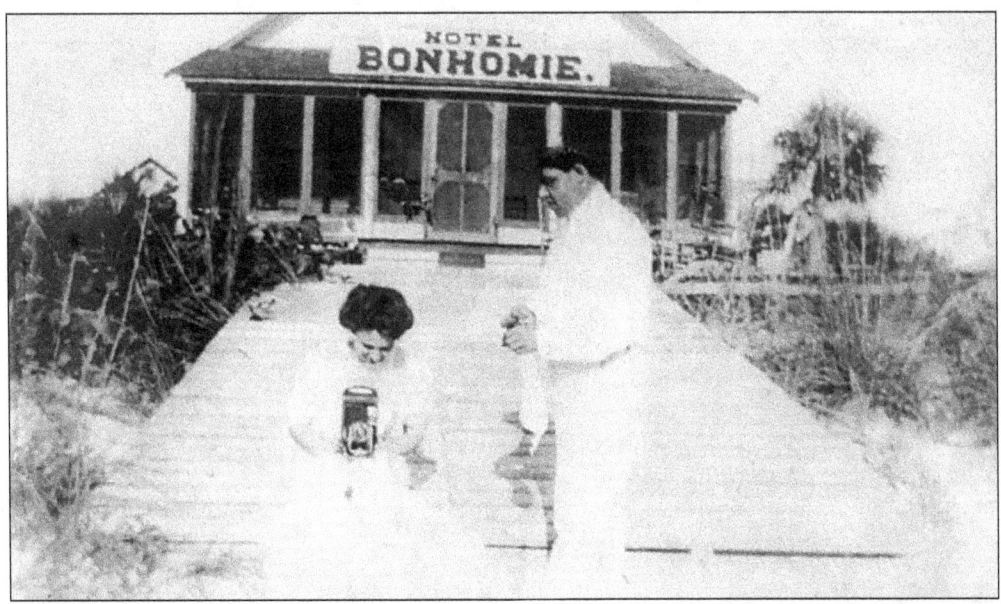

HOTEL BONHOMIE.

Pass-a-Grille's first hotel was the Bonhomie, started in 1901 by pioneer and entrepreneur George Lizotte. A rustic structure with 10 rooms where everyone used the same "bath" (the Gulf of Mexico, according to owner Lizotte), the Bonhomie was credited with opening the Gulf Beaches to the tourist trade. Early guests included fishermen and tourists who ventured over from the mainland to enjoy one of their famous "shore dinners."

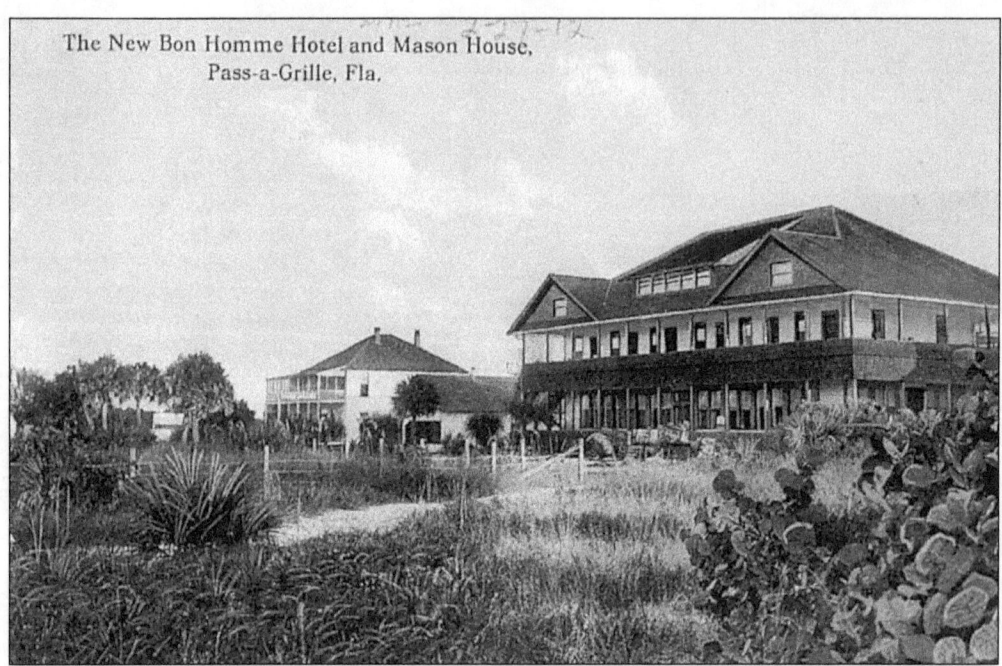

The New Bon Homme Hotel and Mason House,
Pass-a-Grille, Fla.

The Bonhomie was torn down by Lizotte in 1910 to make way for the Hotel Lizotte, shown here on the right. The Lizotte (referred to on the card as the "New Bon Homme") boasted 60 bedrooms, 1 bath, and a 300-seat dining room. Lizotte added another building several years later. To the left is the Mason House.

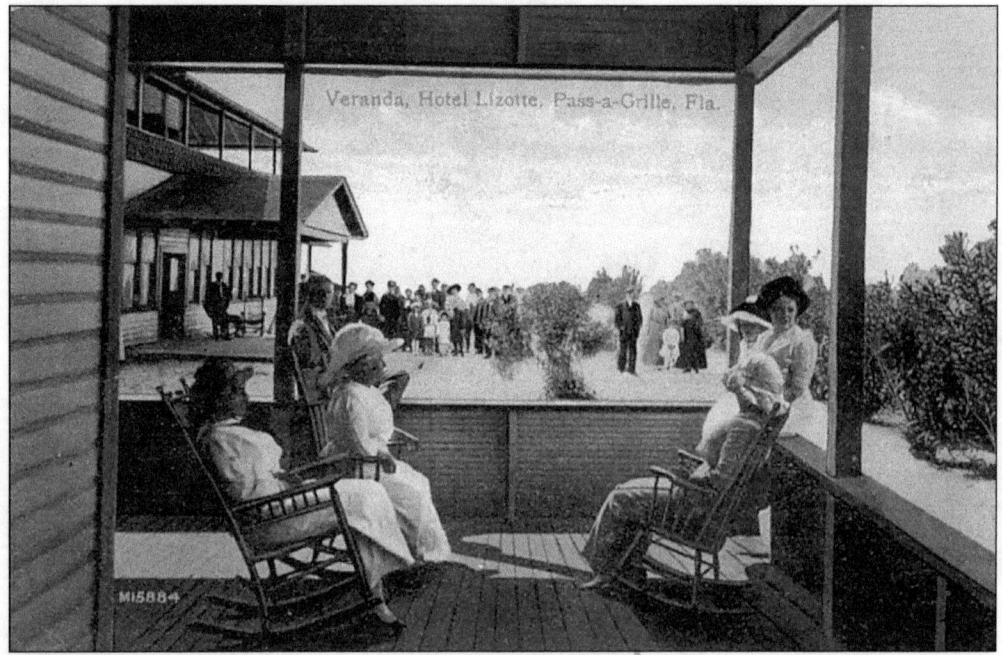

Veranda, Hotel Lizotte, Pass-a-Grille, Fla.

MI5884

The veranda of the Hotel Lizotte was a popular gathering spot for guests to rock, chat, and enjoy the sun.

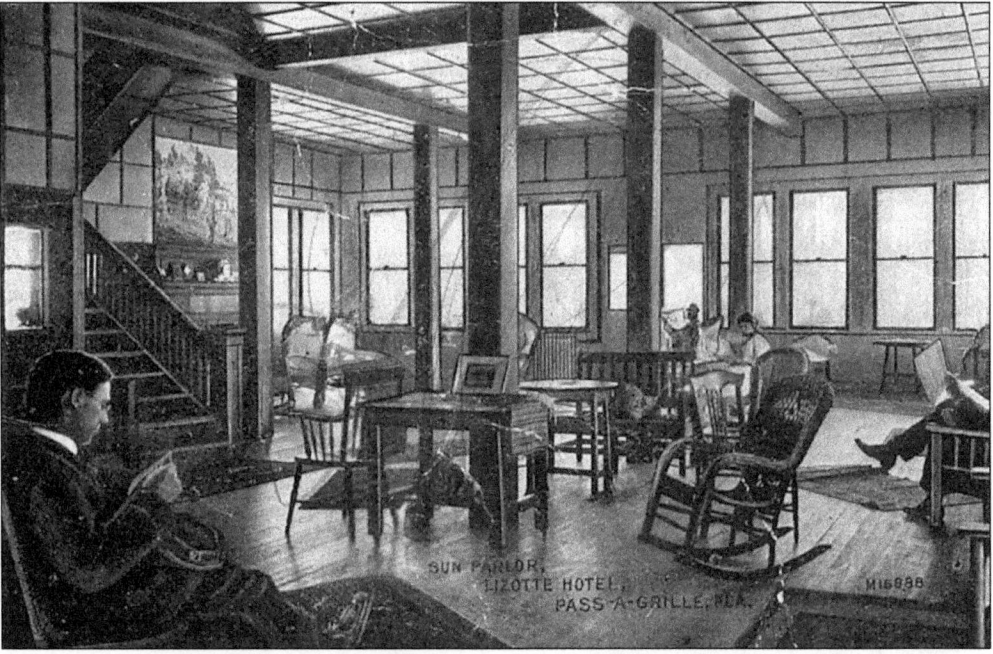

George Lizotte displays a string of fish in front of his namesake hotel, the Lizotte.

The Lizotte's spacious lobby was a place for relaxing and catching up on the latest news.

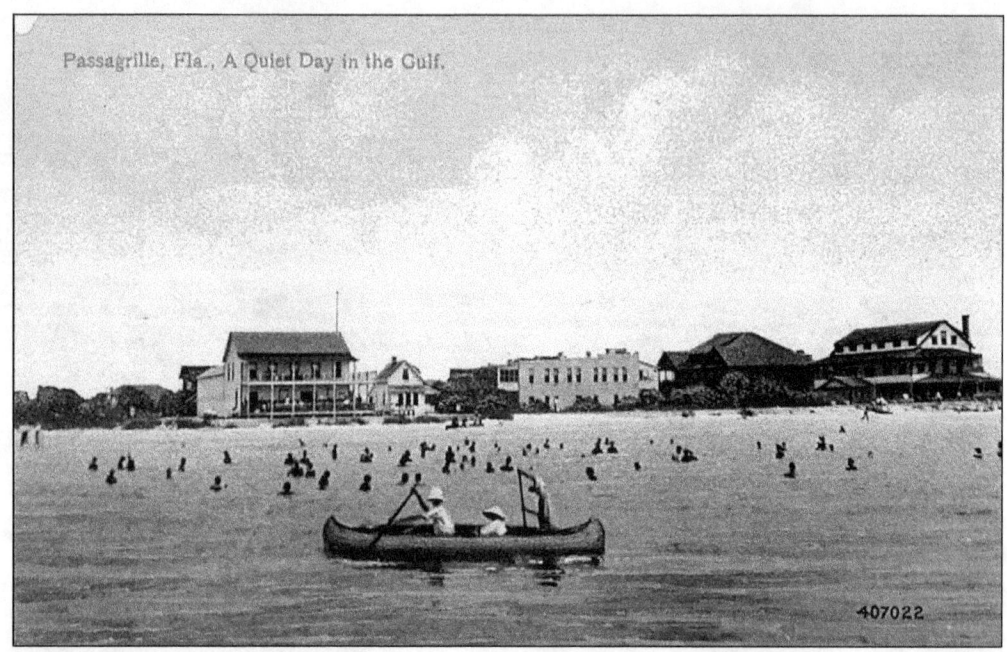

Passagrille, Fla., A Quiet Day in the Gulf.

407022

Bathers and rowers enjoy the Gulf waters along the shore in front of Page's Pavilion (large building on the left) and the Lizotte (two buildings at right). The Girard Building (center) housed a general store and apartments.

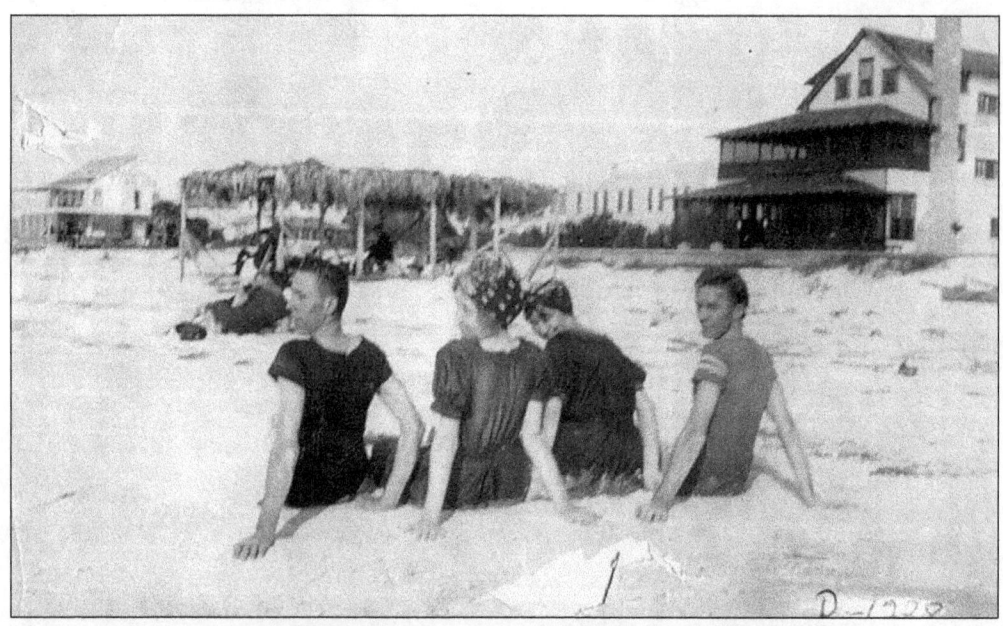

These couples in appropriate "bathing dress" enjoy a day on the beach in front of the Lizotte Hotel, with Page's Pavilion in the background.

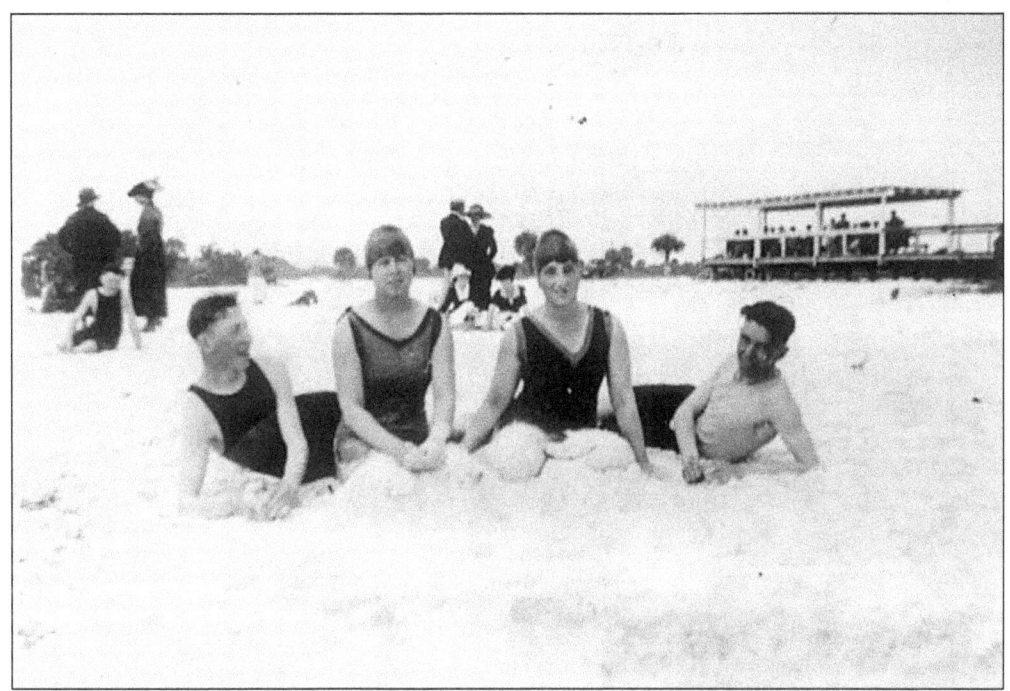

Another fashionable foursome is dressed for a dip in the Gulf. The strollers in the background wear formal Victorian attire.

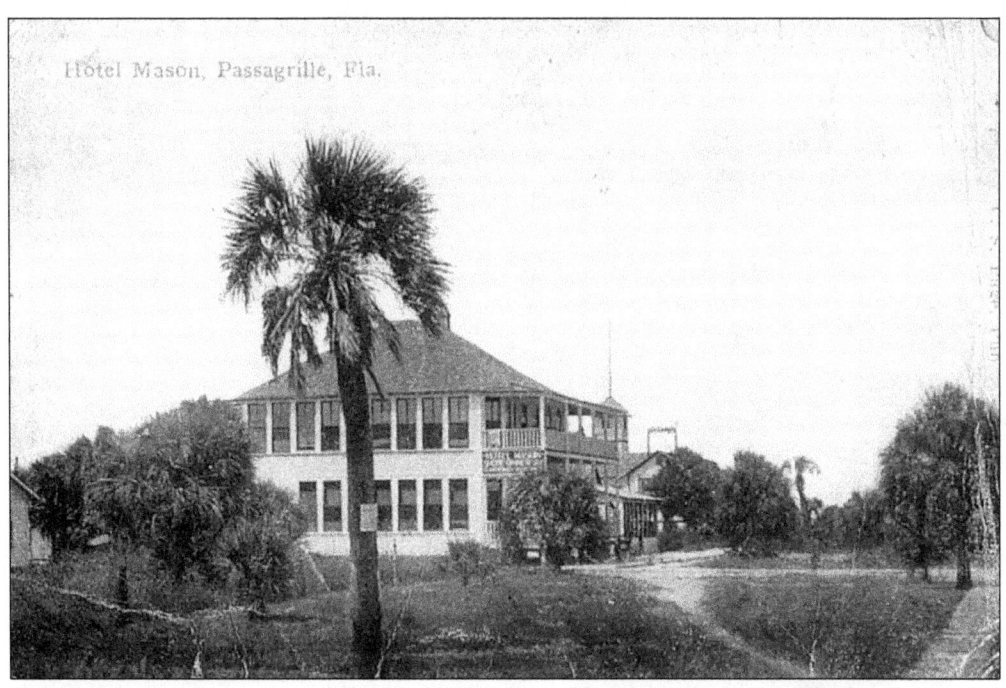

Capt. James A. Mason opened the Hotel Mason on Christmas Day 1907. The hotel provided first-class service to Pass-a-Grille visitors until it was destroyed by fire in 1922.

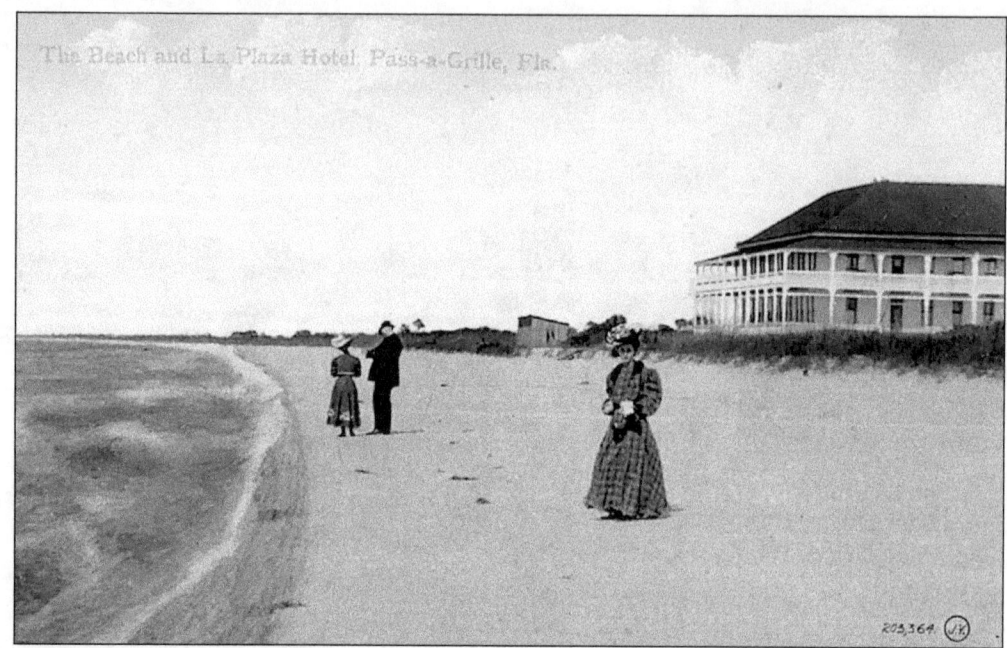

The La Plaza Hotel, opened in 1906 by Anna Hartley, daughter of Pass-a-Grille's earliest settler, Zephaniah Phillips, was the town's "grand hotel." It featured spacious verandas circling the building and grounds overlooking the Gulf.

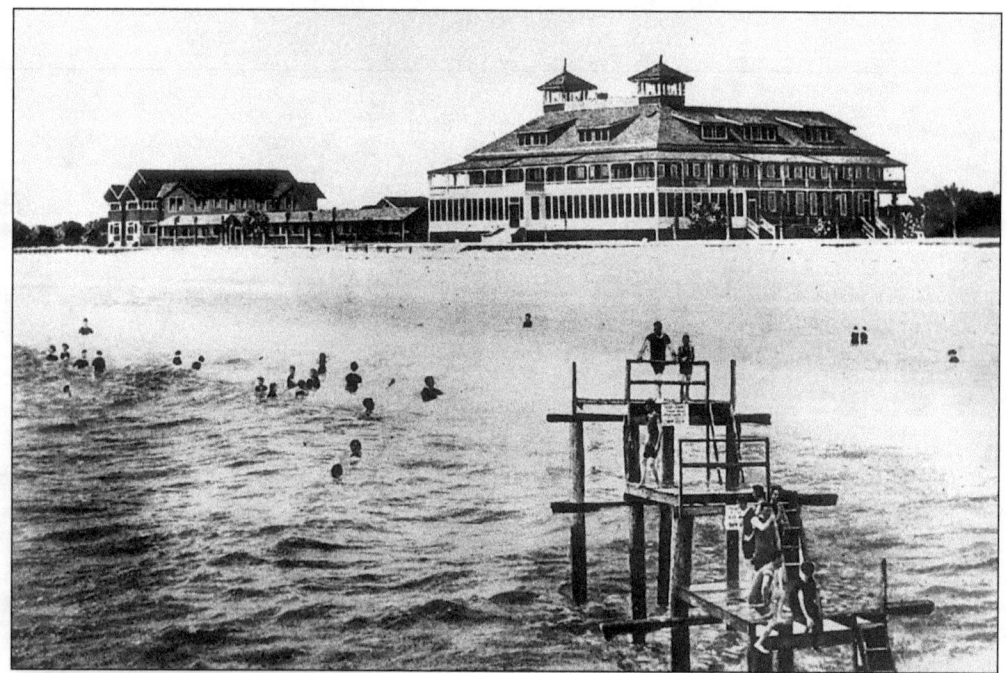

In 1913, St. Petersburg developer H. Walter Fuller purchased the elegant La Plaza Hotel, turning it into the expensive and "luxurious" Pass-a-Grille. The hotel burned in 1922. To the left is the Butler House, which served as Pass-a-Grille Hotel's servant quarters, and exists today as condominiums.

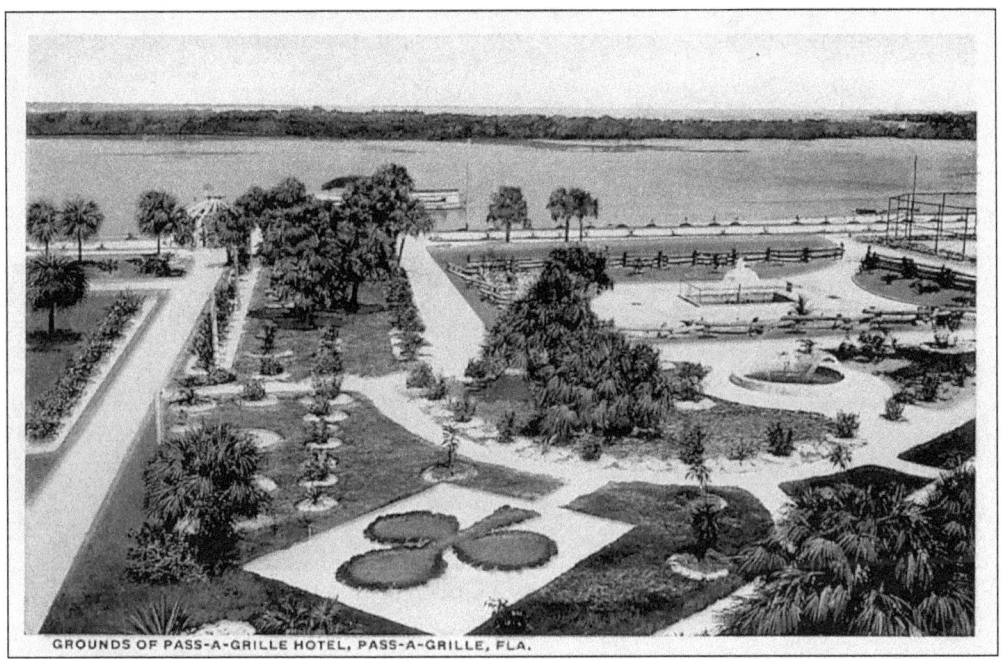

GROUNDS OF PASS-A-GRILLE HOTEL, PASS-A-GRILLE, FLA.

Grounds of the Pass-a-Grille Hotel extended across to the Bay where the boats docked.

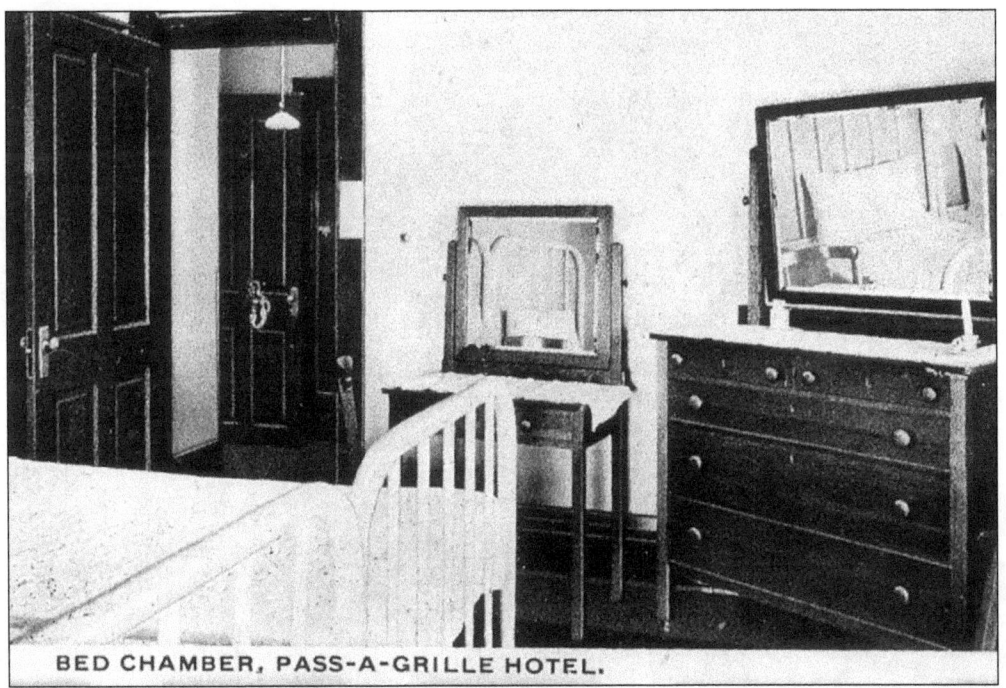

BED CHAMBER, PASS-A-GRILLE HOTEL.

First class "bed chambers," featuring a chest of drawers and dressing table, were offered to guests of the Pass-a-Grille Hotel.

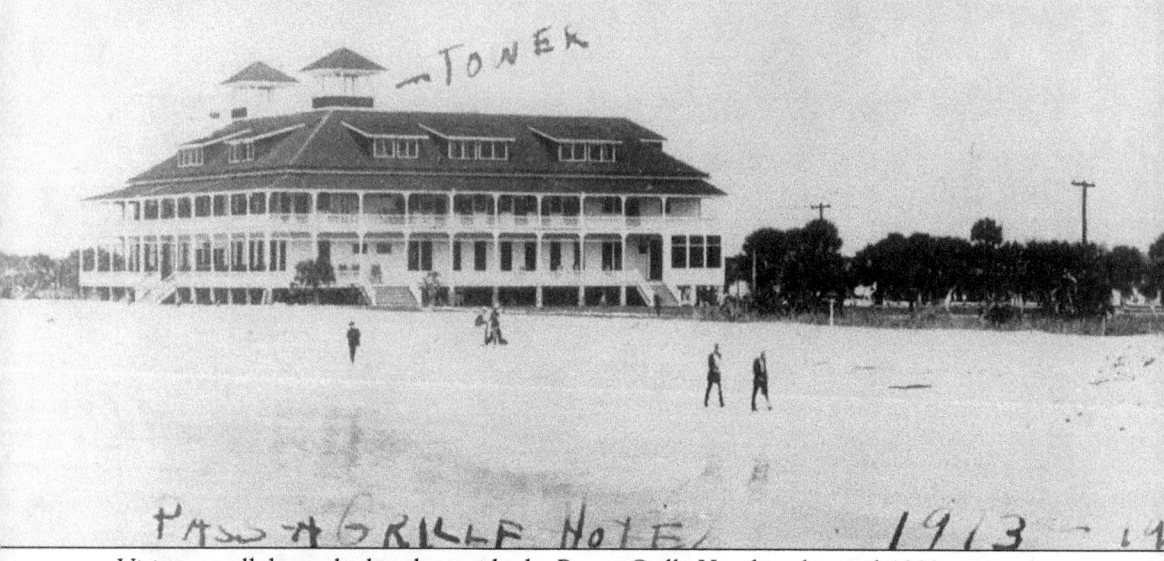

Visitors stroll down the beach outside the Pass-a-Grille Hotel in this mid-1910s view.

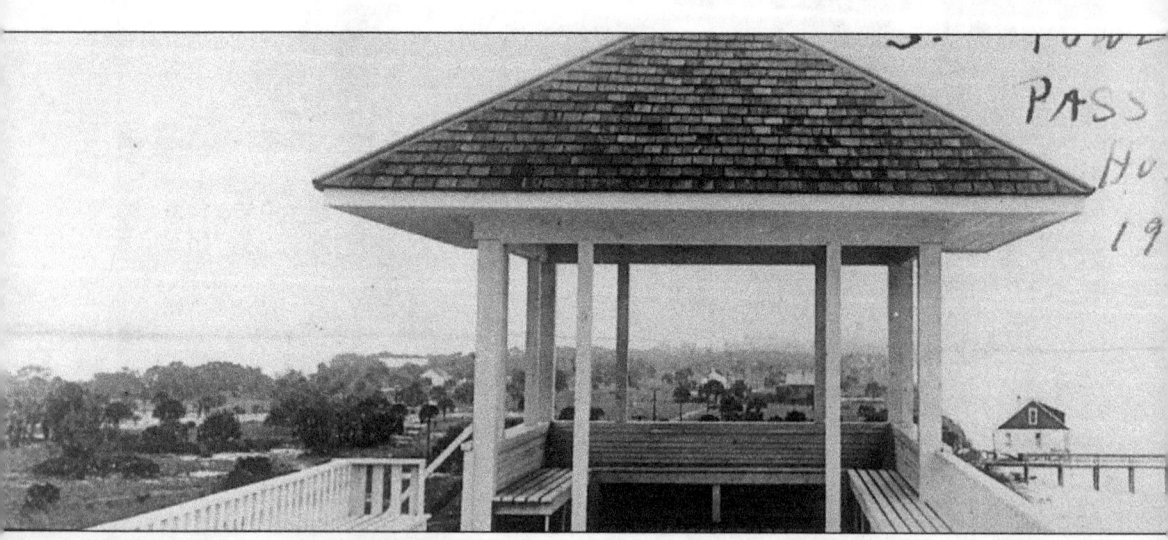

This birds-eye view of the landscape looking south was taken from atop the Pass-a-Grille Hotel.

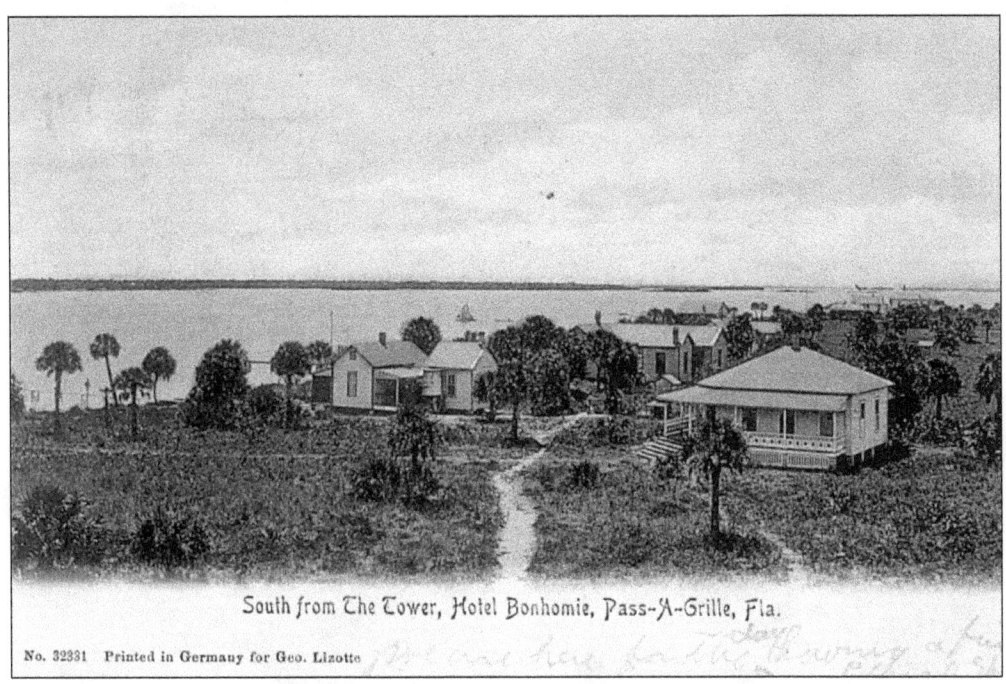

South from The Tower, Hotel Bonhomie, Pass-A-Grille, Fla.

No. 32331 Printed in Germany for Geo. Lizotte

Wooden cottages dot Pass-a-Grille's waterfront overlooking Boca Ciega Bay.

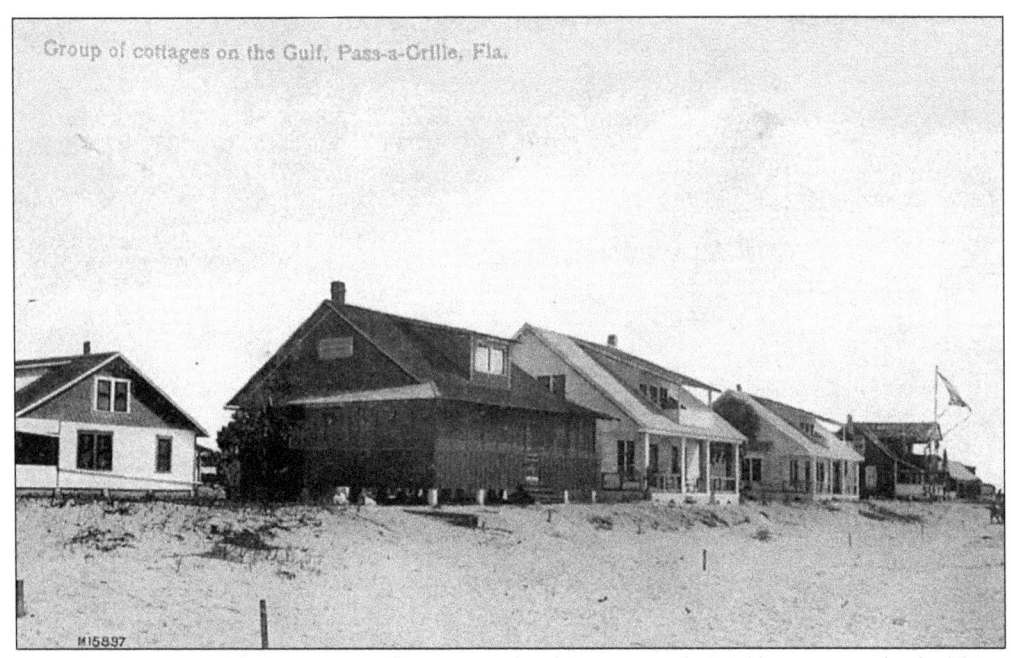

Group of cottages on the Gulf, Pass-a-Grille, Fla.

M15897

Beach cottages were welcome retreats for mainland visitors seeking relaxation and relief from the summer's heat.

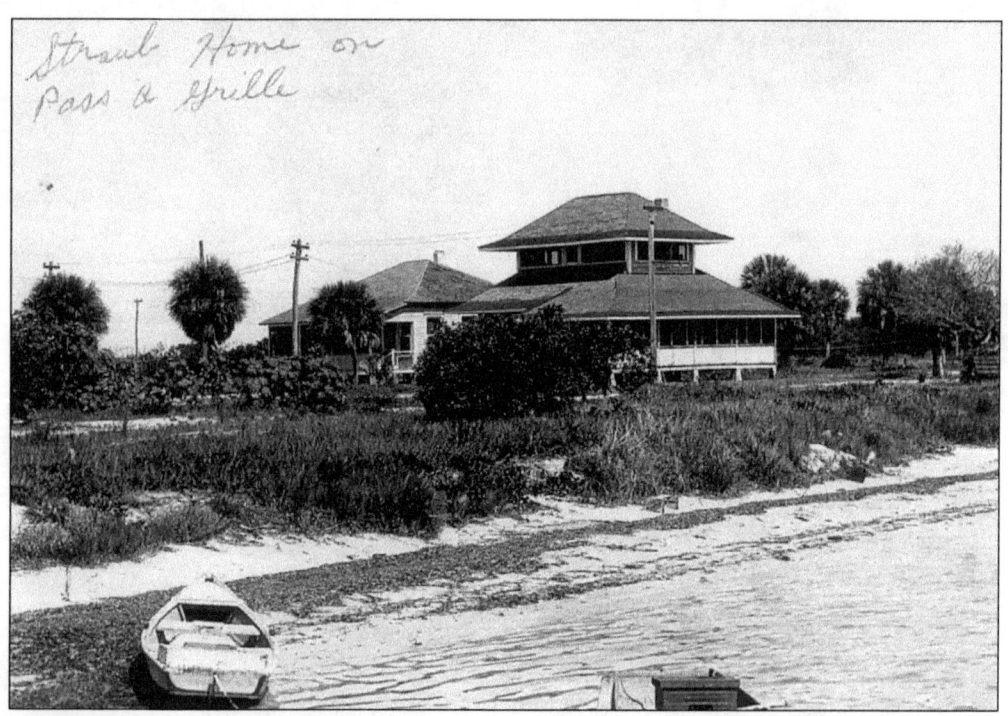

More sumptuous homes were built by the rich and famous. This cottage, Loafer Lodge, was the vacation home of the St. Petersburg Times editor, William L. Straub.

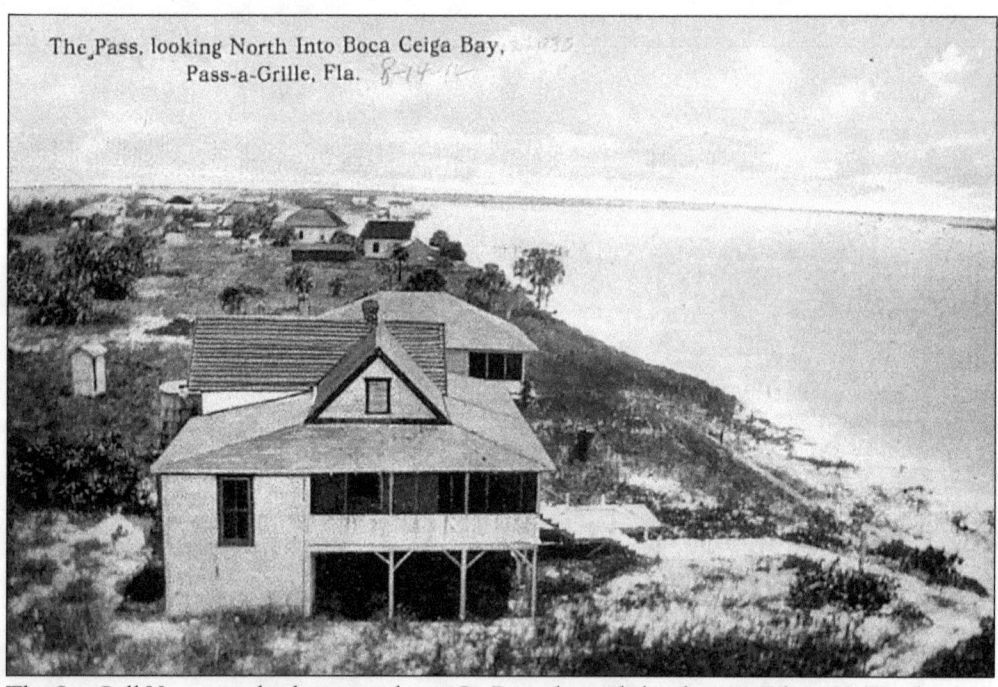

The Sea Call House, in the foreground, was St. Petersburg philanthropist Edwin H. Tomlinson's summer retreat.

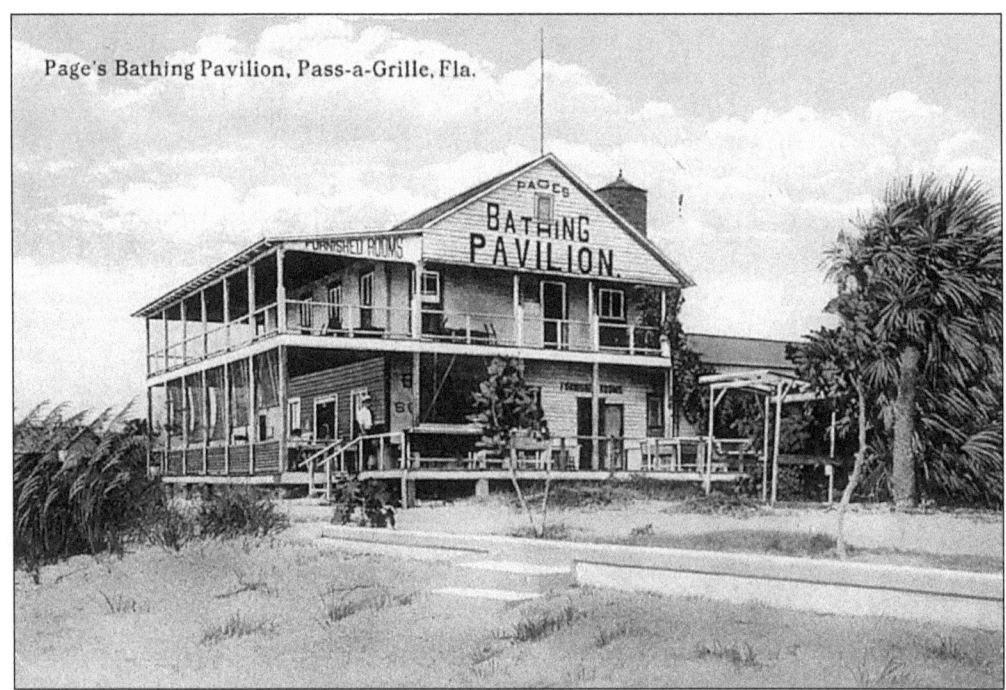

Page's Bathing Pavilion, Pass-a-Grille, Fla.

Early beach development featured bathhouses, where excursionists could change into beach attire for a wade into the surf. Pass-a-Grille's first "bathing pavilion" was Page's, built around 1905 by Charles S. Page. The structure enjoyed a long run, serving a variety of establishments until it was torn down in the 1960s.

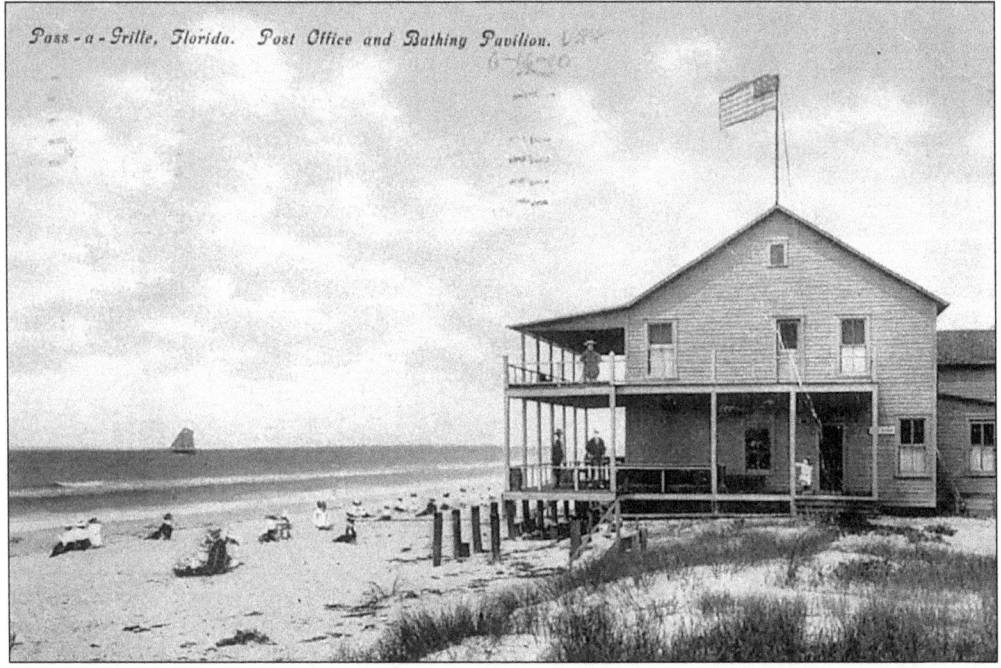

Pass-a-Grille, Florida. Post Office and Bathing Pavilion.

Page's Pavilion was also home to the Pass-a-Grille post office.

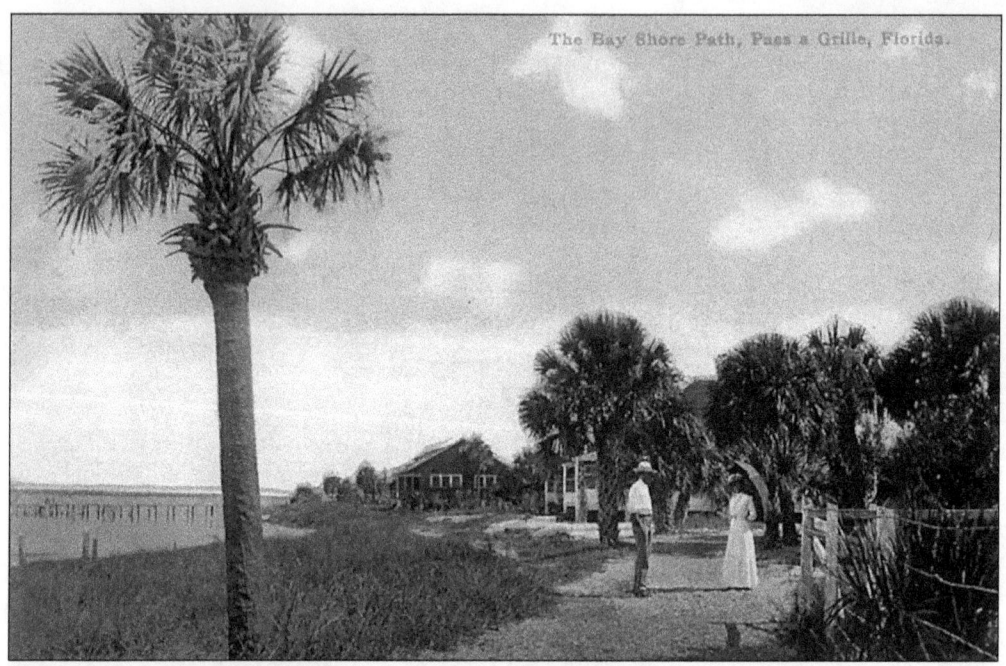

The bay shore path was a popular promenade in early Pass-a-Grille.

One of the beach's earliest inhabitants was the legendary Silas Dent (right), who arrived at Pass-a-Grille with his father and brother Noah from Douglas, Georgia, around 1900. Known as the "Happy Hermit," Silas Dent lived in a palm-thatched dwelling on Cabbage Key, making his living by fishing and clamming.

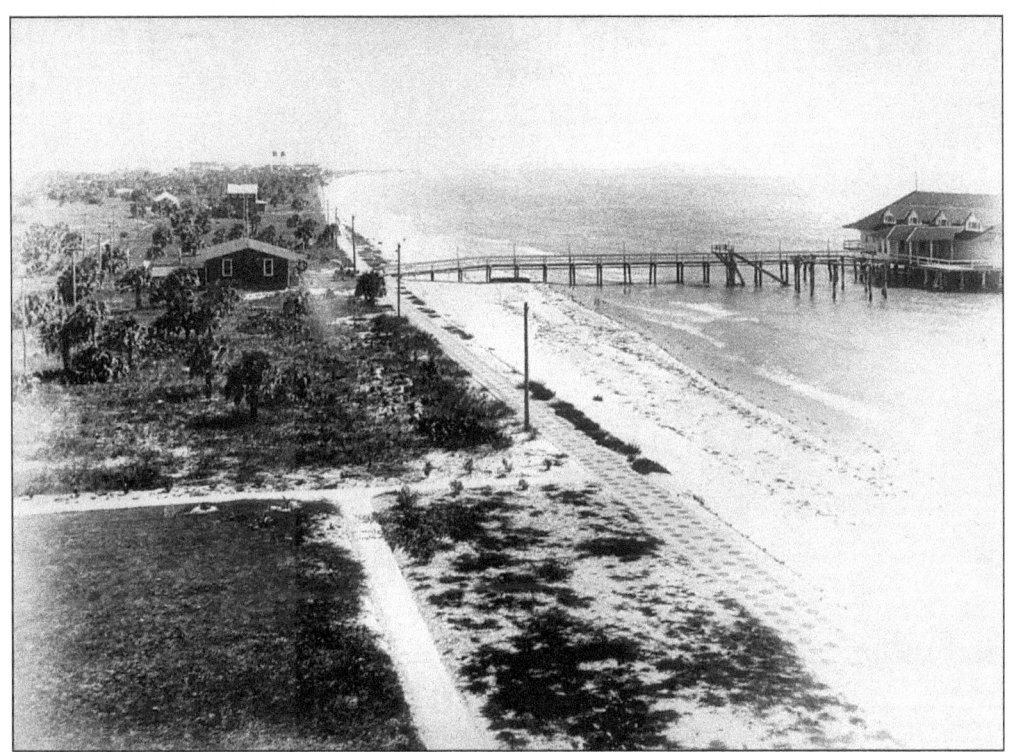

The casino at the end of the pier at Twenty-third Avenue, shown here in 1910, was destroyed in the hurricane of 1921.

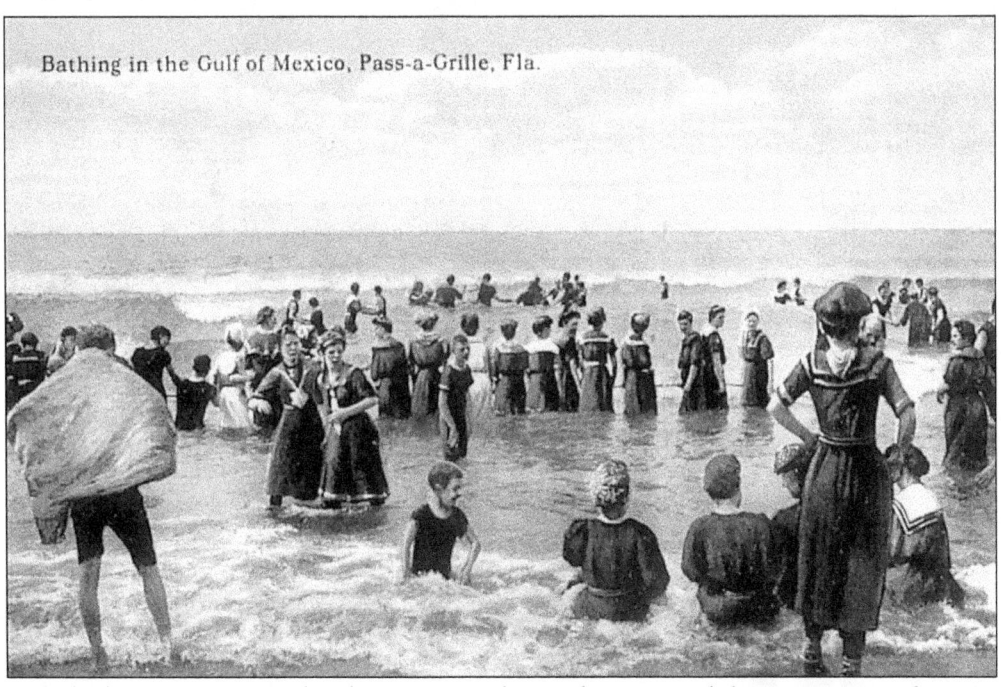

Bathing in the Gulf of Mexico, Pass-a-Grille, Fla.

Early bathers in snappy sailor dress enjoy a dip in the waves while on excursion from St. Petersburg. Women were not allowed to bare their ankles.

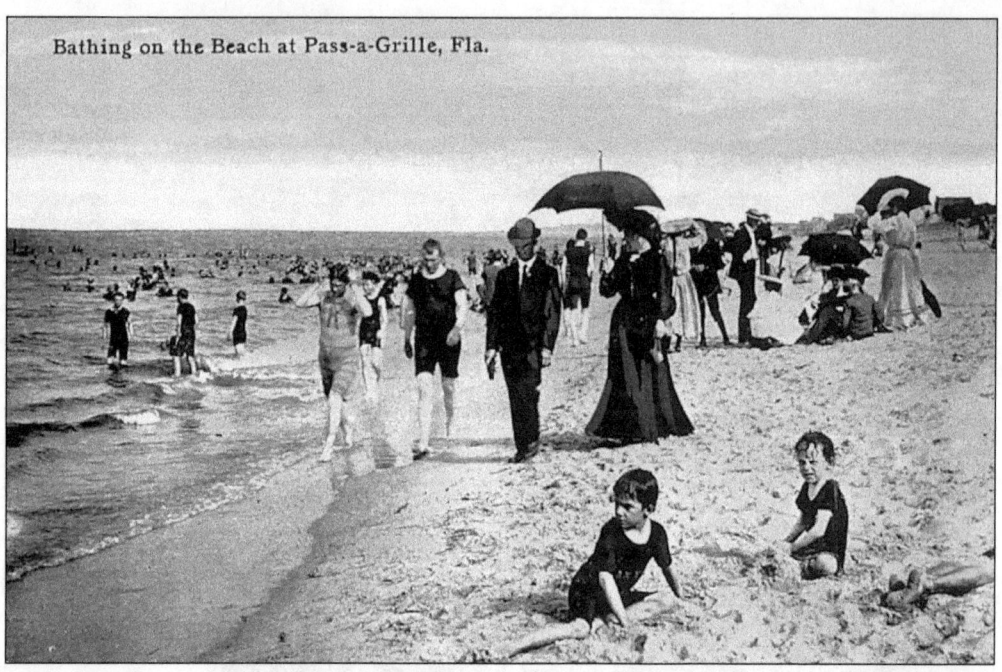

Bathing on the Beach at Pass-a-Grille, Fla.

Decked out for sand and surf, beachgoers line the shore at Pass-a-Grille.

The "Marina and Curio Shop" in the background was typical of the primitive structures that served early beach visitors.

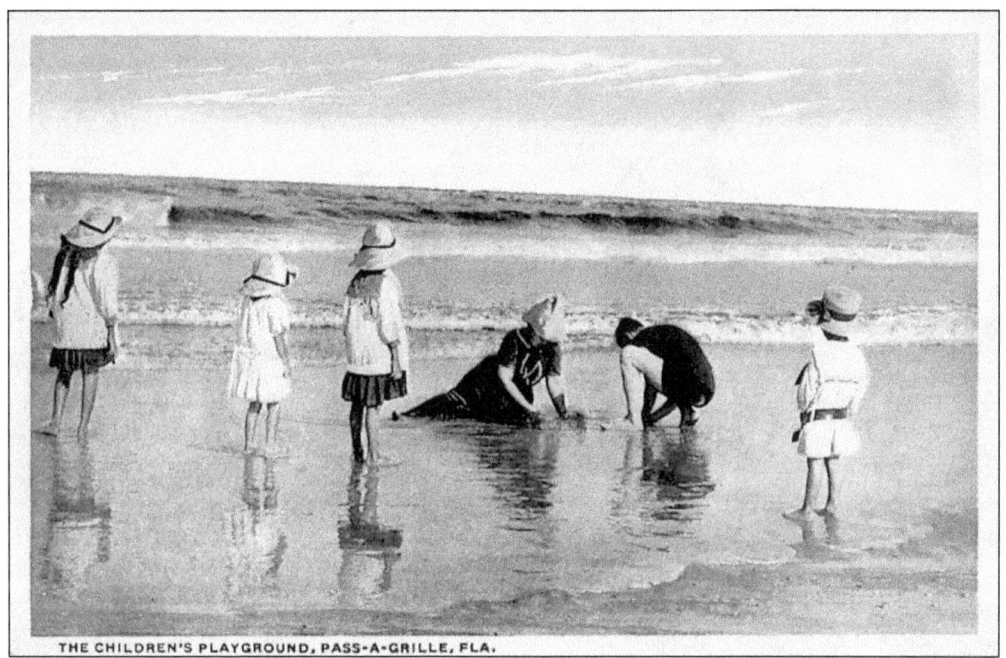

THE CHILDREN'S PLAYGROUND, PASS-A-GRILLE, FLA.

Hatted children test the Gulf waters.

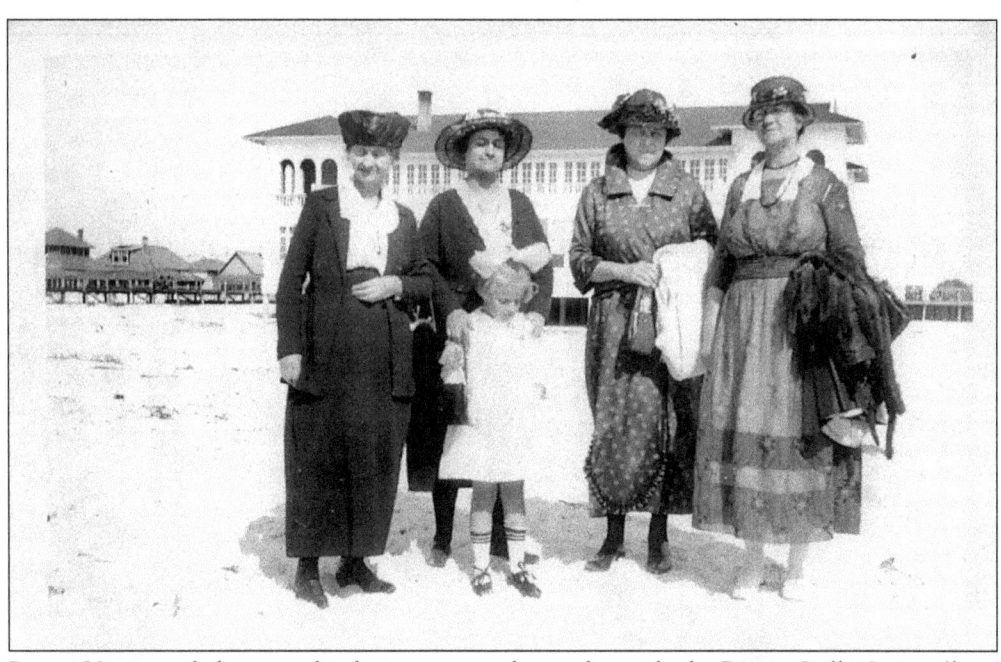

Proper Victorian ladies pose for the camera on the sand outside the Pass-a-Grille Casino (later the Pass-a-Grille Beach Hotel).

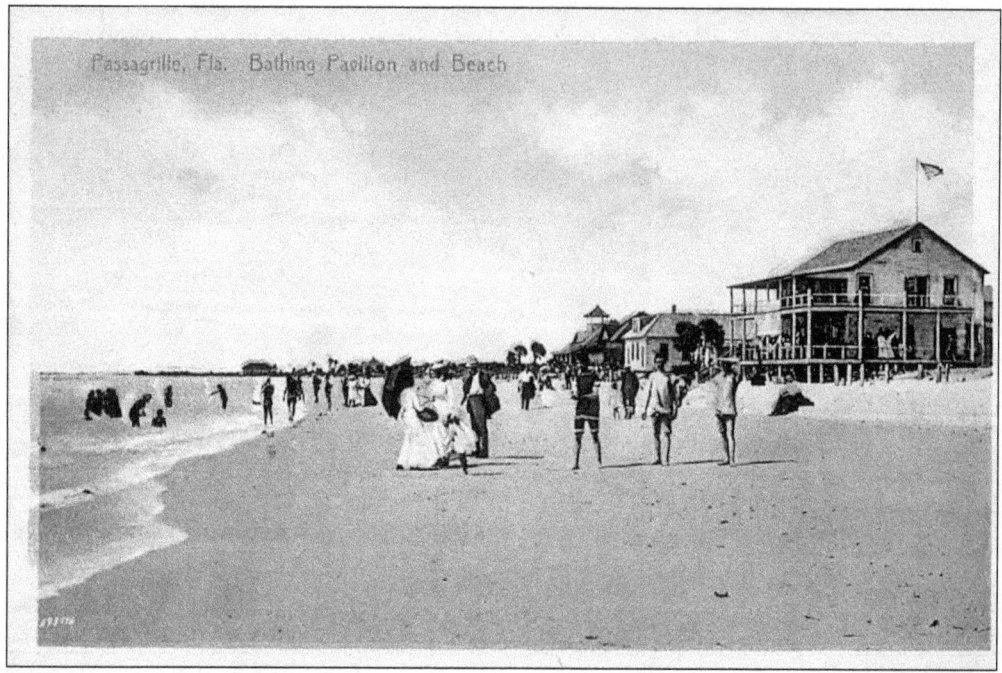

Bathing pavilions, such as Page's shown here, offered early visitors discreet facilities to change into rented beach attire. This card was "Published by C.S. Page, Passagrille, Fla," proprietor of the pavilion.

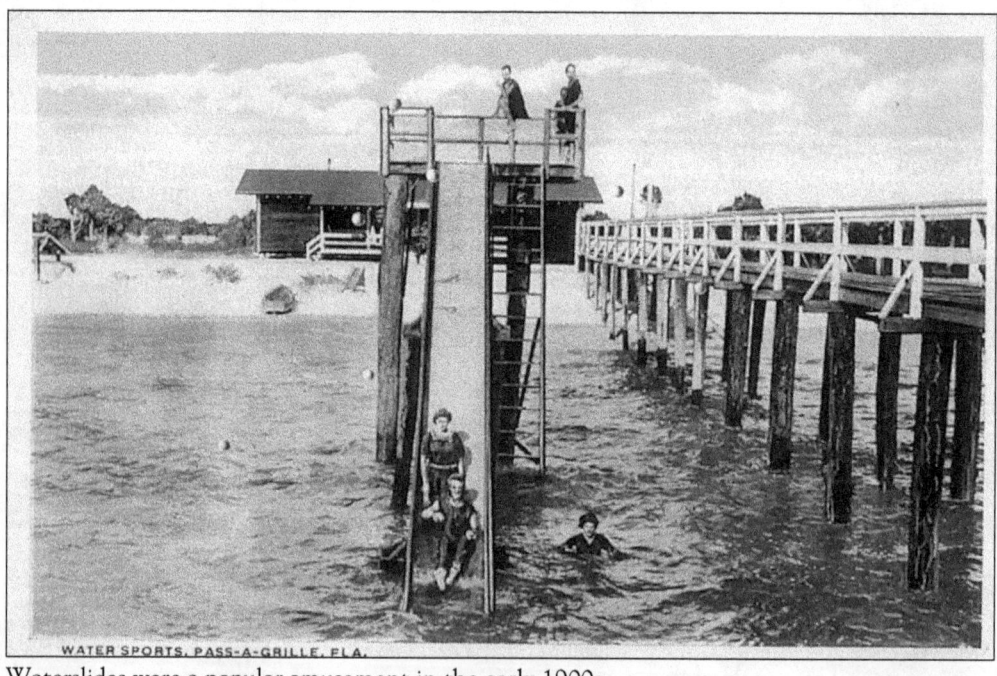

Waterslides were a popular amusement in the early 1900s.

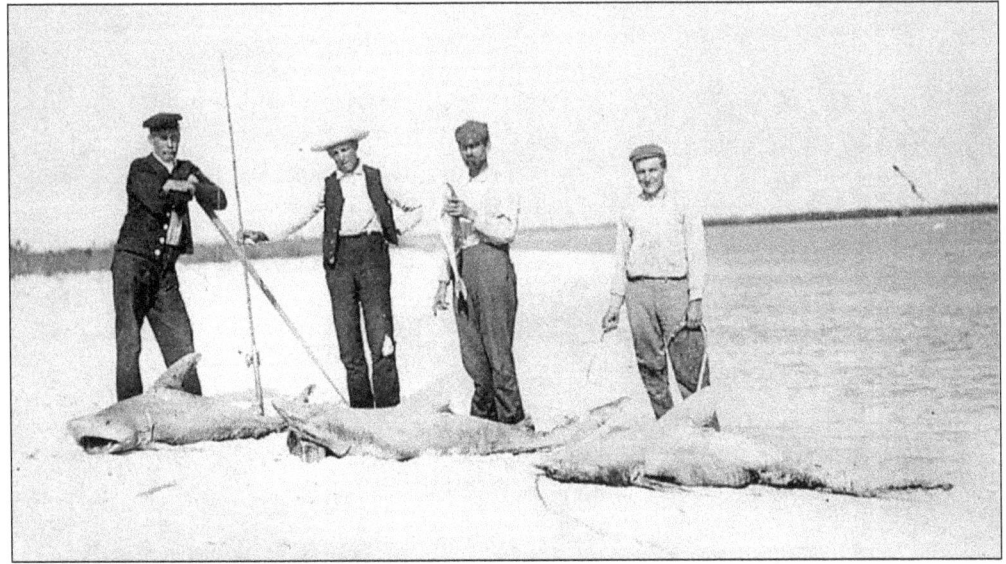

Many of Pass-a-Grille's early visitors were sport fishermen, attracted by the abundance of tarpon, mullet, kingfish, and numerous other challenging species in the Gulf and Bay waters. Here, a group of mammoth tarpon, measuring almost the length of their captors, is hung up to dry by famed fishing guide George Roberts (left) and a buddy. The structure in the background is a typical palmetto-thatched "fisherman's shack."

George Roberts (right) reportedly skipped his wedding to fish, telling his bride-to-be, "Lady, you can get married any time, but you have to catch these tarpon when they're hungry."

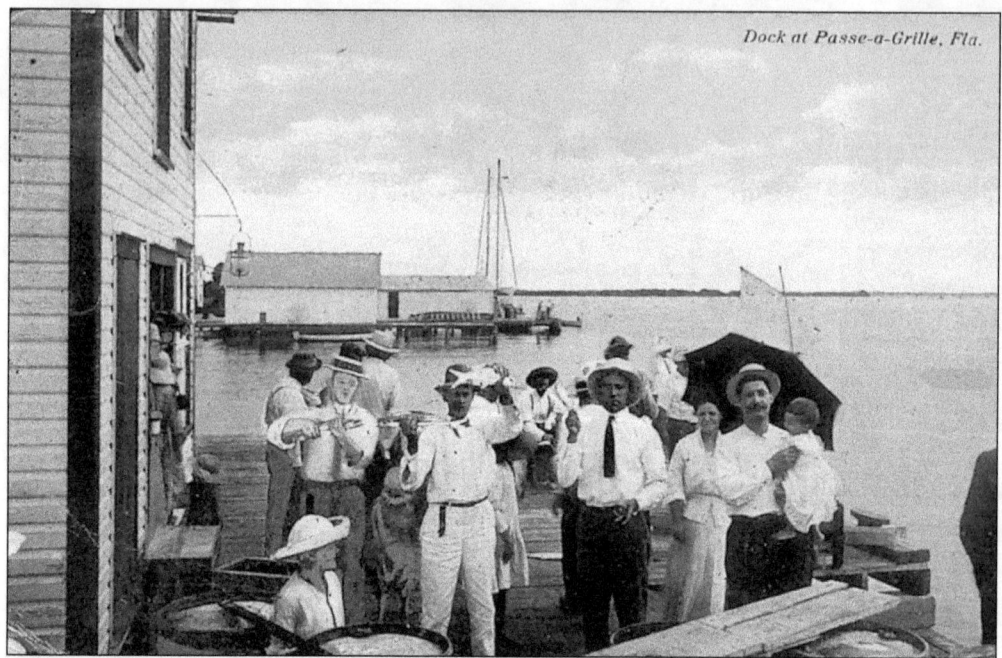

Dock at Passe-a-Grille, Fla.

These nicely dressed fishermen came to Pass-a-Grille on an excursion with their families.

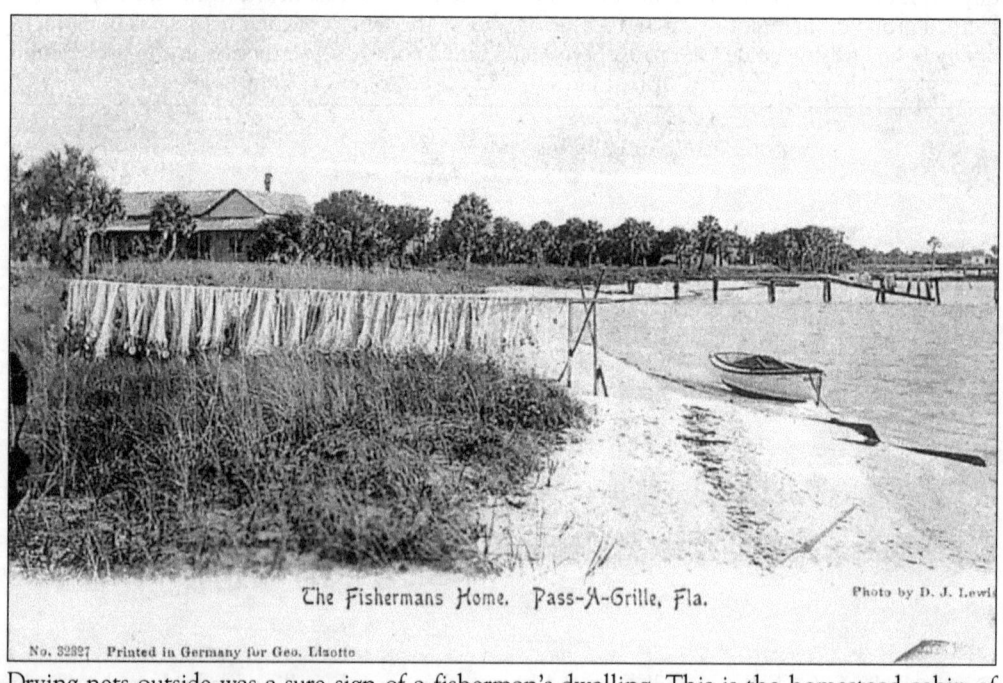

The Fishermans Home. Pass-A-Grille, Fla.

Photo by D. J. Lewis

No. 32327 Printed in Germany for Geo. Lisotto

Drying nets outside was a sure sign of a fisherman's dwelling. This is the homestead cabin of Zephaniah Phillips, built in 1886.

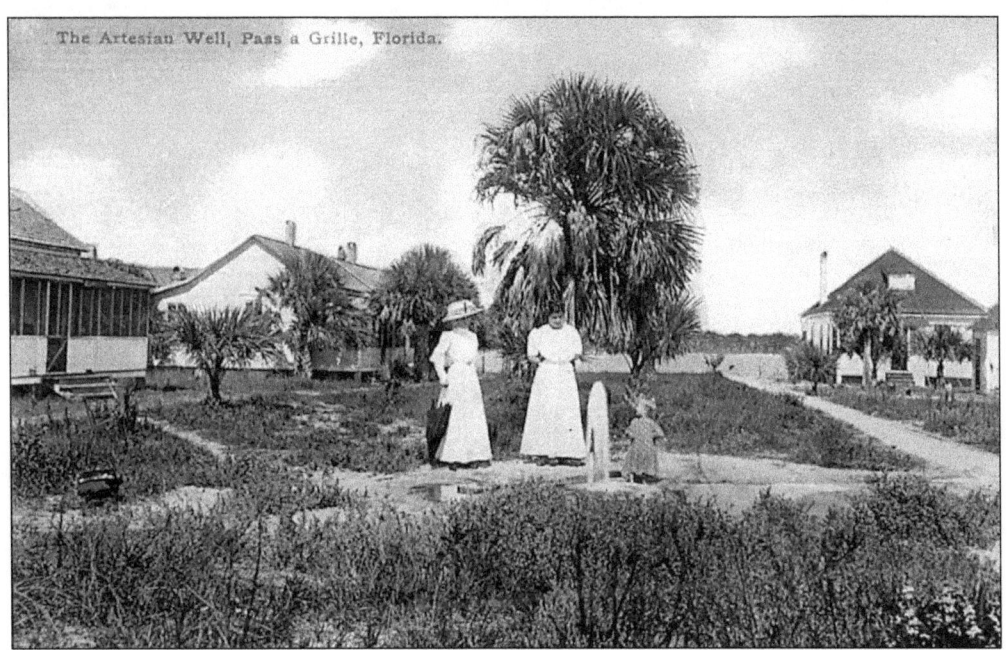

Drinking water was supplied by the town's artesian well.

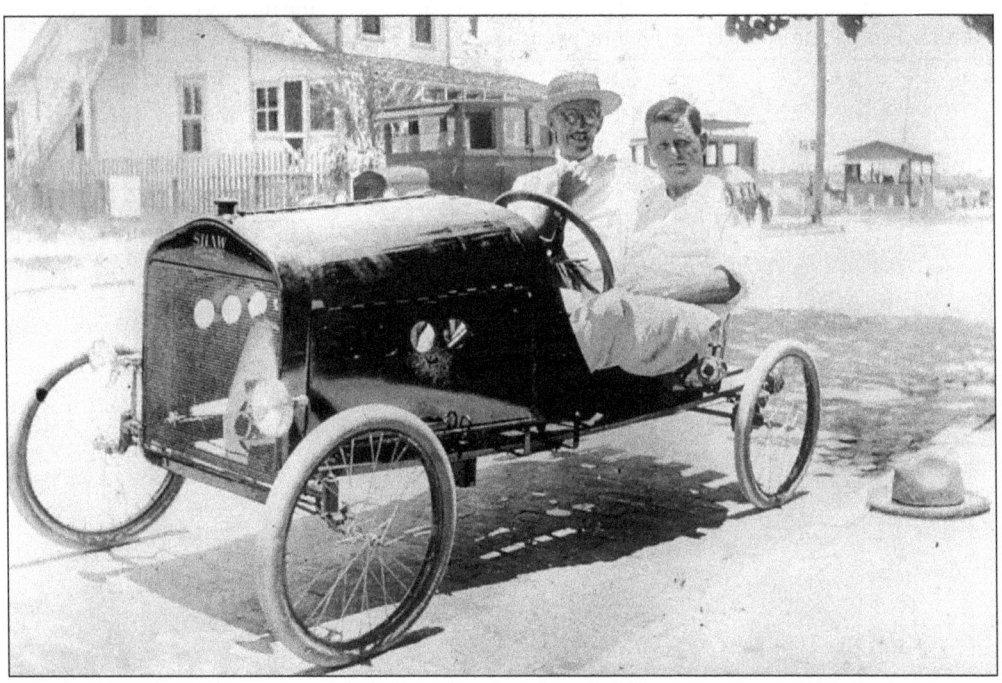

Wholesale fish dealer Harry H. Bell steers his friend's show car down Eighth Avenue in downtown Pass-a-Grille.

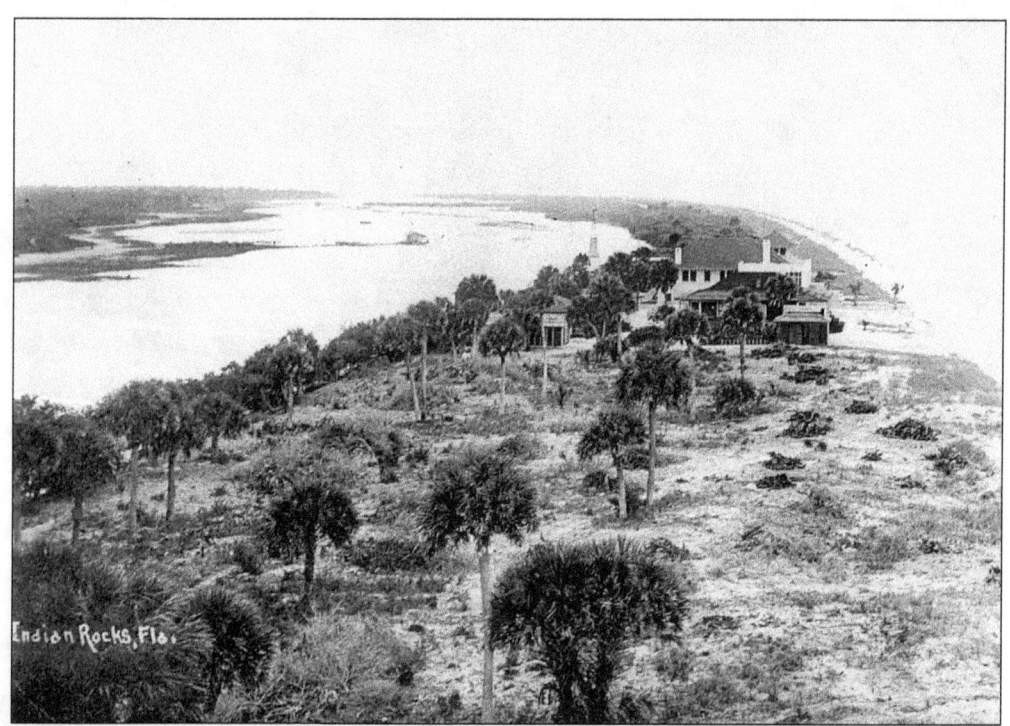

Moving north along the beach strip, the next settlement of any size was at Indian Rocks Beach (called "Indian Rocks" in early days). Though settled in the 1880s, the area grew slowly until the first bridge from the mainland was built in 1915. Development in the early 1900s was mostly on the mainland side of the bay, with beachside structures consisting mainly of summer cottages built by Tampa families who arrived by excursion train.

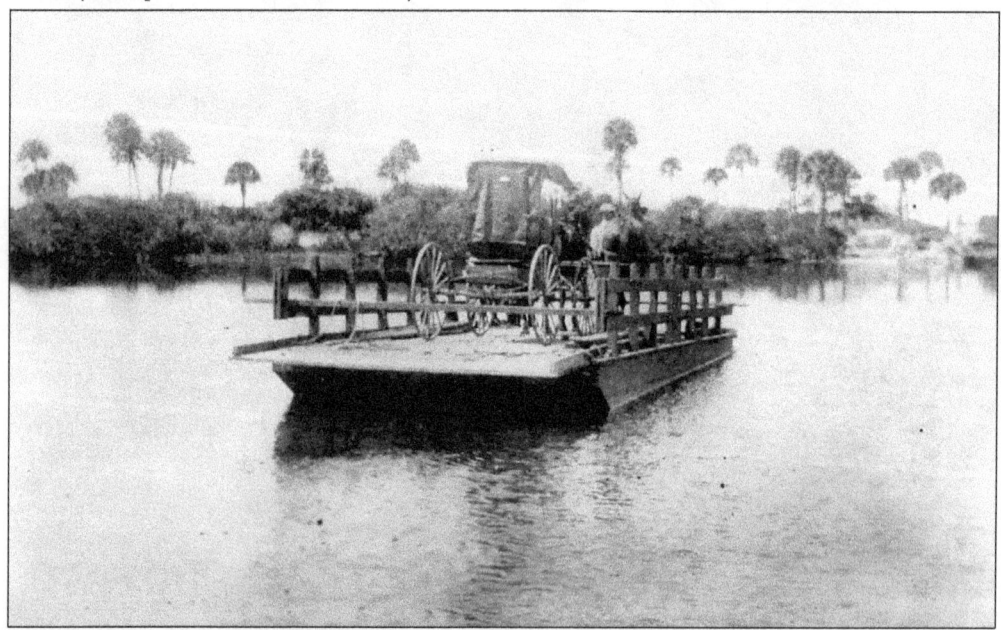

The ferry to the beach was a flat-bottomed scow called "Squaw" owned by H.K. (Dad) Hendricks, shown here in an 1890 photo.

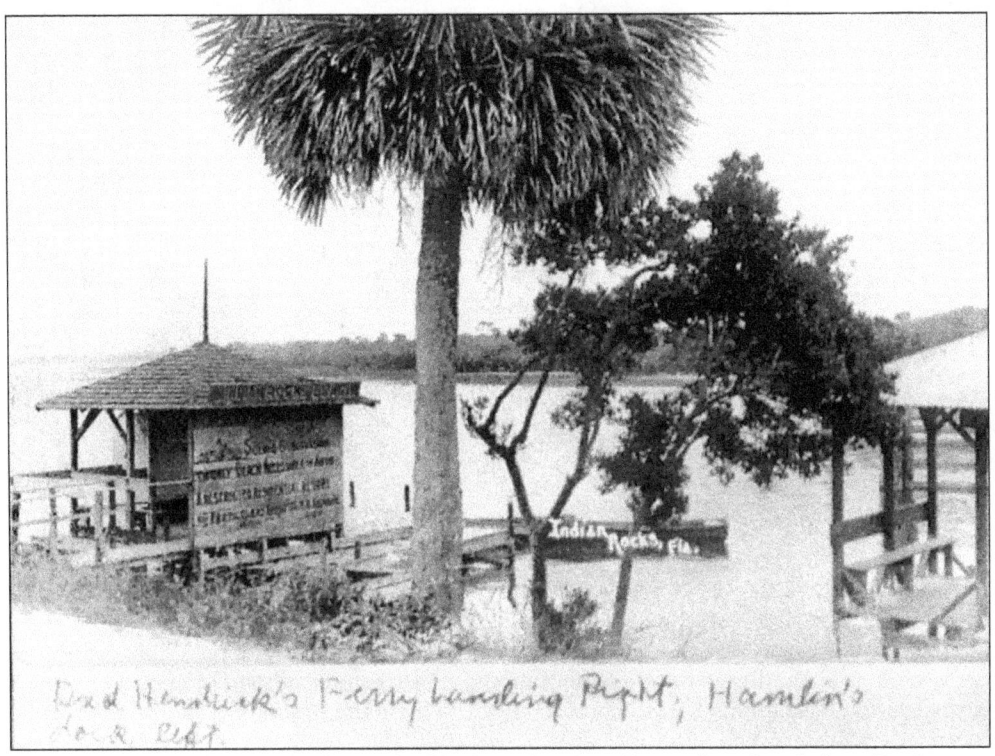

The sign on the dock at Dad Hendrick's Ferry Landing Point describes Indian Rocks as a "restricted residential resort," *c.* 1915.

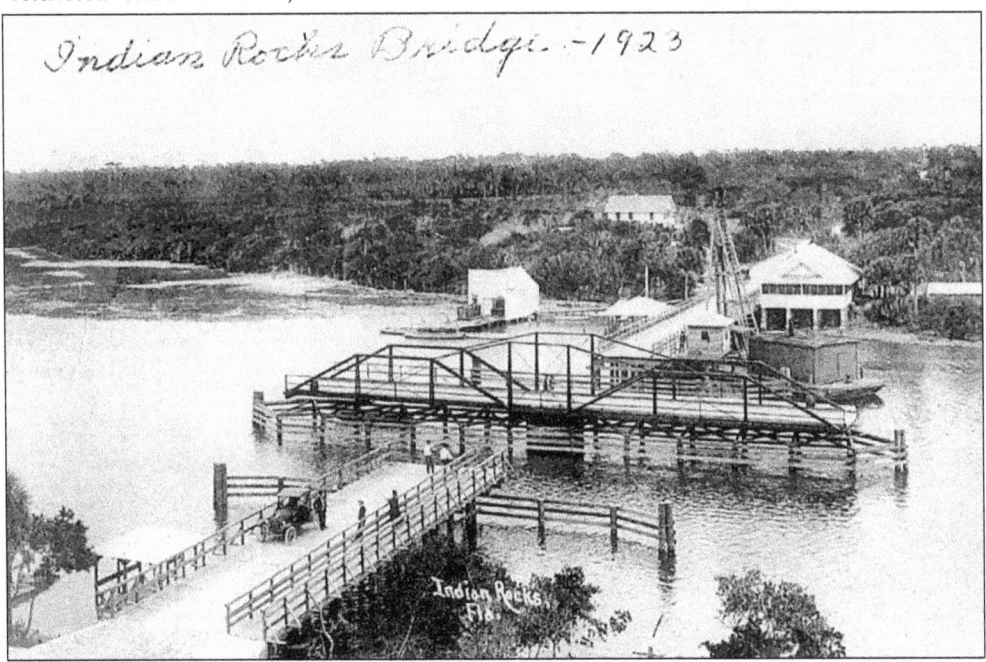

The building of the Indian Rocks Bridge connecting the mainland to the beach put Dad Hendricks' ferry out of business, although he later became a bridge tender on the new structure. The bridge was opened with a giant key, allowing boats to pass.

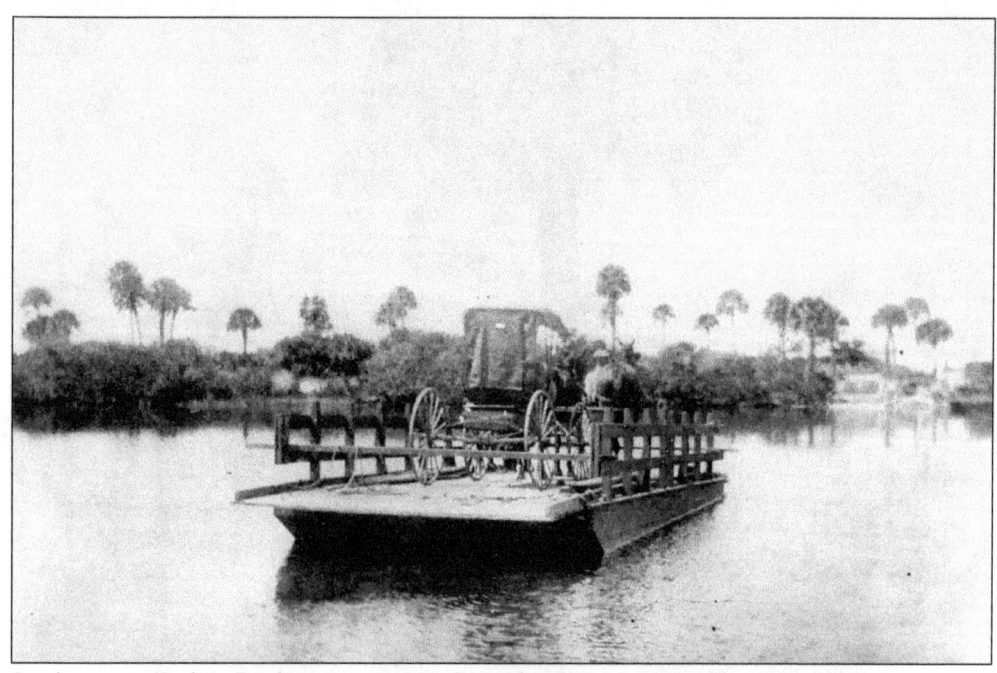

Settlement at Indian Rocks was sparse in the early 1900s. Scattered homes can be seen among the palmetto jungle in this *c.* 1919 photo, with the Gulf on the left and the Bay on the right.

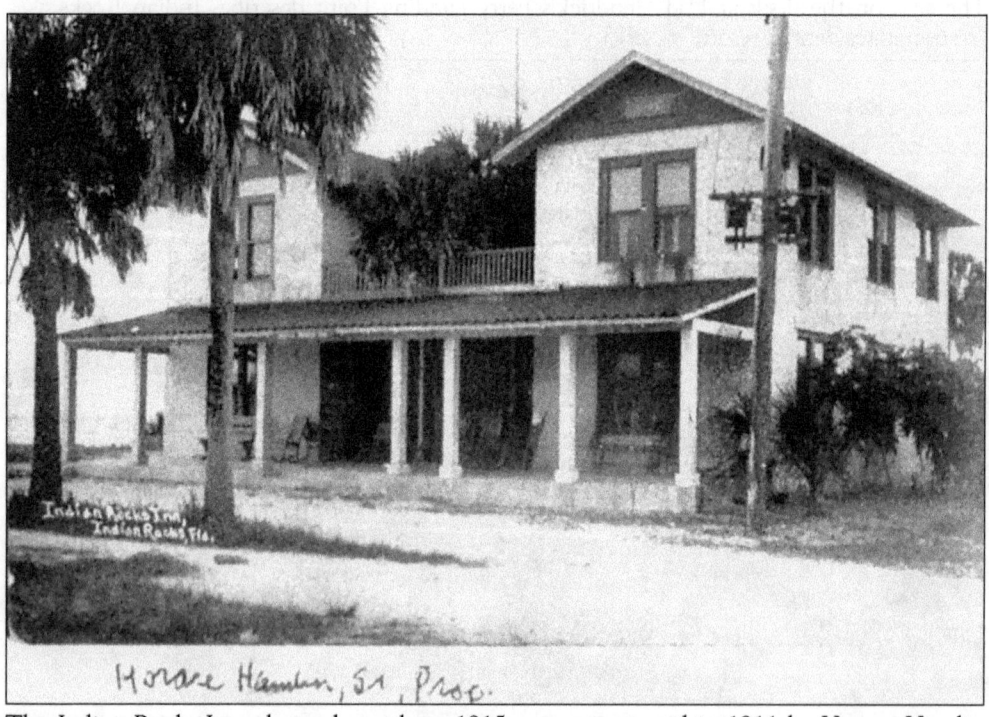

The Indian Rocks Inn, shown here about 1915, was constructed in 1911 by Horace Hamlin to serve the tourists brought in by train from Tampa. The Inn let its rooms, six in all, at $15 a night. The offer of "All you can eat for 50¢" at the restaurant lasted until World War II.

Many of the early beach cottages were simple but spacious structures, built by wealthy Tampans to accommodate the large families prevalent in that era.

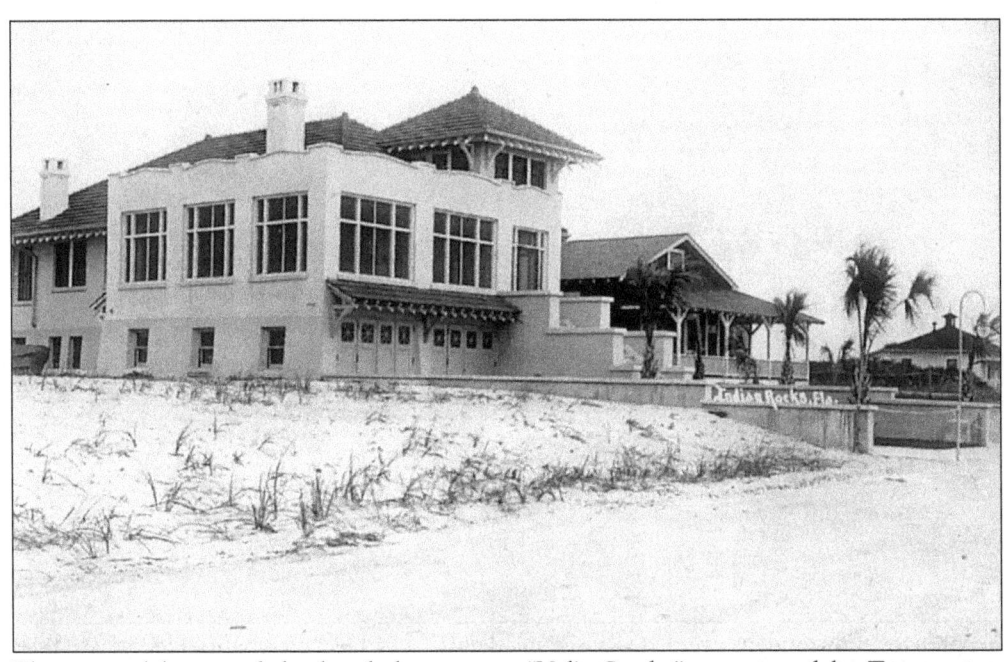

The most elaborate of the beach houses was "Val's Castle," constructed by Tampa cigar manufacturer Val Antuono in 1910. Note the road ran in front of the houses along the beach.

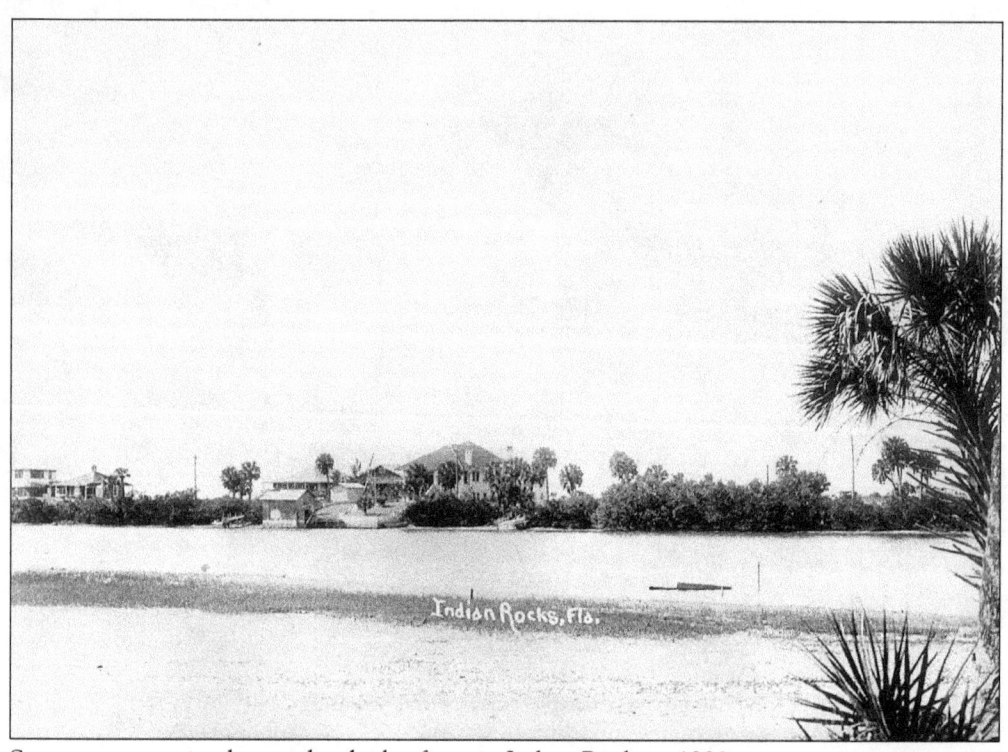

Sumptuous vacation homes dot the bayfront in Indian Rocks *c*. 1920.

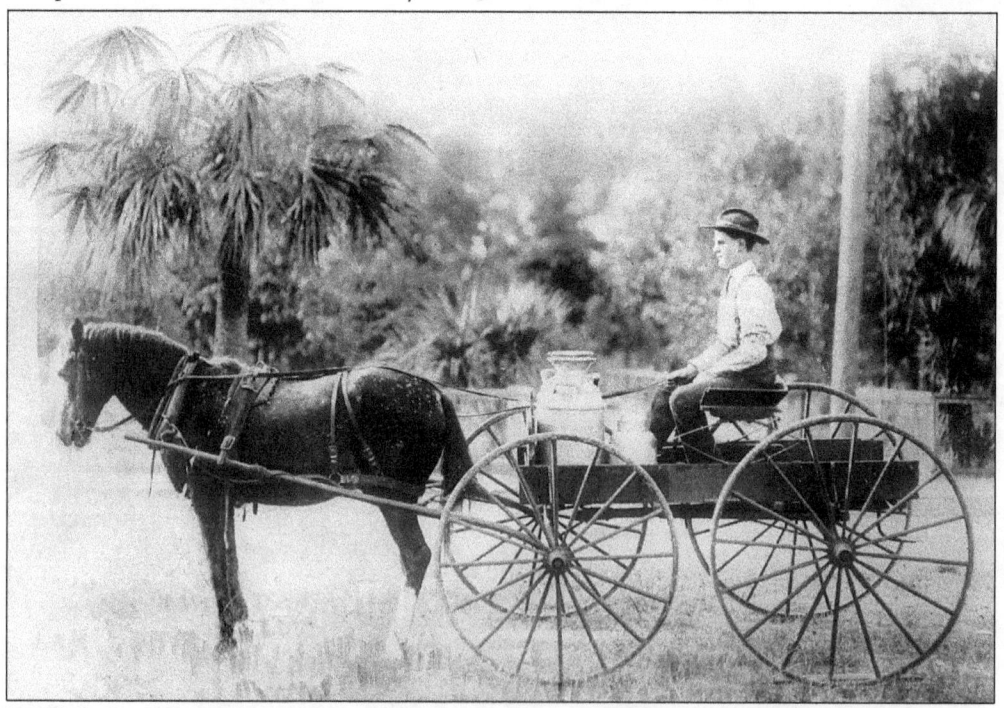

Supplies for early residents were at times home-delivered by local merchants. George Mitchell Sellers had the first milk route in Tarpon Springs, north of Clearwater. Charlie the horse pulled the milk wagon for 22 years.

This 1914 photo shows the formal dress worn even on the beach by Victorian-era tourists. Note the camera carried by the woman on the right.

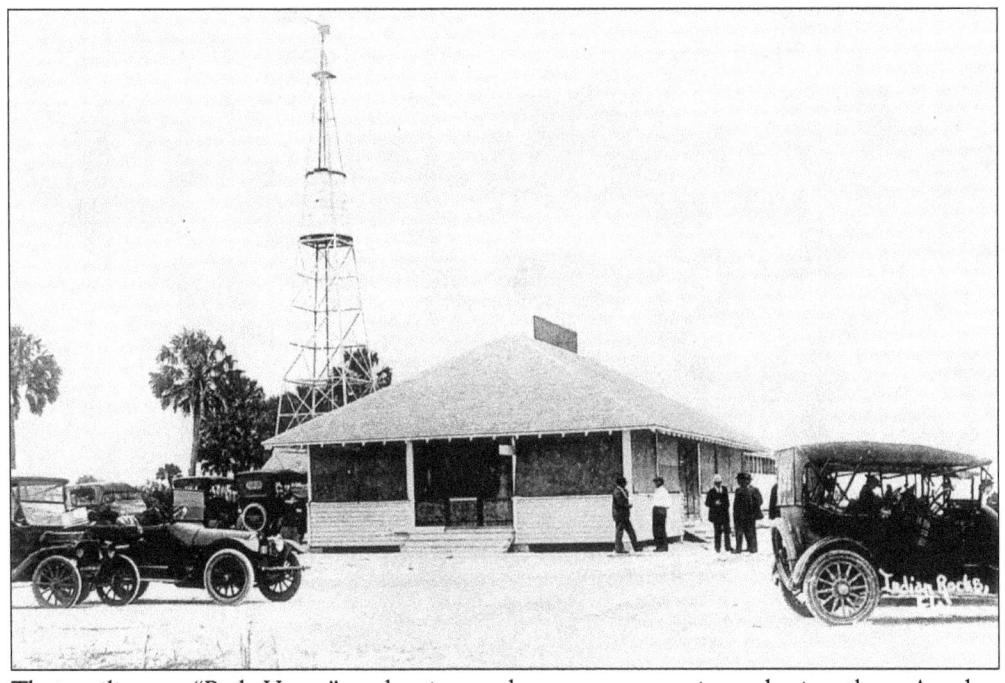

The pavilion, or "Bath House" as the sign reads, was a community gathering place. Another sign offered "Bathing suits" and "large sanitary rooms."

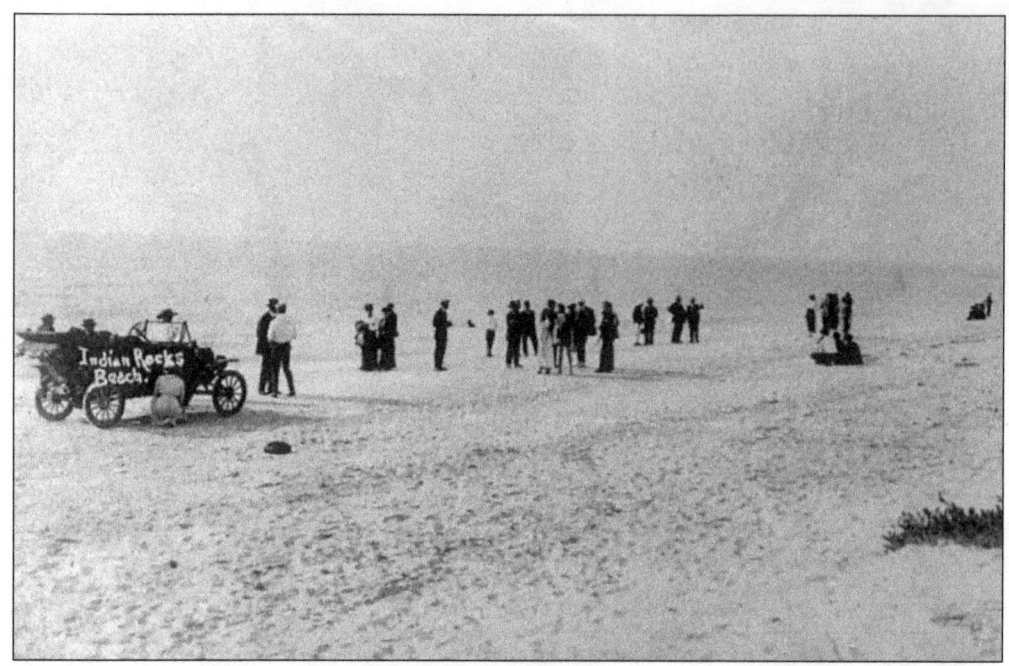

The automobile was a sign of wealth and prestige in the early days of the 1900s, and the more prosperous visitors began to ferry their "horseless carriages" over for a jaunt on the beach.

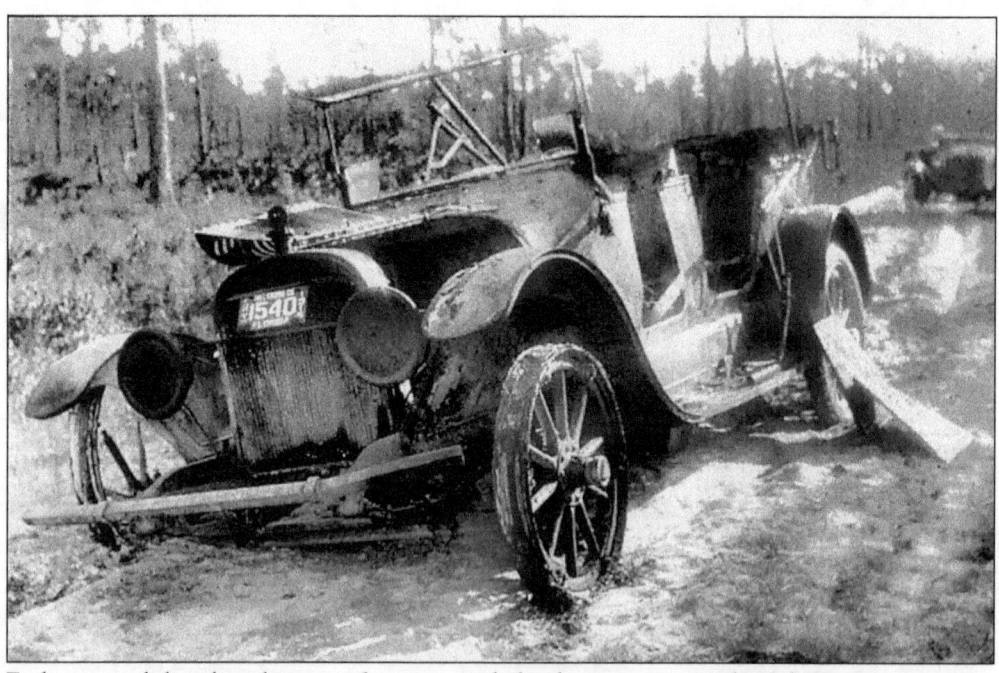

Early automobiles, though, were often no match for the primitive roads of that era.

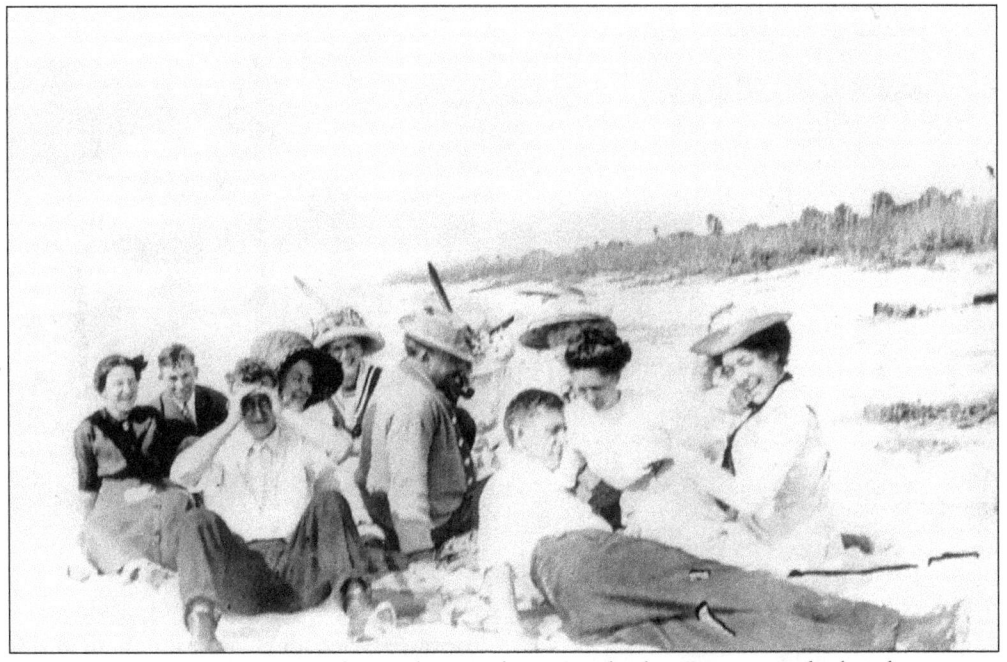

Clearwater Beach, at the northernmost tip of Tampa Bay's Gulf Beach area, was first settled in the late 1800s. The first roads were primitive sand trails, as shown in this early 1900s view.

This 1896 shot shows a group of picnickers in their "Sunday best" enjoying the beach.

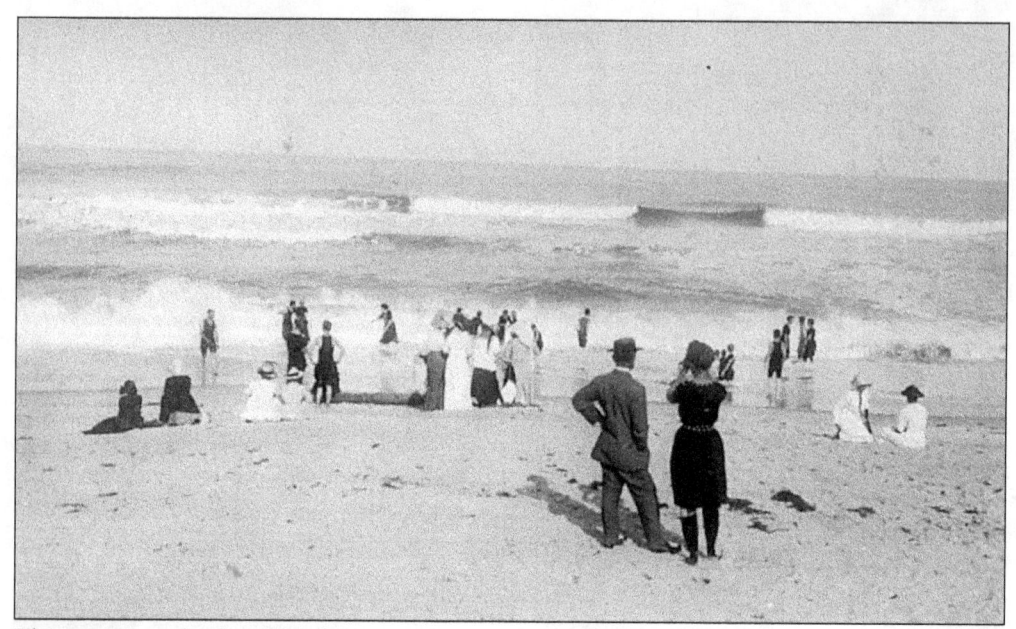

The woman in the foreground is snapping a picture of a group on the beach.

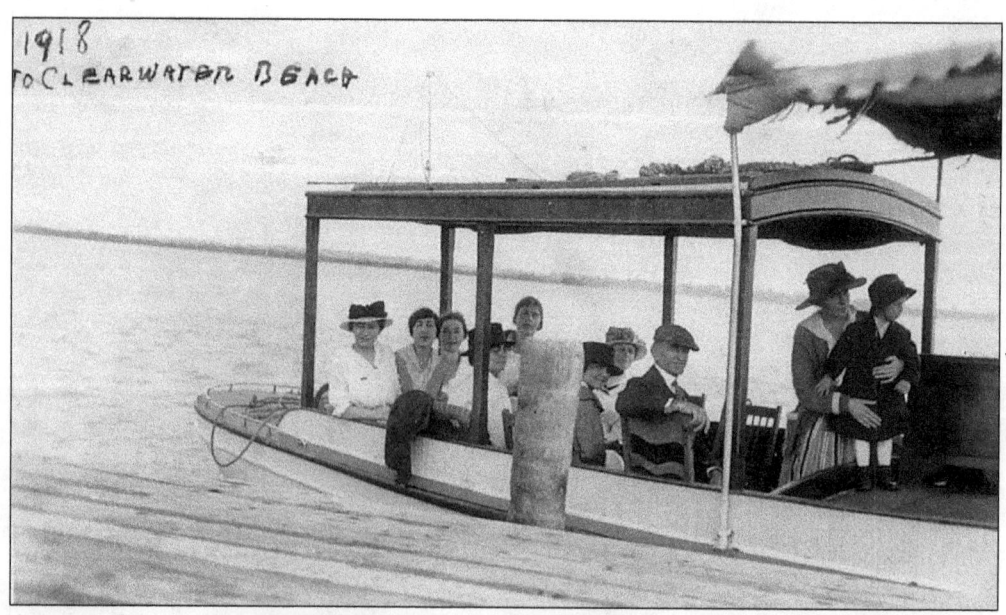

A group of excursionists arrives at the dock at Clearwater Beach for a day at the shore in this 1918 view.

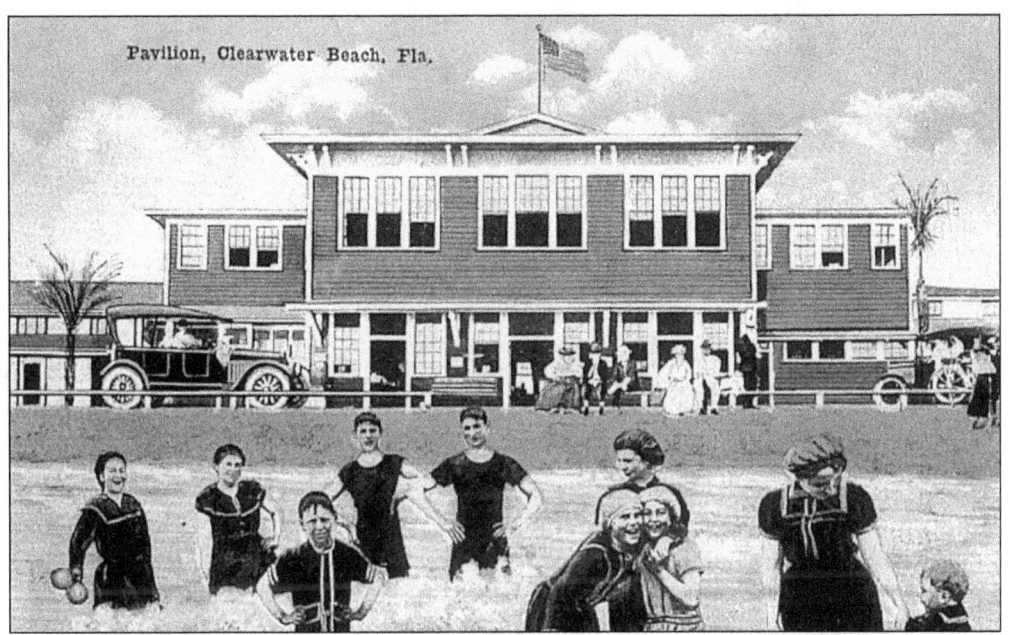

The Clearwater Beach Pavilion remained a favorite "changing spot" for beachgoers until it was razed in the 1930s.

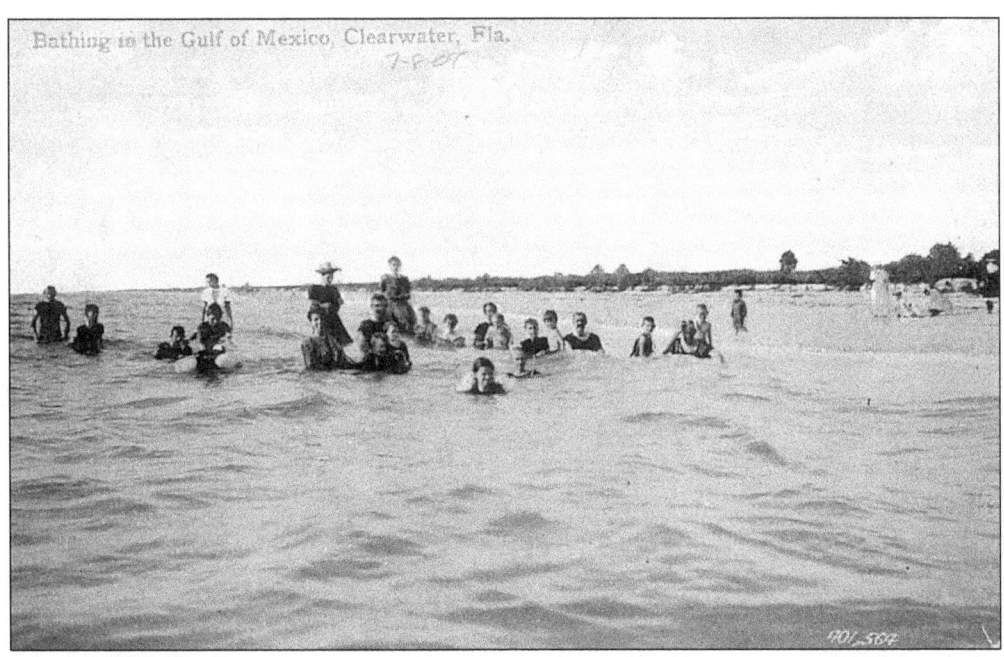

As with other beach settlements, surf bathing in the Gulf of Mexico was the most popular attraction at early Clearwater Beach.

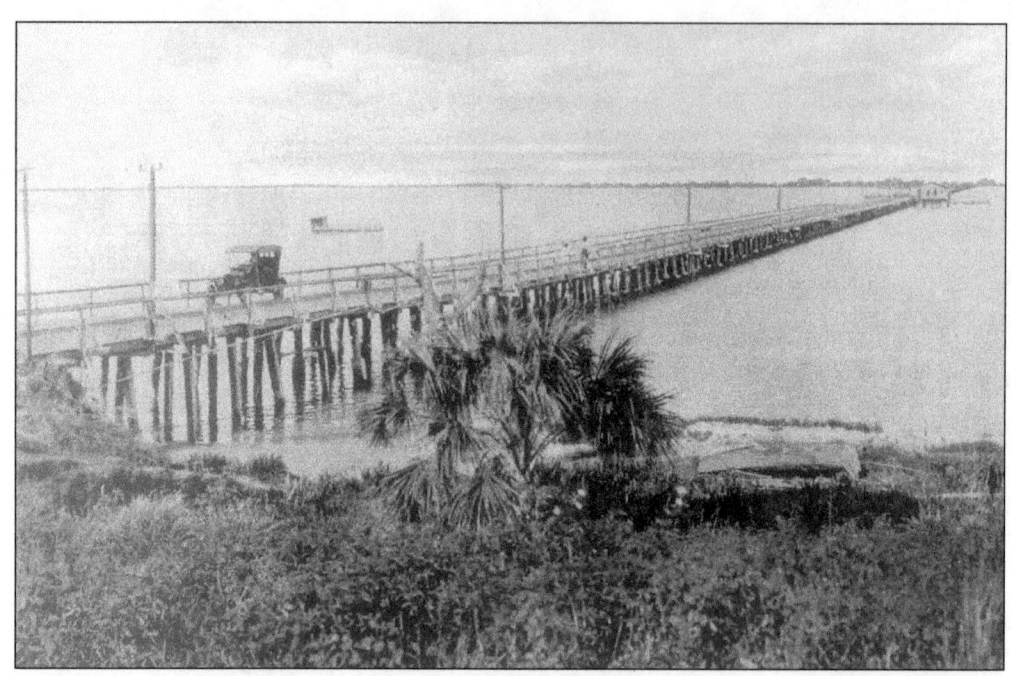

With the city of Clearwater right across the bay, the coming of the Clearwater Beach Bridge in 1916 made the beach accessible to automobiles, and the crowds followed. In this 1916 view, Jeff Miller traverses the wooden bridge in a 1913 Model T Ford.

Clearwat Beach, Clearwater, Fla.

This scene, together with the photo on the right, gives a panoramic view of Clearwater Beach, from the Gulf of Mexico on the left to Clearwater Bay on the right.

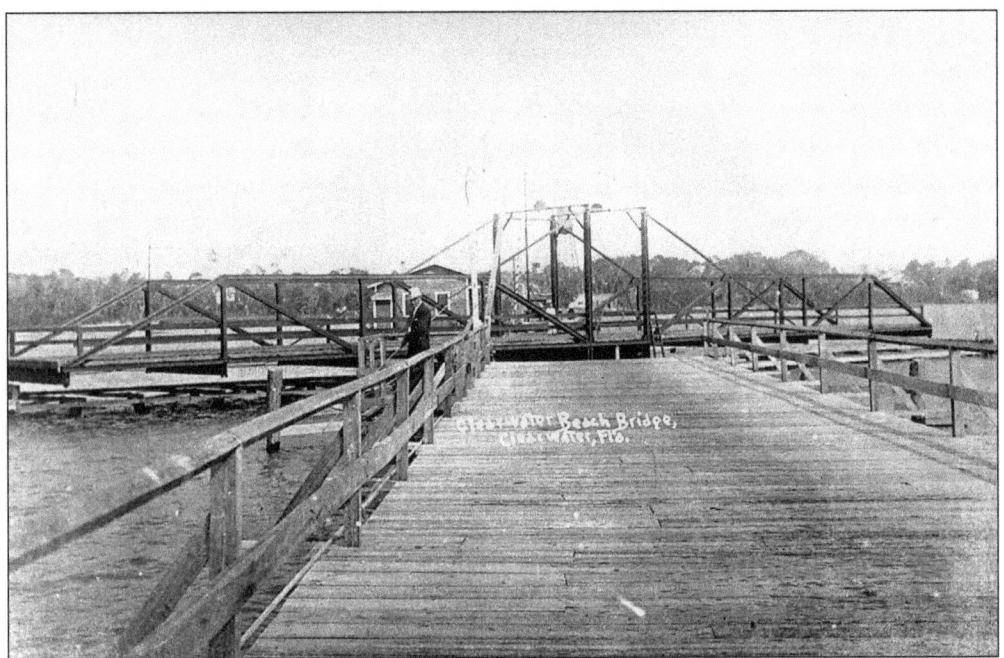

The bridge, like the one at Indian Rocks, was a "swing bridge" that would swing open to allow boats to pass.

The bridge from the mainland is shown here at its terminus at Mandalay Avenue.

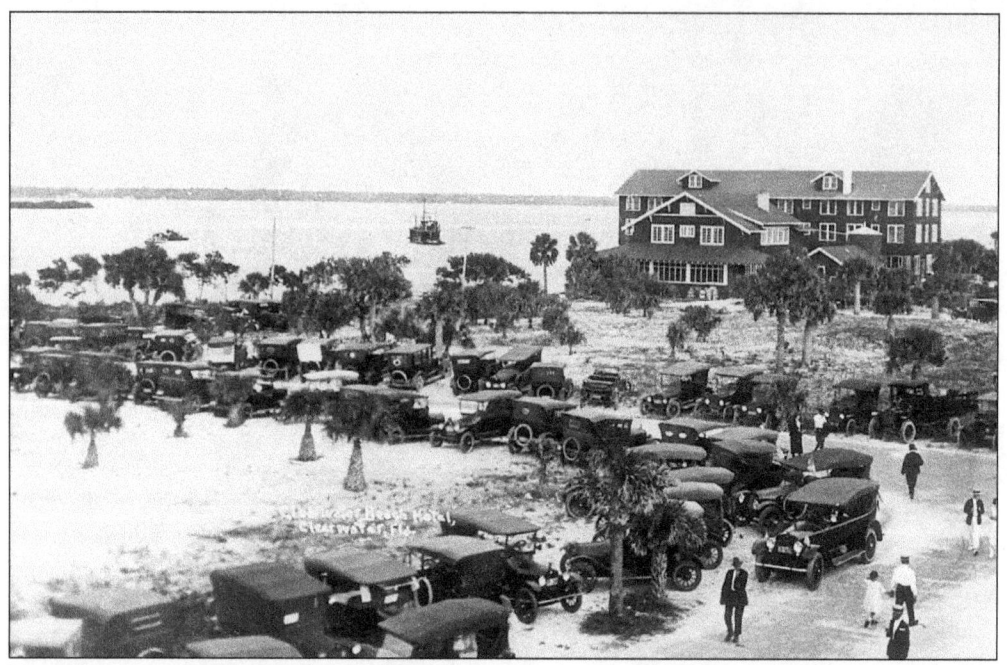

The Clearwater Beach Hotel, constructed in 1917 shortly after the opening of the causeway, quickly became a popular tourist destination.

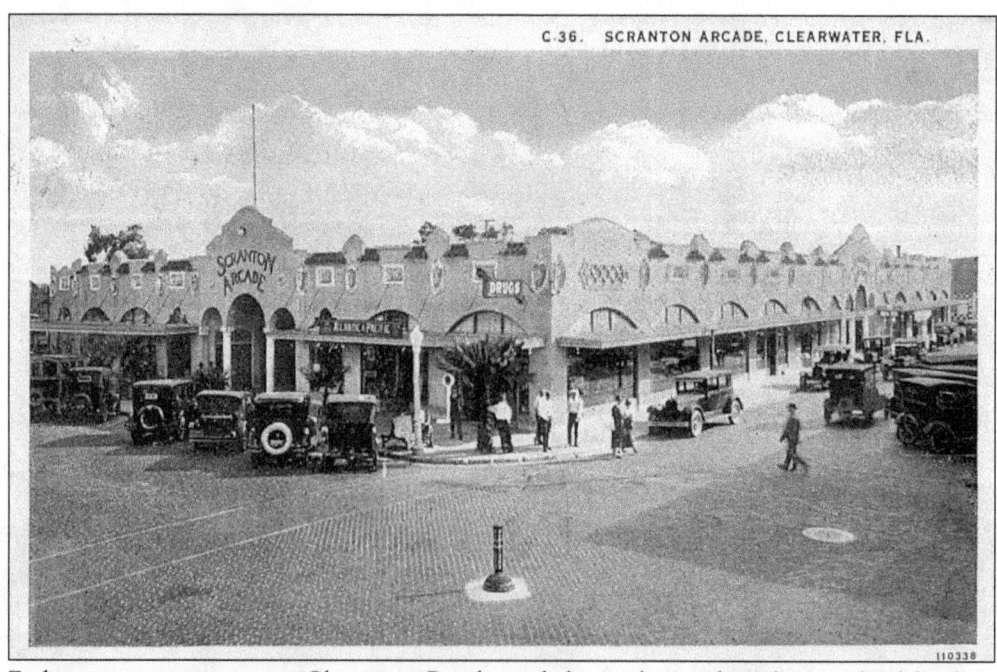

Early tourists staying over at Clearwater Beach needed to make a trek to the mainland for their shopping needs. The Spanish-styled Scranton Arcade located in downtown Clearwater was a forerunner of today's shopping mall, and housed such tenants as the Atlantic and Pacific Tea Co. (A&P), a drug store, a smoke shop, and a telegraph office.

Two

THE BELLEVIEW
WHITE QUEEN OF THE GULF

The first major structure along the beaches was the grand Hotel Belleview, which was the largest wooden structure in the world at the beginning of the 20th century.

The hotel was constructed in the mid-1890s by developer Henry B. Plant as part of his Plant System, which was an integrated, linked system of hotels and railroads along the Florida West Coast that Plant envisioned to rival Henry Flagler's East Coast empire. The hotels were built in the Grand style with little expense spared, and the Belleview was no exception. Completed in 1897, the rambling hotel was constructed entirely of Florida heart pine and offered 145 rooms when it opened. Subsequent additions increased the size to its present 310 rooms.

From the beginning, the hotel was planned to be world class. The Swiss Chalet style was complemented by elegant public rooms, extensive grounds, and a championship golf course topped off by a grand entryway and rental "cottages," which were actually small mansions themselves. True to the Victorian tradition of avoiding the beach, the hotel was built on the mainland side of Clearwater Bay, but featured easy beach access by ferry and later bridge for beach sightseeing and excursions.

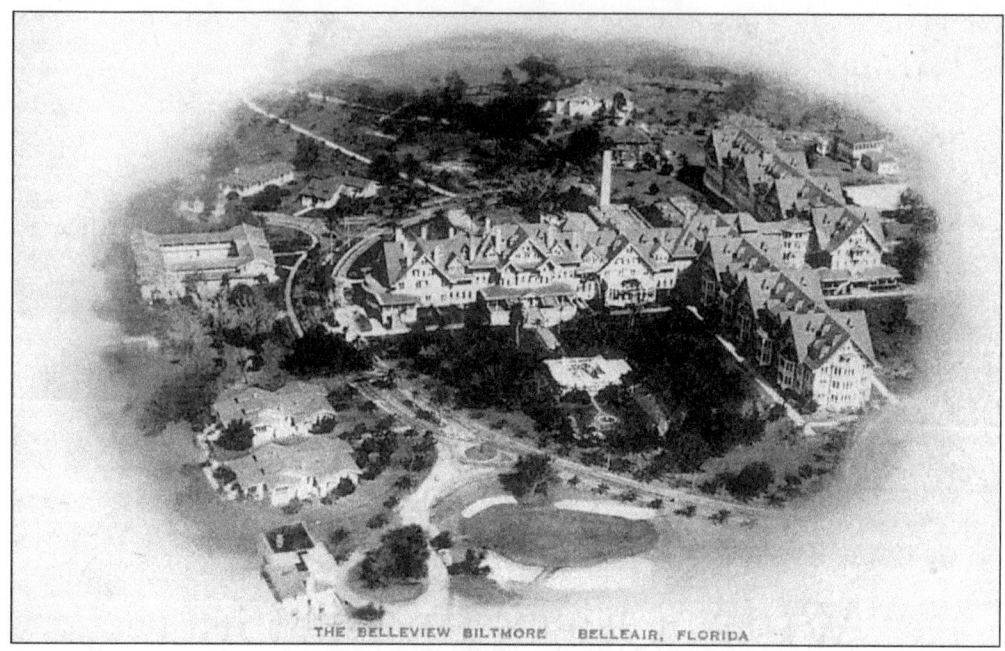

THE BELLEVIEW BILTMORE BELLEAIR, FLORIDA

The Belleview was built by railroad and hotel magnate Henry B. Plant as part of his Plant System of integrated transportation and lodging facilities. This hotel, which became known as the "White Queen of the Gulf," was Plant's favorite. Advertised as "the largest occupied wooden structure in the world," the rambling hotel offered every amenity.

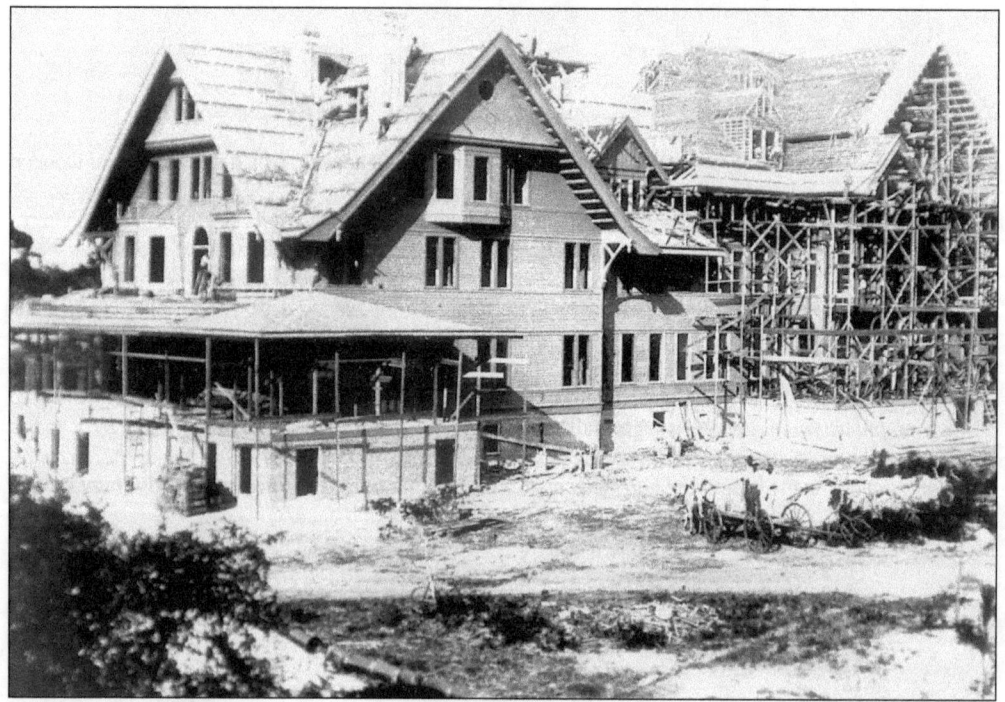

Shown here under construction in 1896, the Belleview was built of 100-percent Florida heart pine in the Swiss Chalet style and was initially painted brown with a red shingle roof. The site was Belleview Island in Clearwater Bay, reached from the mainland by a wooden bridge.

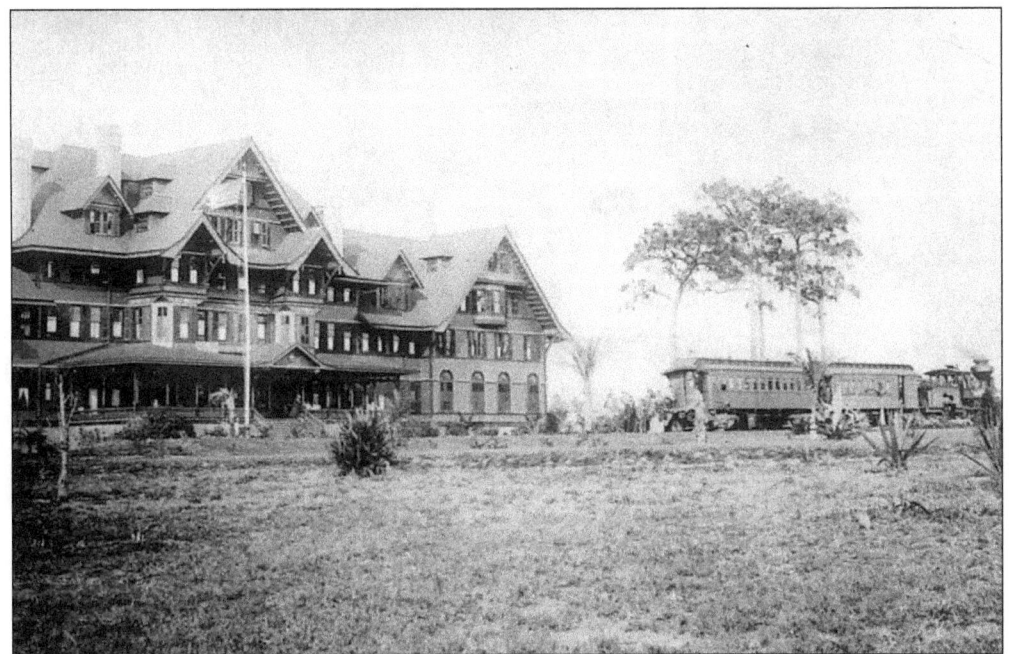

A spur of Plant's Atlantic Coast Line (ACL) railroad took guests directly to the hotel entrance, fulfilling the promise of the Plant system's rail/hotel linkage. The spur could accommodate up to 15 private cars at one time.

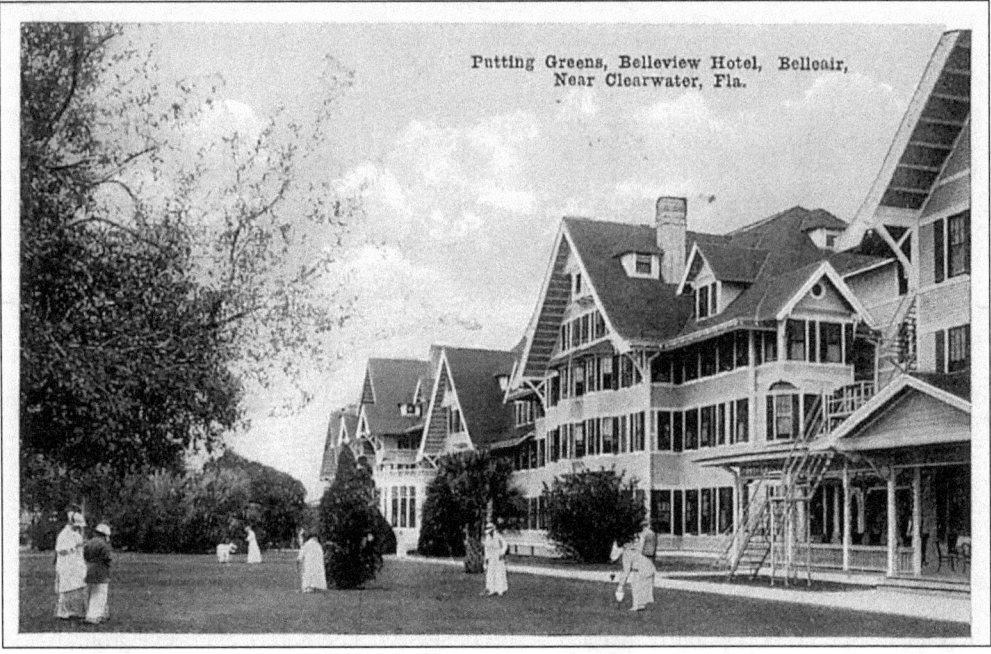

Golfing played an important role in the Belleview's development as a winter resort for well-to-do vacationers. Two 18-hole courses created by renowned designer Donald J. Ross were played by golfing greats of the day, along with the rich and famous who visited the hotel.

These children and a buggy are shown *c.* 1900 in front of the Belleview's grand entrance.

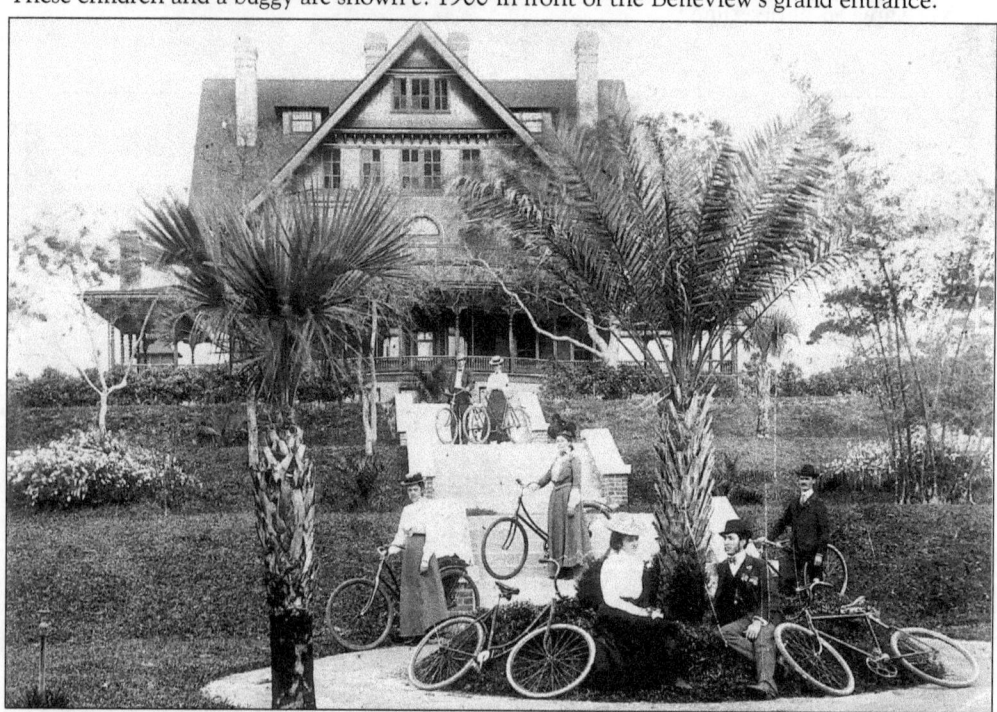

Bicycling was another popular recreation at the Belleview. The hotel's extensive grounds and five-mile bicycle track offered cyclers plenty of opportunity for sport and exercise. In this scene, *c.* 1898, bicyclers rest in front of one of the 12 "cottages," which were actually small mansions built on the hotel grounds by wealthy winter vacationers.

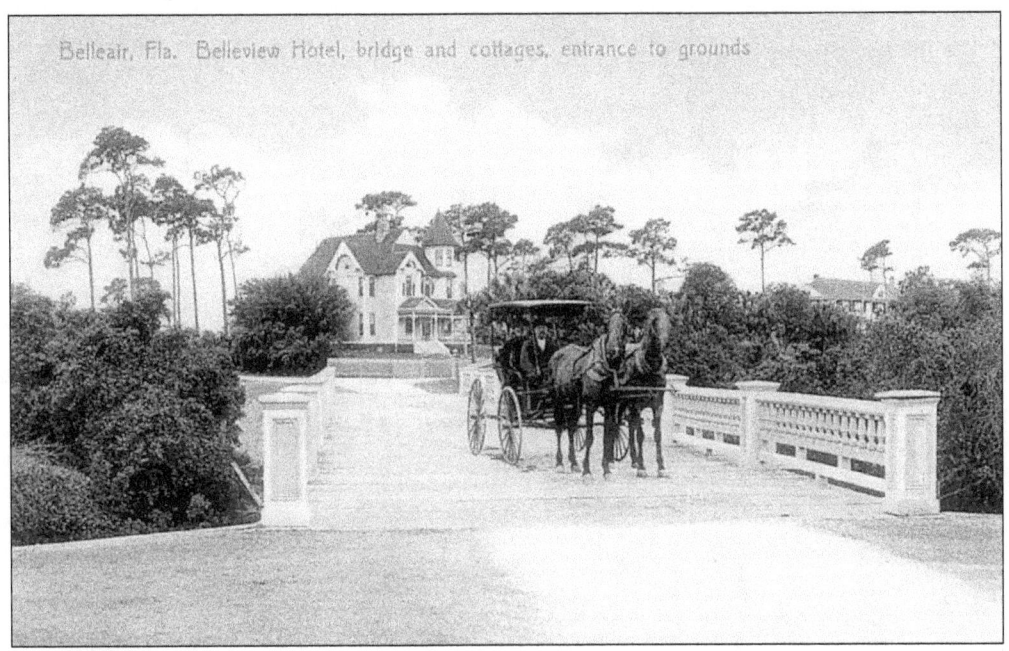

Belleair, Fla. Belleview Hotel, bridge and cottages, entrance to grounds

The Belleview's lush, extensive grounds on Clearwater Bay were a delightful spot for a stroll or carriage ride.

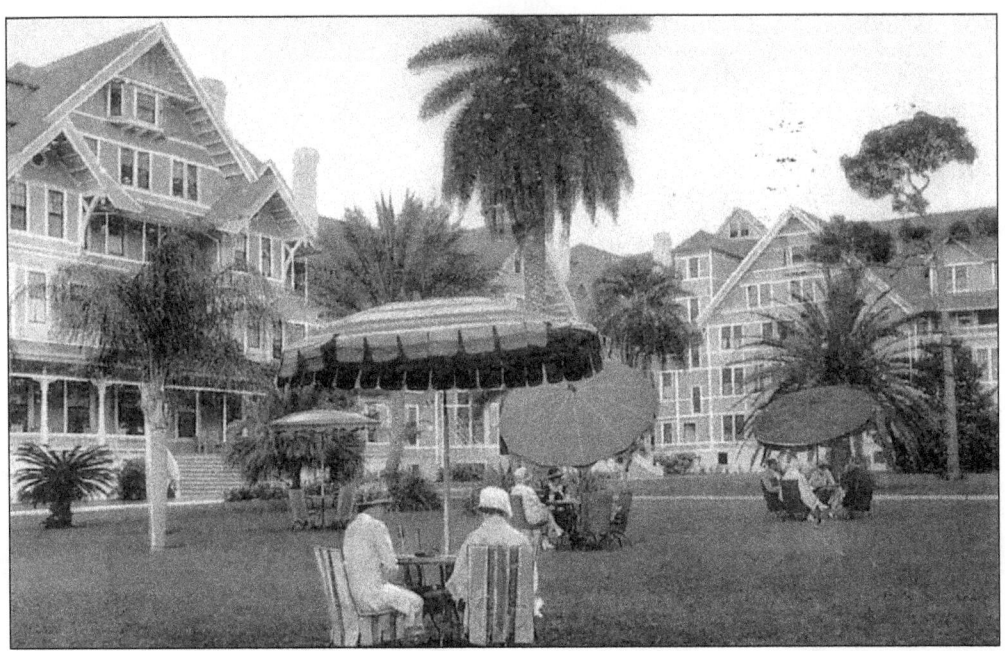

Shown in this 1927 photo, the Belleview's spacious grounds offered plenty of opportunity for socializing and relaxing.

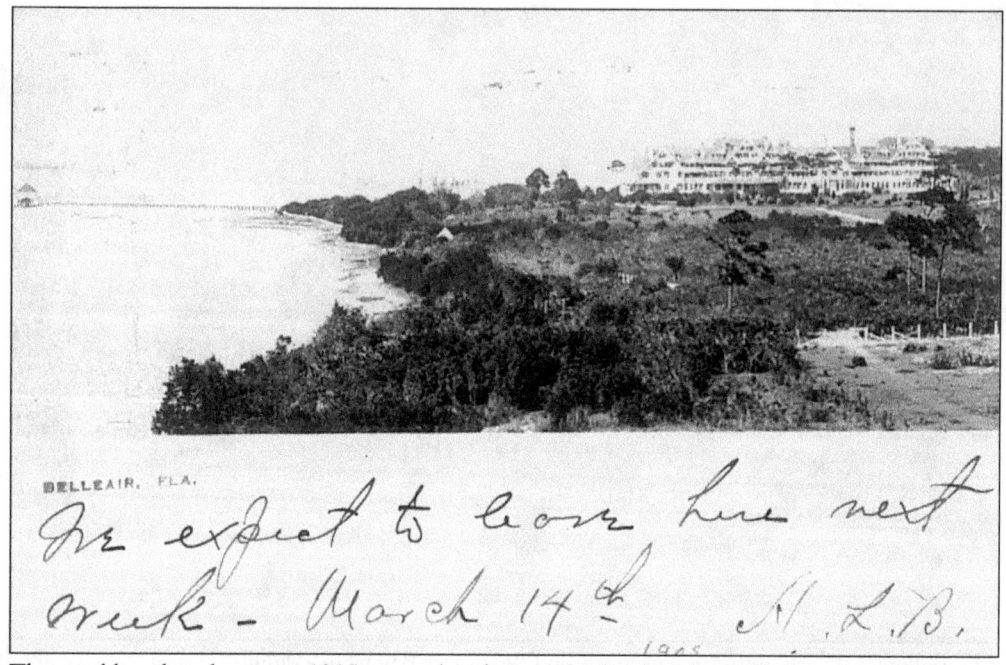

BELLEAIR. FLA.

We expect to leave here next week - March 14th N.L.B.

The rambling hotel was, in 1905, an isolated spot of splendor along the largely undeveloped West Coast of Florida. After Henry Plant's death in 1899, his son Morton had the Belleview repainted its trademark white with green roof. The hotel was purchased by John McEntee Bowman in 1919 and added to the Biltmore chain.

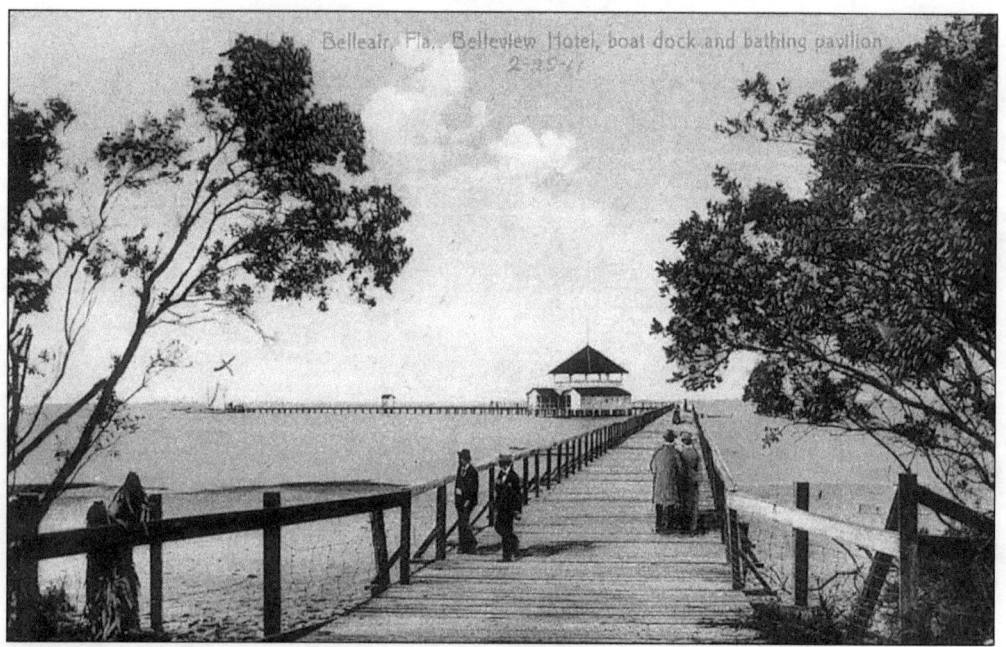

A bathing pavilion and boat dock gave guests an opportunity to swim or take the private shuttle boat to the Belleview's Gulf beach property on Sand Key.

56

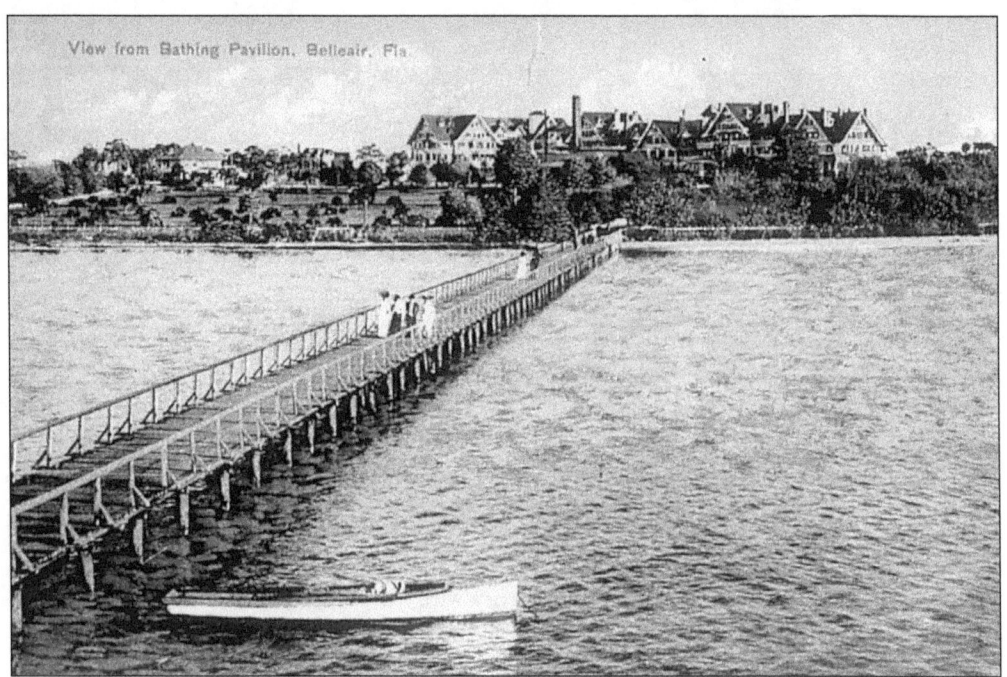

The hotel is seen from the pier leading to the bathing pavilion in this card dated 1912.

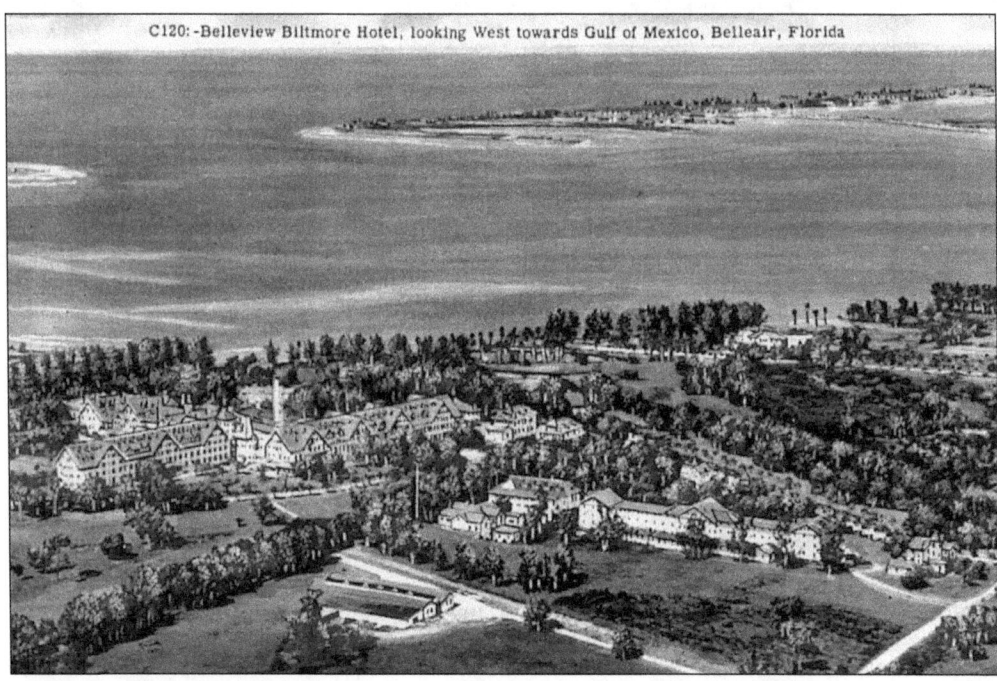

This view shows the hotel in relation to the Gulf of Mexico (top of picture). At this time, no bridge connected Sand Key (upper left) and Clearwater Beach (upper center).

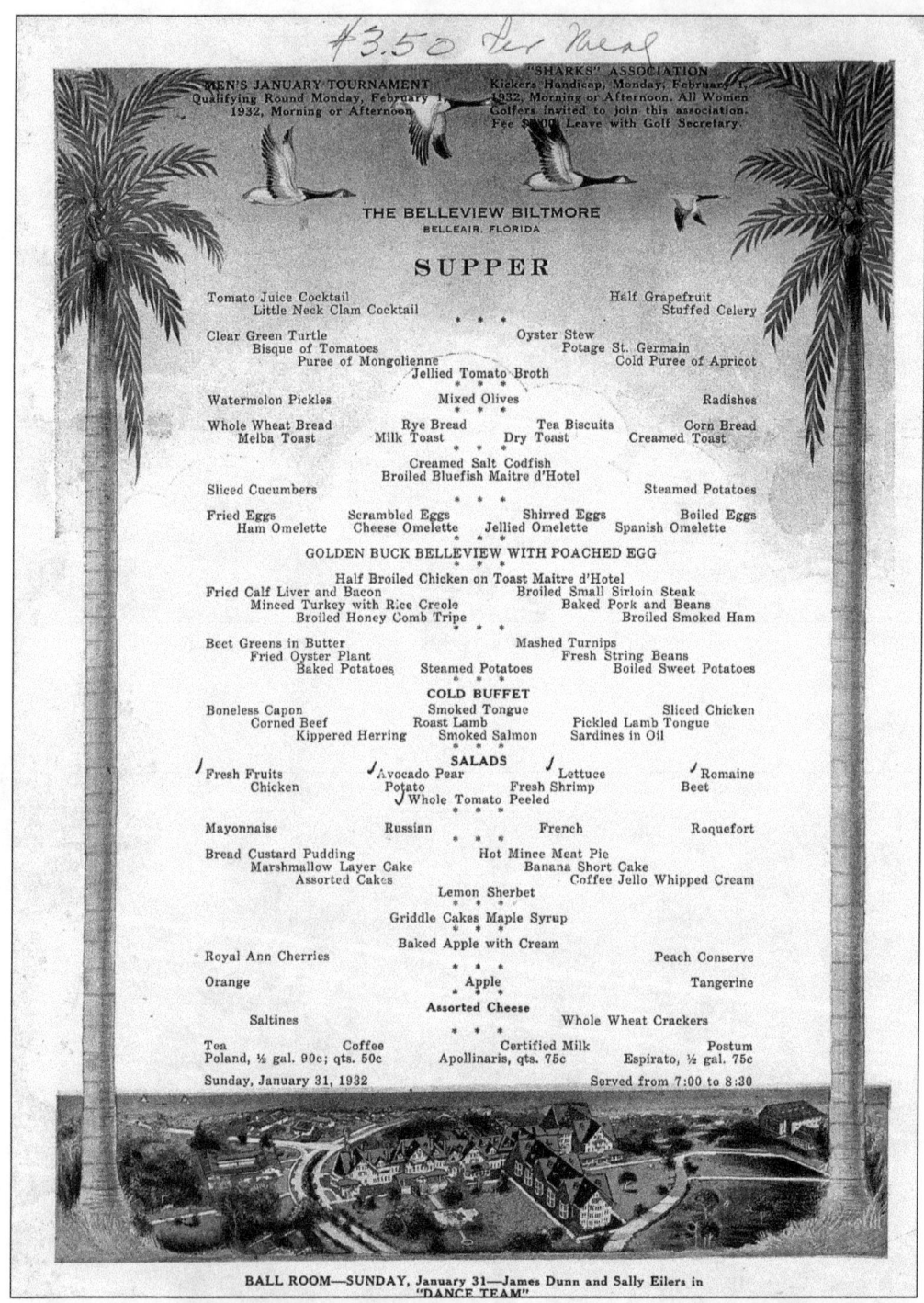

$3.50 per meal

MEN'S JANUARY TOURNAMENT
Qualifying Round Monday, February 1,
1932, Morning or Afternoon

"SHARKS" ASSOCIATION
Kickers Handicap, Monday, February 1,
1932, Morning or Afternoon. All Women
Golfers invited to join this association.
Fee $1.00 Leave with Golf Secretary.

THE BELLEVIEW BILTMORE
BELLEAIR, FLORIDA

SUPPER

Tomato Juice Cocktail	Half Grapefruit
Little Neck Clam Cocktail	Stuffed Celery

* * *

Clear Green Turtle	Oyster Stew
Bisque of Tomatoes	Potage St. Germain
Puree of Mongolienne	Cold Puree of Apricot

Jellied Tomato Broth

* * *

Watermelon Pickles Mixed Olives Radishes

* * *

Whole Wheat Bread	Rye Bread	Tea Biscuits	Corn Bread
Melba Toast	Milk Toast	Dry Toast	Creamed Toast

* * *

Creamed Salt Codfish
Broiled Bluefish Maitre d'Hotel

Sliced Cucumbers Steamed Potatoes

* * *

Fried Eggs	Scrambled Eggs	Shirred Eggs	Boiled Eggs
Ham Omelette	Cheese Omelette	Jellied Omelette	Spanish Omelette

GOLDEN BUCK BELLEVIEW WITH POACHED EGG

* * *

Half Broiled Chicken on Toast Maitre d'Hotel
Fried Calf Liver and Bacon Broiled Small Sirloin Steak
Minced Turkey with Rice Creole Baked Pork and Beans
Broiled Honey Comb Tripe Broiled Smoked Ham

* * *

Beet Greens in Butter	Mashed Turnips
Fried Oyster Plant	Fresh String Beans
Baked Potatoes Steamed Potatoes	Boiled Sweet Potatoes

COLD BUFFET

Boneless Capon	Smoked Tongue	Sliced Chicken
Corned Beef	Roast Lamb	Pickled Lamb Tongue
Kippered Herring Smoked Salmon		Sardines in Oil

* * *

SALADS

Fresh Fruits	Avocado Pear	Lettuce	Romaine
Chicken	Potato	Fresh Shrimp	Beet
	Whole Tomato Peeled		

* * *

Mayonnaise Russian French Roquefort

* * *

Bread Custard Pudding	Hot Mince Meat Pie	
Marshmallow Layer Cake	Banana Short Cake	
Assorted Cakes		Coffee Jello Whipped Cream

Lemon Sherbet

* * *

Griddle Cakes Maple Syrup

* * *

Baked Apple with Cream

Royal Ann Cherries		Peach Conserve

* * *

Orange	Apple	Tangerine

Assorted Cheese

Saltines Whole Wheat Crackers

* * *

Tea	Coffee	Certified Milk	Postum
Poland, ½ gal. 90c; qts. 50c		Apollinaris, qts. 75c	Espirato, ½ gal. 75c

Sunday, January 31, 1932 Served from 7:00 to 8:30

BALL ROOM—SUNDAY, January 31—James Dunn and Sally Eilers in "DANCE TEAM"

Dining at the Belleview was an elegant affair, and this 1932 Sunday Supper menu boasted such specialties as "Golden Buck Belleview" along with exotic (by today's tastes) items such as "Broiled Honey Comb Tripe." Music by the house orchestra often serenaded guests.

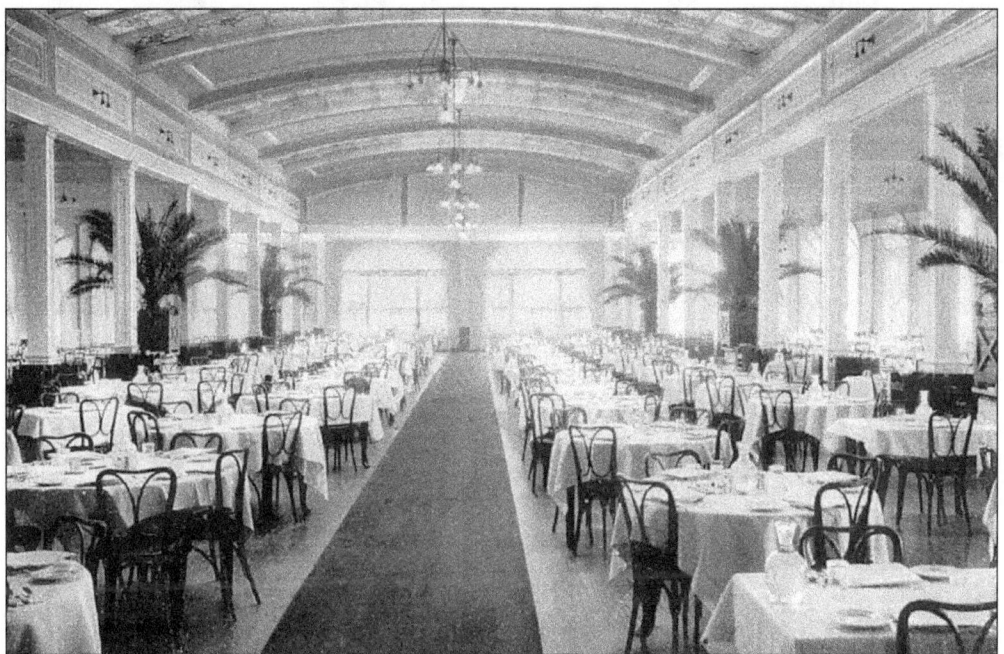

Elegant meals were served in the commodious Tiffany room, which could seat 800 guests after enlargement in the 1920s. The room's ceiling featured leaded glass panes, still in place, styled after the work of Louis Tiffany.

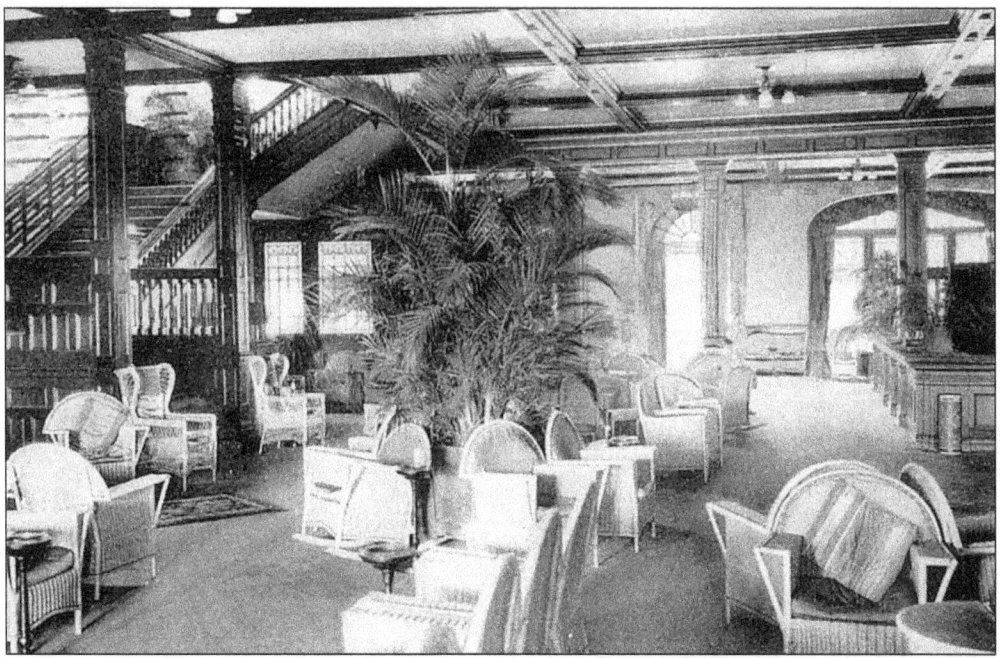

The wood-paneled lobby, shown here, featured a grand staircase and wicker furnishing. This view looks out toward the original entrance to the hotel. Located in the area today is the dining room (foreground) and bar (right).

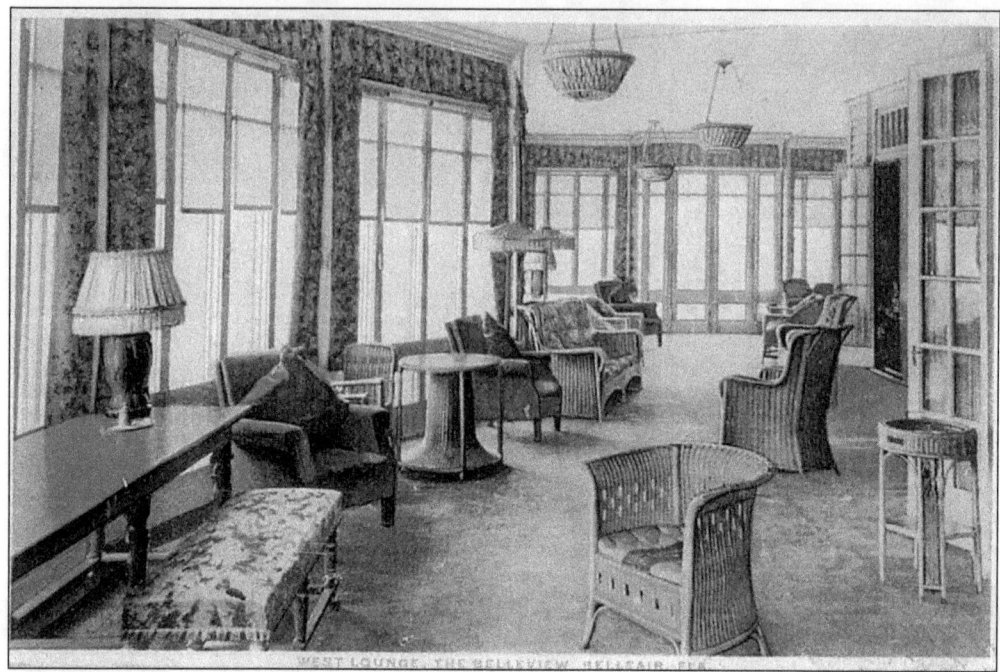

The West Lounge, done in wicker, was graced by floor-to-ceiling windows designed to admit generous amounts of Florida sunshine and Bay breezes.

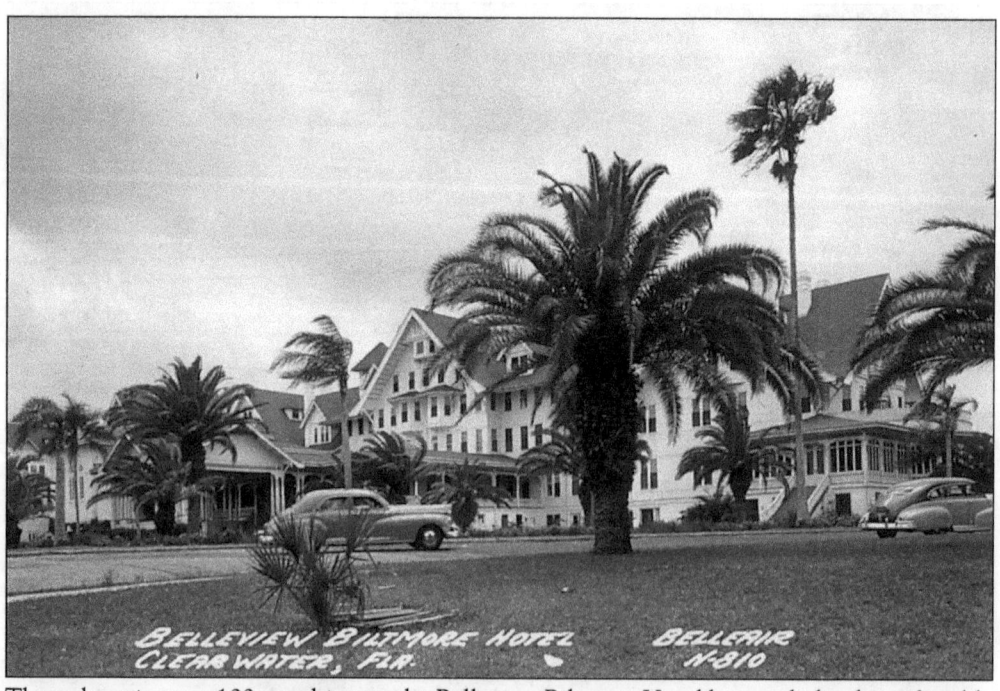

Throughout its over 100-year history, the Belleview Biltmore Hotel has symbolized comfortable elegance in the classic Florida style.

Three

THE BEACH

AS A DIVERSION
1920s–1930s

Construction of wooden bridges from the mainland around 1920 gave beach development a boost, but the boom times that remade St. Petersburg had only a ripple effect on the beach strip.

This era saw new hotels, mostly small wooden structures and cottages, at Pass-a-Grille and Indian Rocks, to accommodate visitors that now included family tourist groups as well as fishermen. Beach pavilions and casinos offered improved bathing facilities and dancing to swing bands in the evening. Shore dinners became even more popular.

A change in attitude toward the beach—from viewing the surf and sand as a curiosity to visiting the beach for a pleasurable diversion from St. Pete "city life"—helped pave the way for the tourist explosion and mass development following World War II.

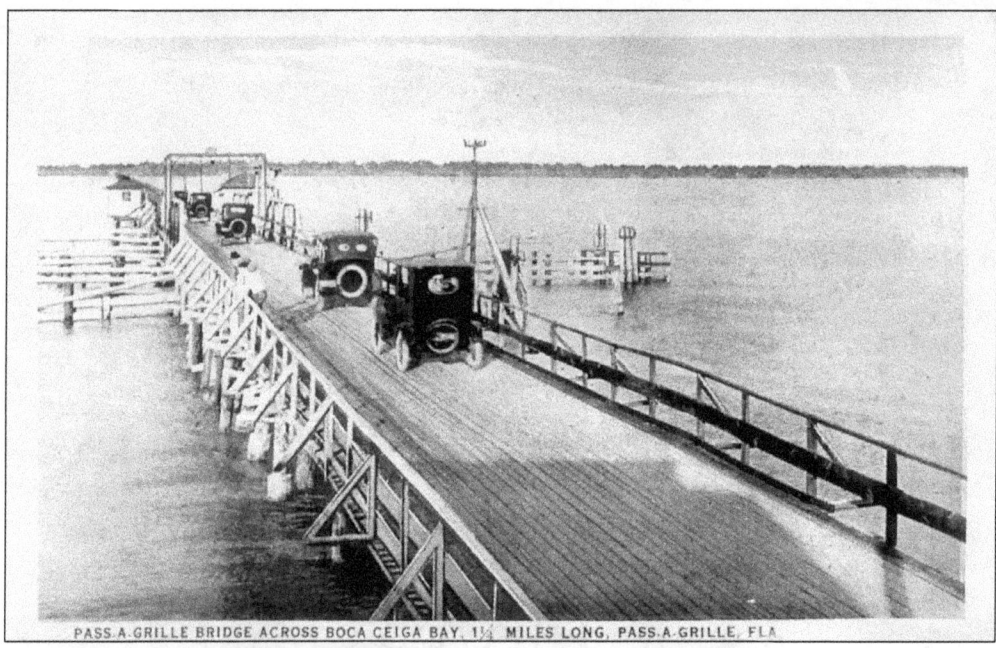

PASS-A-GRILLE BRIDGE ACROSS BOCA CEIGA BAY, 1½ MILES LONG, PASS-A-GRILLE, FLA.

The completion of bridges in the late 1910s connecting the mainland to the keys at Pass-a-Grille, Indian Rocks, and Clearwater spurred development by giving motorists quick and easy access to the Gulf. The toll bridge from St. Petersburg to Pass-a-Grille, built in 1919 by William McAdoo, brought a flood of visitors to the beach.

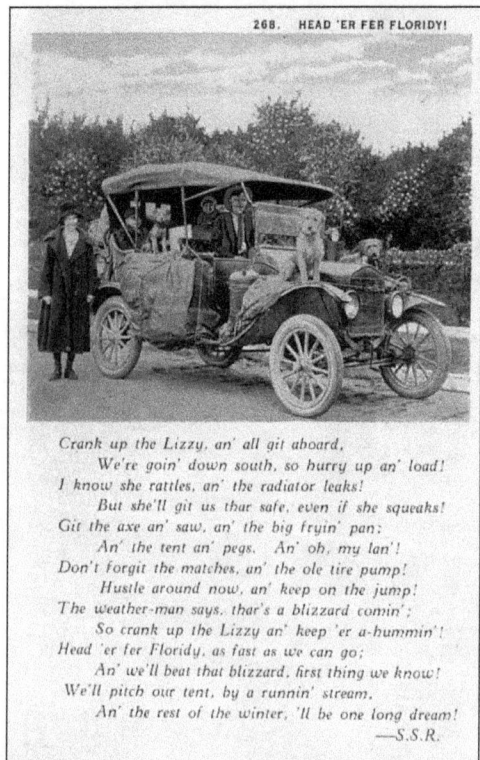

268. HEAD 'ER FER FLORIDY!

Crank up the Lizzy, an' all git aboard,
 We're goin' down south, so hurry up an' load!
I know she rattles, an' the radiator leaks!
 But she'll git us thar safe, even if she squeaks!
Git the axe an' saw, an' the big fryin' pan;
 An' the tent an' pegs. An' oh, my lan'!
Don't forgit the matches, an' the ole tire pump!
 Hustle around now, an' keep on the jump!
The weather-man says, thar's a blizzard comin';
 So crank up the Lizzy an' keep 'er a-hummin'!
Head 'er fer Floridy, as fast as we can go;
 An' we'll beat that blizzard, first thing we know!
We'll pitch our tent, by a runnin' stream,
 An' the rest of the winter, 'll be one long dream!
 —S.S.R.

The coming of the automobile along with the building of roads and bridges started the influx of tourists from northern climates.

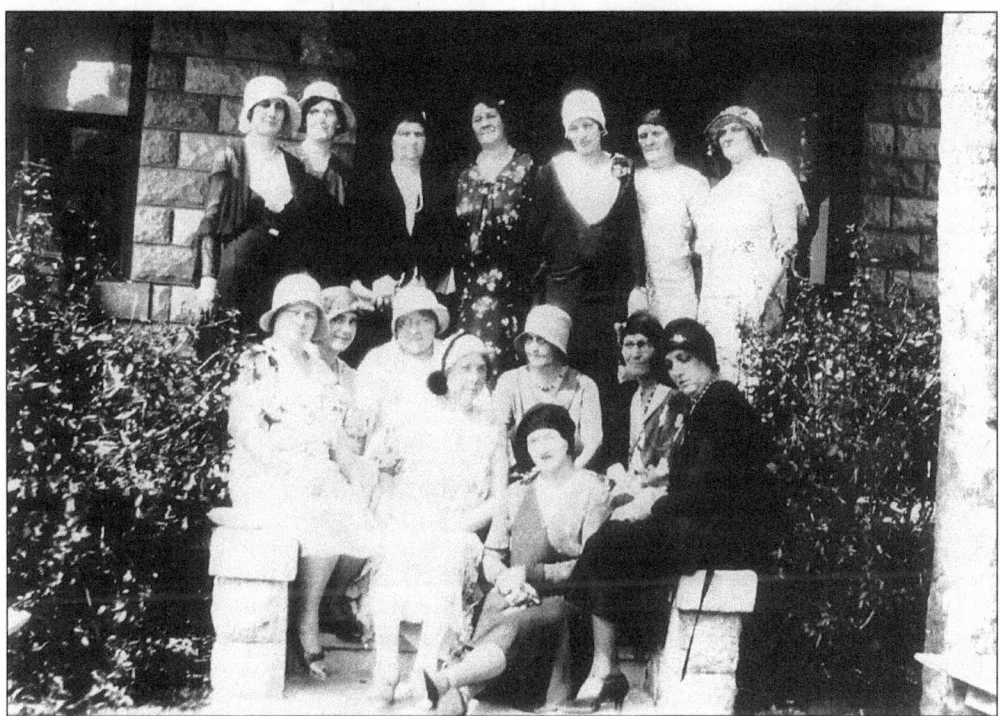

Ladies of the Pass-a-Grille Women's Town Improvement Association, which later became the Pass-a-Grille Women's Club, gather for a photo in 1927 in front of their building, which was once the Tenth Avenue School. It is located down the street from the Gulf Beaches Historical Museum.

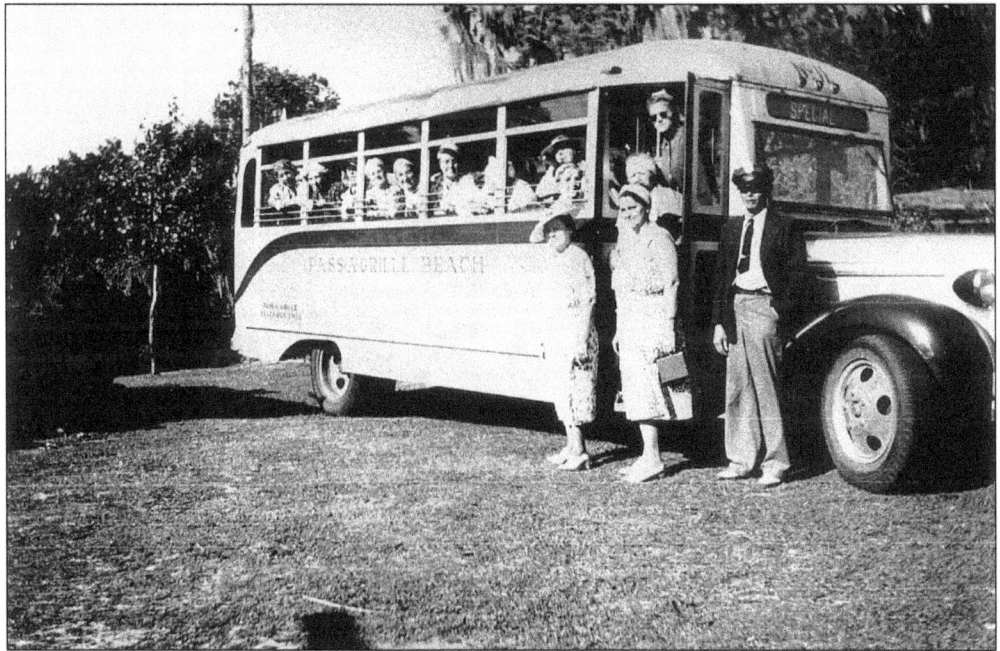

The Pass-a-Grille Beach Bus is crowded with passengers on this run in 1939. The town operated its own bus line from 1930 until 1960.

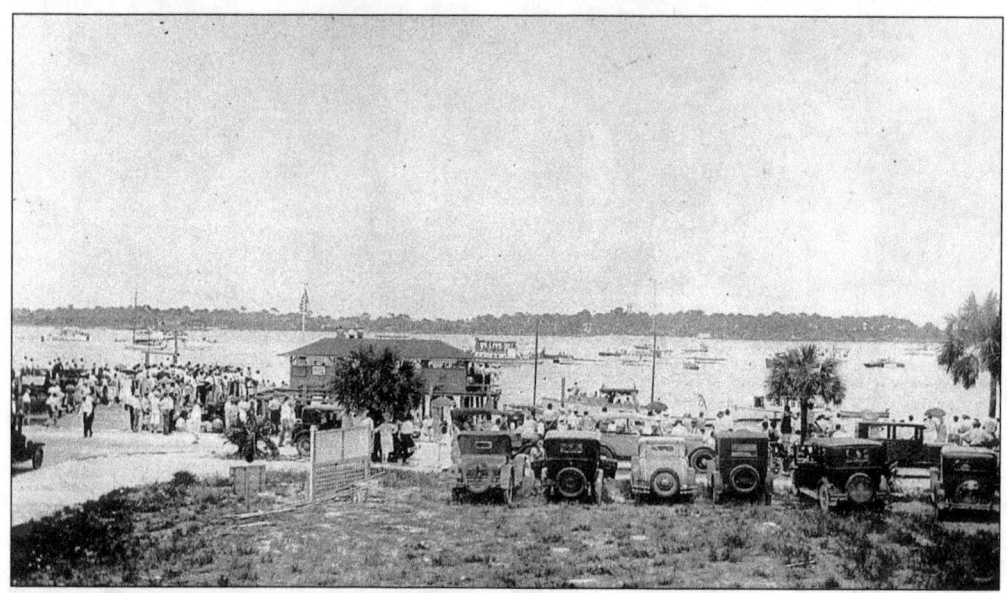

Visitors watch a boat procession at Merry Pier in 1928. The pier, a joint venture of Joseph E. Merry, Roy Hanna, and George Lizotte, was built around 1900 and served as the embarkation point for steamers from the mainland as well as other boat traffic.

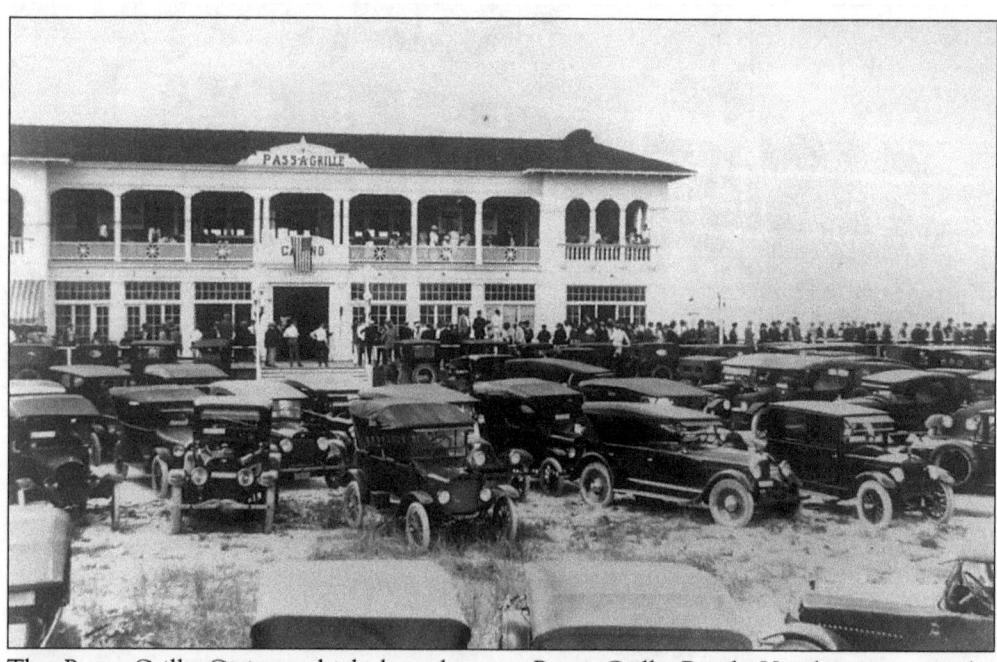

The Pass-a-Grille Casino, which later became Pass-a-Grille Beach Hotel, was a popular bathhouse and gathering spot in the 1920s.

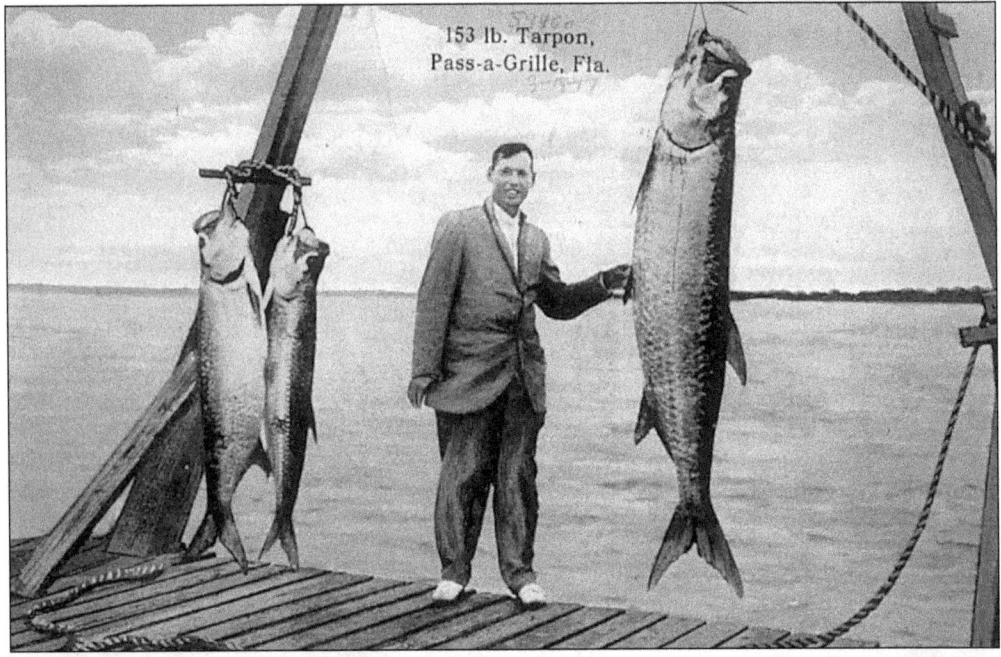

This 1923 photo captures a family beach outing at Pass-a-Grille. Dad is probably behind the camera.

153 lb. Tarpon,
Pass-a-Grille, Fla.

Fishing was a prime lure that brought early tourists to the Gulf Beaches. The many varieties of challenging sport fish drew anglers from far and near, and pictures like the one shown here of a prize tarpon, the king of sport fish, spread the word that the fish were indeed biting.

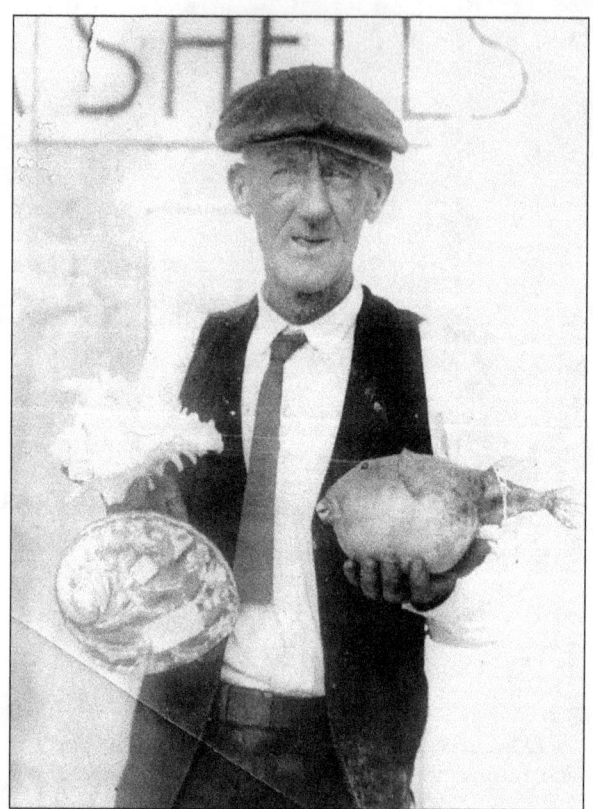

Joseph Lee said that he sells seashells because "it is better to settle down to something than to wander."

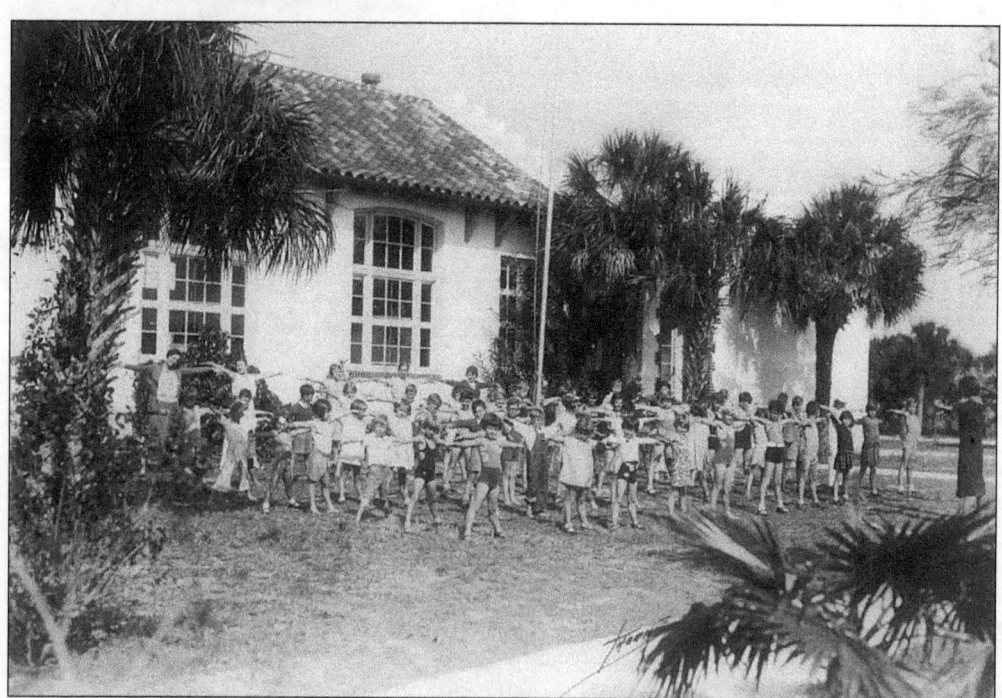

Students take their morning calisthenics at the famed Sunshine School in Pass-a-Grille.

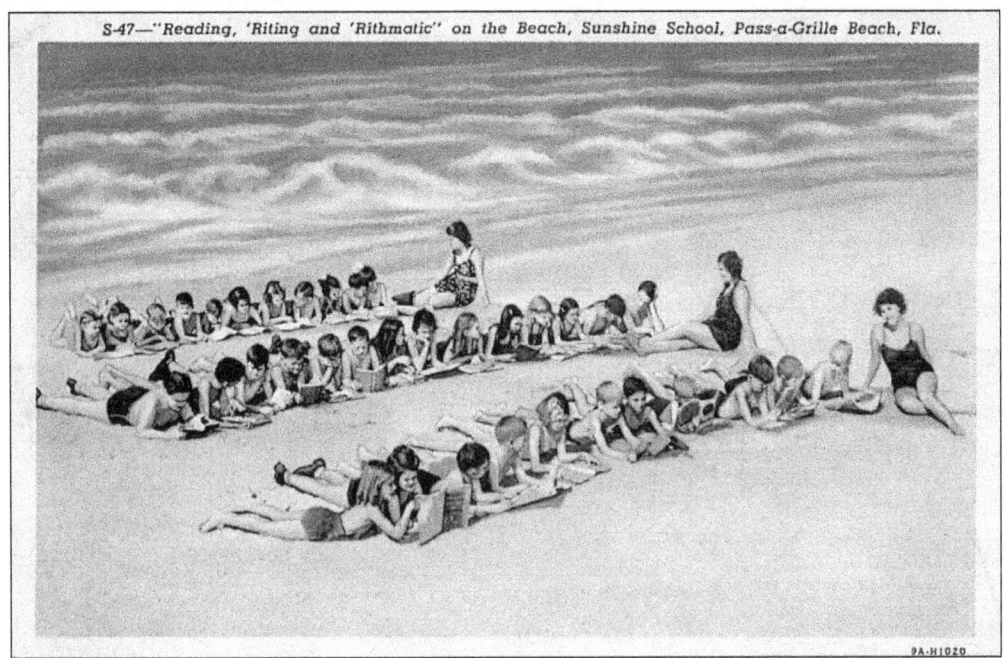

Sunshine School students did most of their learning outdoors, including this "Reading, 'Riting and 'Rithmatic" session on the beach.

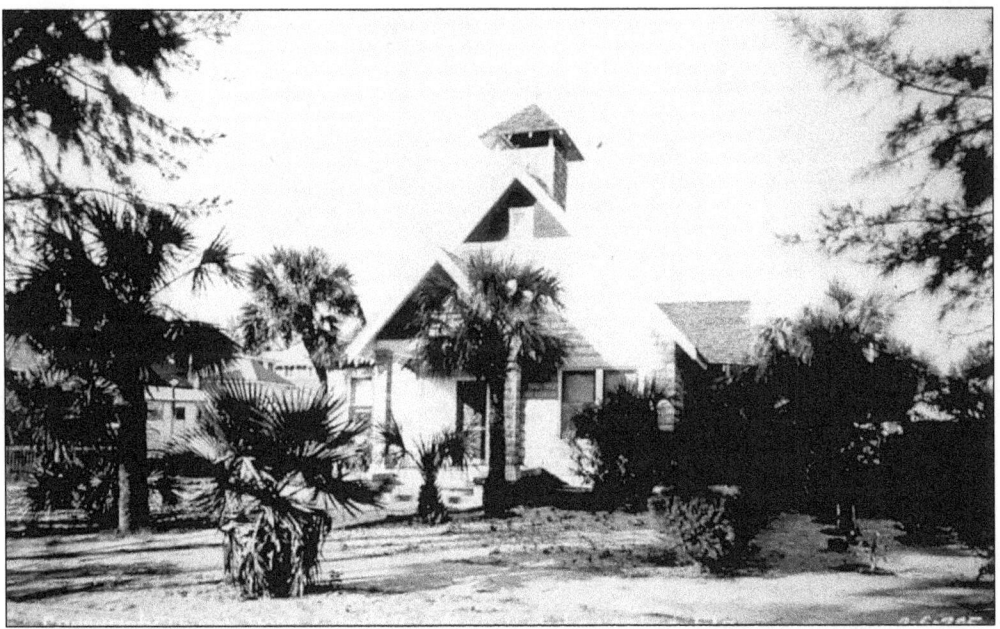

The Pass-a-Grille Community Church on Tenth Avenue served the community from 1917 until the church constructed a new building in 1958. The original building is now home to the Gulf Beaches Historical Museum.

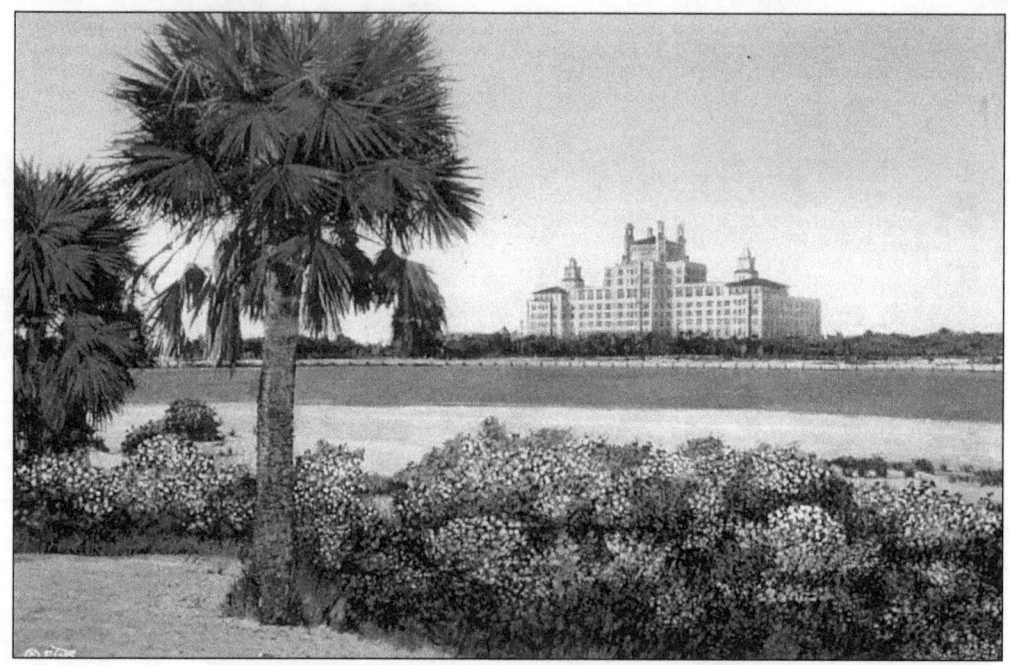

The Don CeSar, the elegant "Pink Lady," opened in December 1927 as the fulfillment of a dream by St. Petersburg developer Thomas J. Rowe. The castle-like structure, which cost over $1,000,000—a staggering sum for the day—was the only major imprint of the boom era on the beaches, and remains, to this day, the largest and finest hotel facility on the Gulf Beach strip.

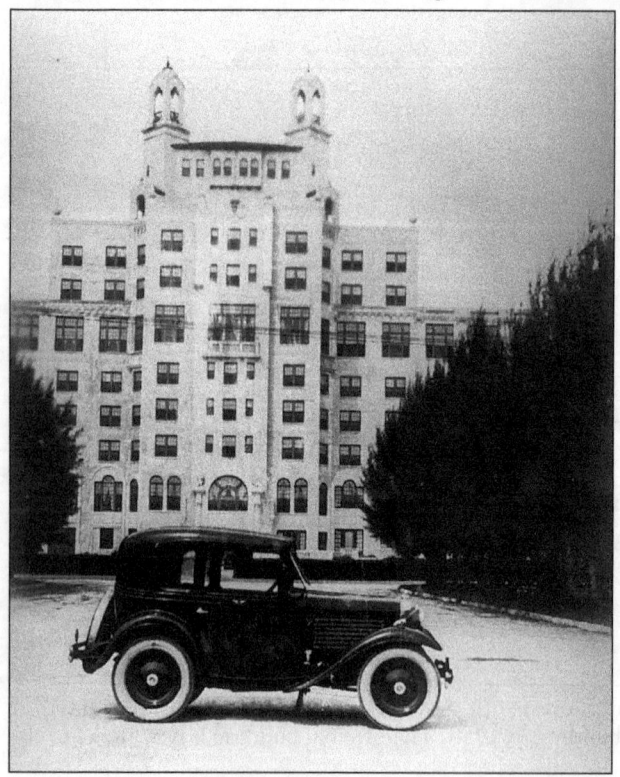

A full-page ad in the St. Petersburg Times announced the Don CeSar's opening, proclaiming triumphantly, "Hurling its Beauty to the Sky, this Castle-like Hostelry on the Shores of the Gulf Thrills You with its Grandeur." The hotel was an instant success, and the beachfront was finally considered an attractive diversion for well-heeled tourists.

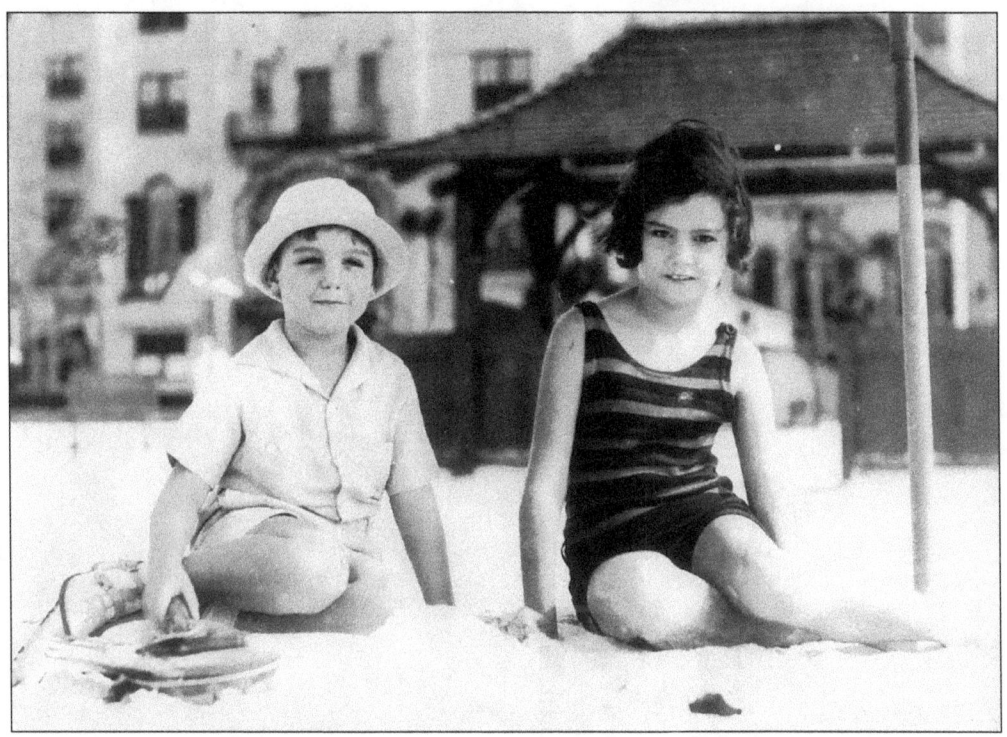

Robert E. Lee IV, the grandson of the famous Confederate general, enjoys the beach outside the Don CeSar with his sister Mary Walker Lee.

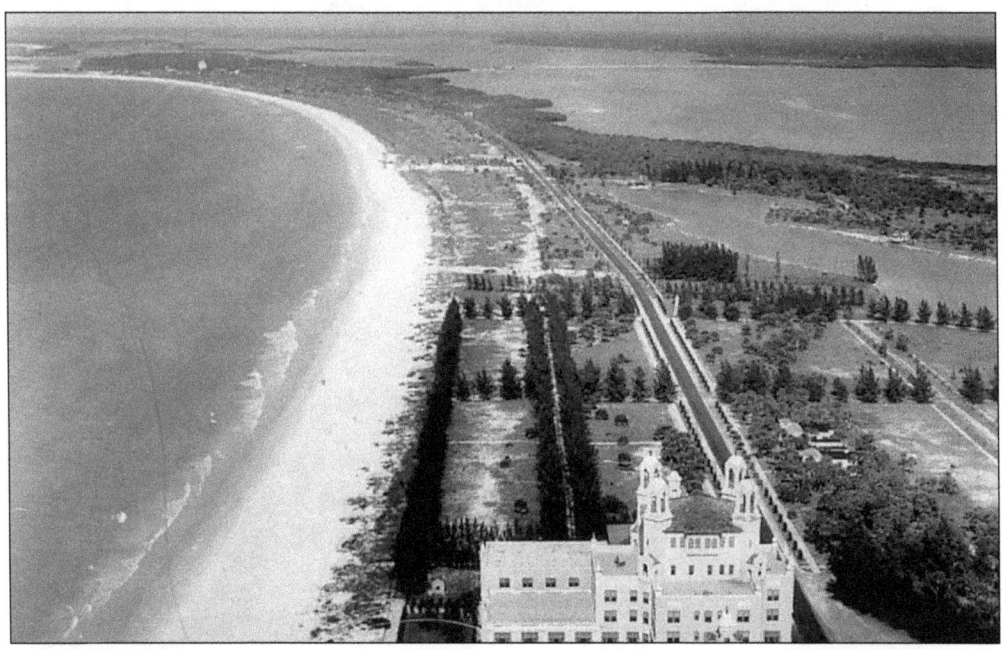

As shown in this scene, looking north from the Don CeSar c. 1930, beachfront development was sparse, as the boom era that transformed St. Petersburg had largely missed the beach.

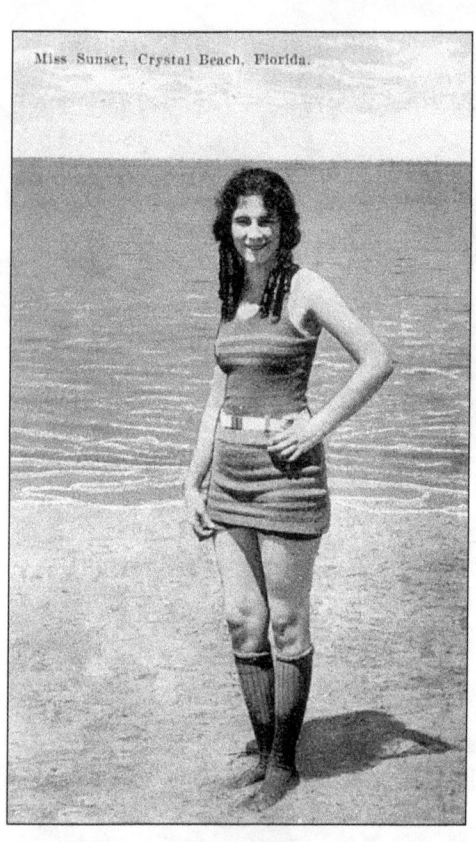

Miss Sunset, Crystal Beach, Florida.

A bathing beauty shows off the 1920s look in beach attire.

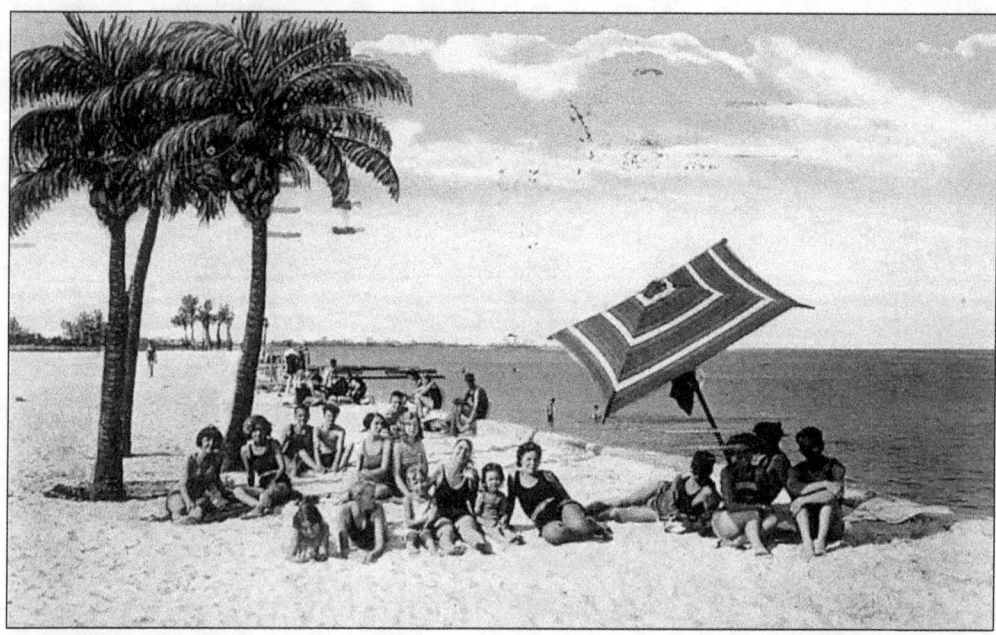

This 1930 postcard describes these beachgoers as "the leaders in fashion" enjoying "the healthy fad of sunbathing."

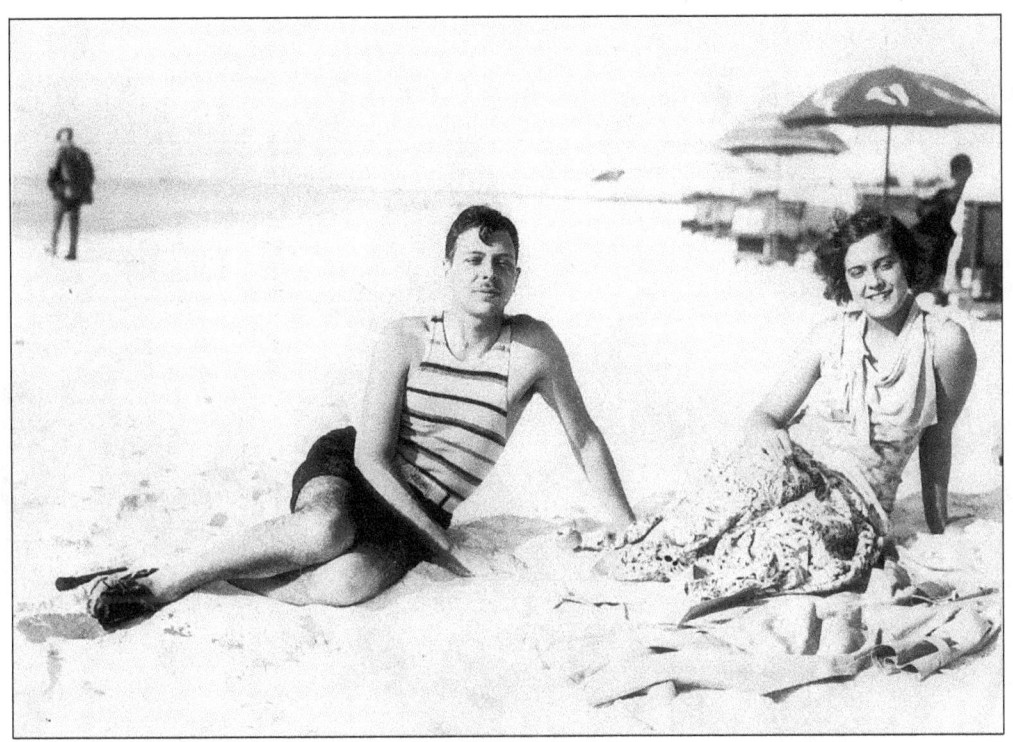

The stylish dress of this New York couple vacationing at St. Petersburg Beach c. 1935 reflects the latest in beach fashion.

The bridging of John's Pass in 1927 accelerated the development of what was to become Madeira Beach on the north side of the pass.

Redington's Beach Bungalows

AR down the west coast of Florida, on the beautiful sub-peninsula of Pinellas, stretching out into the blue waters of Tampa Bay and the Gulf of Mexico, is sunny St. Petersburg.

Nestled along the silvery shore line of this glorious Gulf of Mexico, adjoining the "Sunshine City", are the delightful Redington bungalows—ideal homes for a day, a week, a month or a season's visit to the land of flowers and sunshine.

Here in this sub-tropical paradise, climate, sea, and soil have combined to give you an "All-Year-Around" vacation land unsurpassed in any clime.

Nowhere in the world will you find a more healthful climate; nowhere will you find more beautiful waters than those of the Gulf of Mexico. Days of perpetual sunshine and gorgeous balmy nights fanned by

sea breezes. Mile upon mile of pure sandy beaches, fringed by stately meet the eye from every viewpoint a fascinating outlook.

Typical Beach Bungalow

ON THE WEST COAST

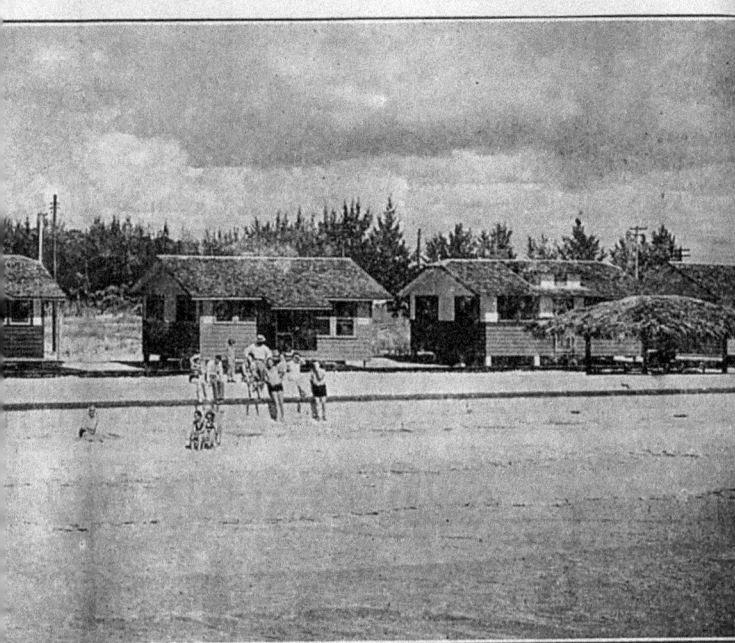

The Redington Beach Bungalows were typical of the cottage development that catered to tourist families by offering "individual homes designed for comfort, health, and convenience." Each "private bungalow" is described as containing "a good-sized living room, two bedrooms, beds equipped with Simmon's coiled springs and comfortable mattresses; bathroom and kitchen equally well equipped with splendid facilities."

And here in this remarkable setting, facing the finest gulf beach in Florida, are the Redington bungalows. Individual homes designed for comfort, health and convenience—good enough for those accustomed to the best, and yet not so high in rental charges as to be out of reach of those in modest circumstances.

There are seventeen modern, comfortable, clean beach bungalows ready for your inspection. A large number face directly on the Gulf of Mexico. They are completely furnished and ready for you to step into and start housekeeping. All are excellently ventilated and designed.

Each private bungalow contains a good-sized living room, two bedrooms, the beds equipped with Simmon's coil springs and comfortable mattresses; bathroom and kitchen equally well equipped with splendid facilities.

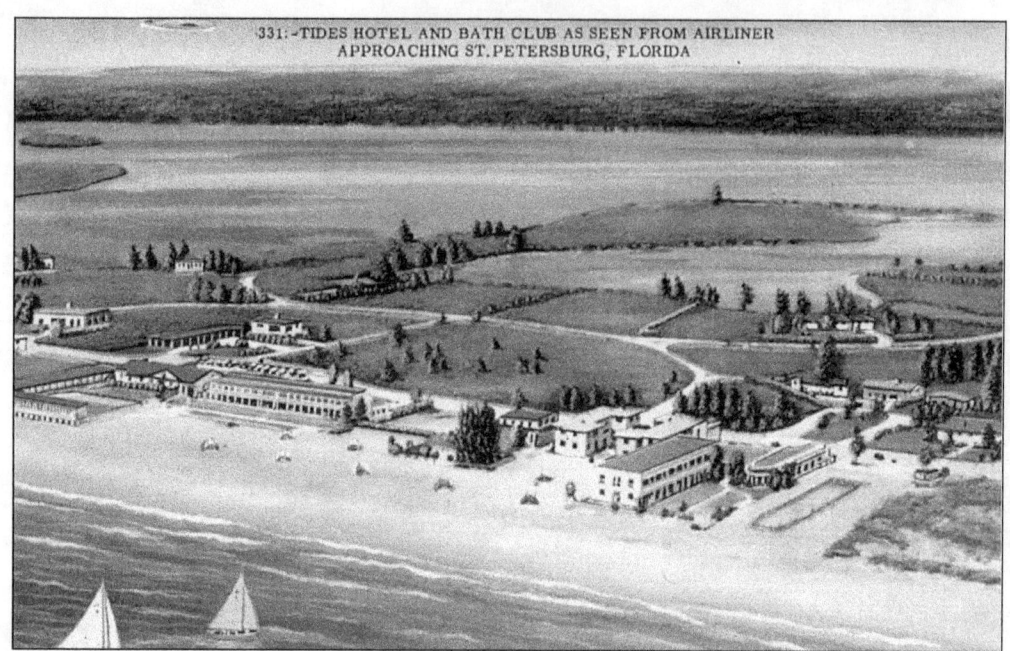

For all the increased traffic to the beaches, however, development remained spotty. The sprawling Tides Hotel, built in 1939 at Redington Beach, was the first major beach construction since the Don CeSar's debut in 1926. The resort remained a popular tourist spot until it was torn down in 1992 to make way for the exclusive Tides condominiums.

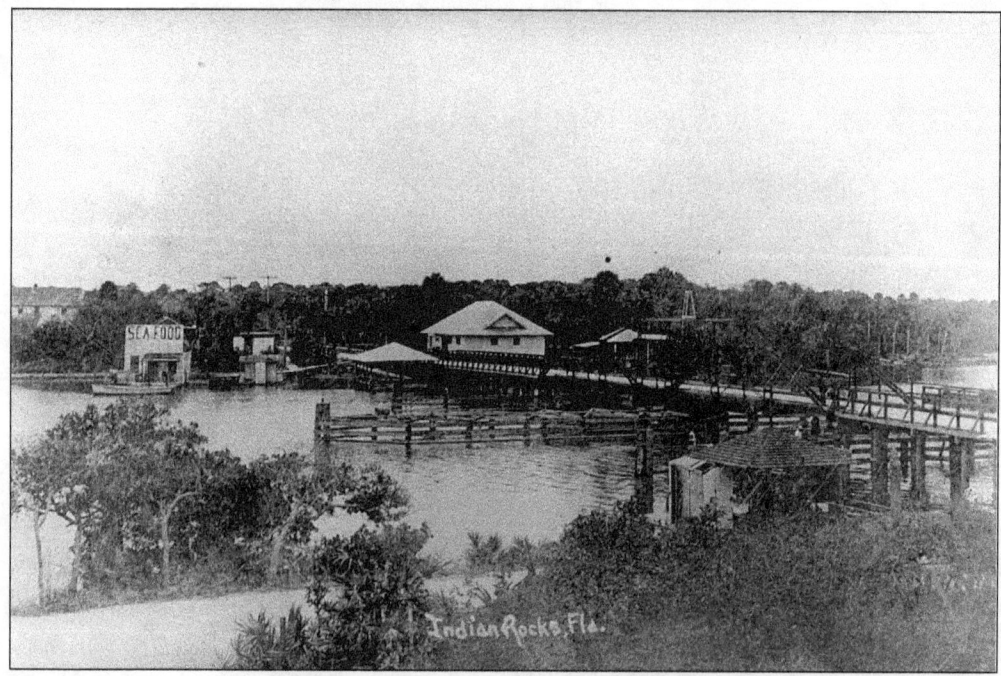

Though this early view (1921) of the Indian Rocks bridge looks rather lonely, the opening of bridges to the mainland and connecting the keys made the beach accessible to autos and increased tourists' sampling of the delights of the seaside. Note that most development is still on the mainland side of the Bay.

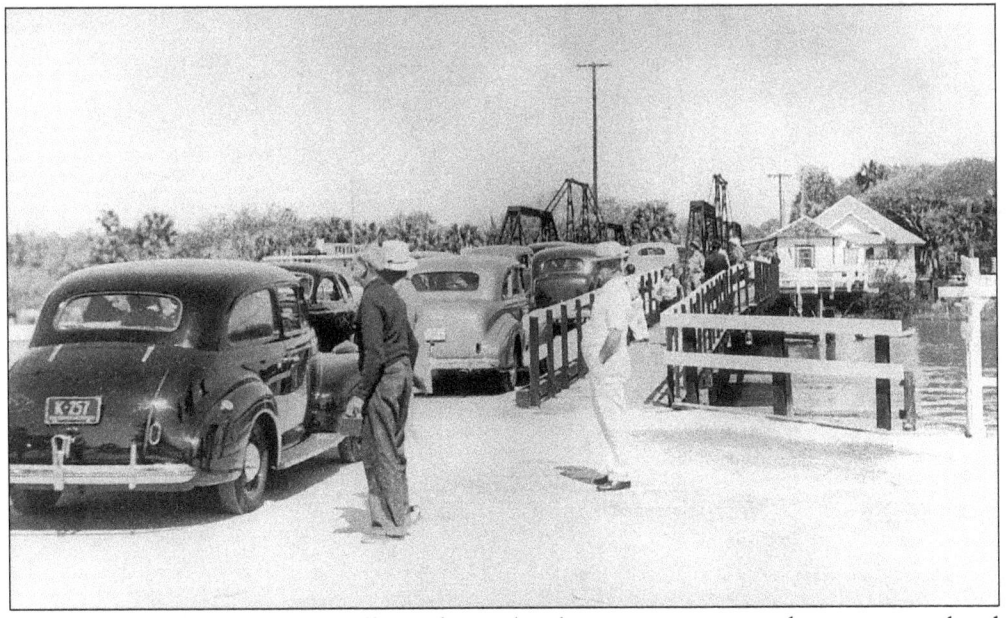

In this view, taken several years later in 1924, not a lot has changed. A grocery store can be seen adjacent to the bridge on the mainland side.

By the 1930s, traffic jams, especially on the weekends, were a common sight as motorists lined up to enjoy a day at the beach.

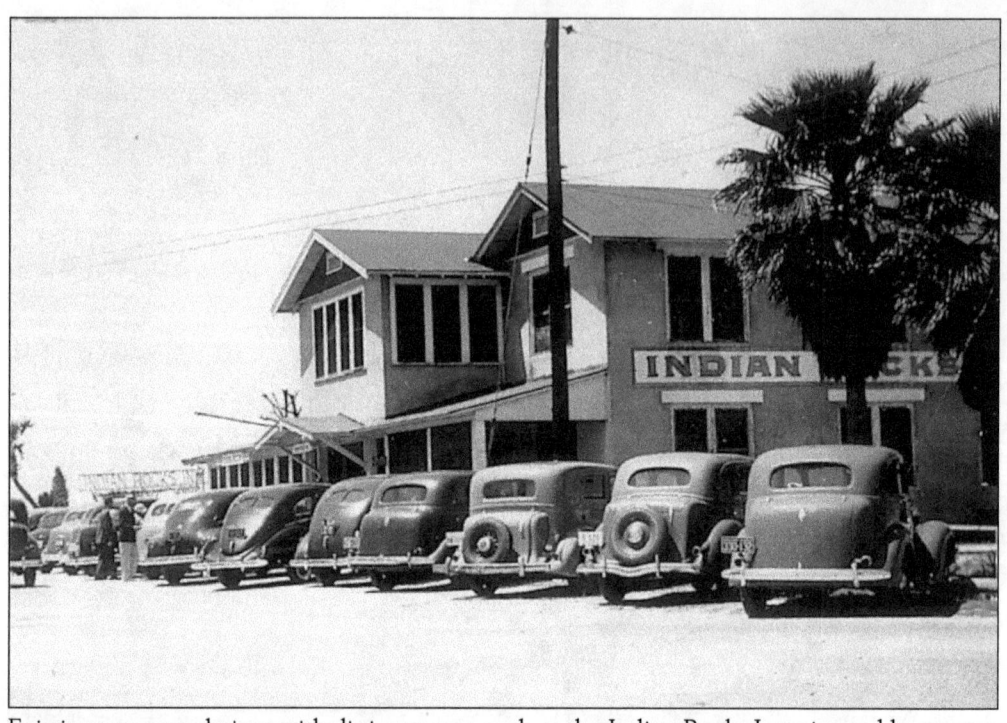

Existing accommodations with dining rooms, such as the Indian Rocks Inn pictured here, were expanded to attract the increasing tourist trade brought over on the bridge.

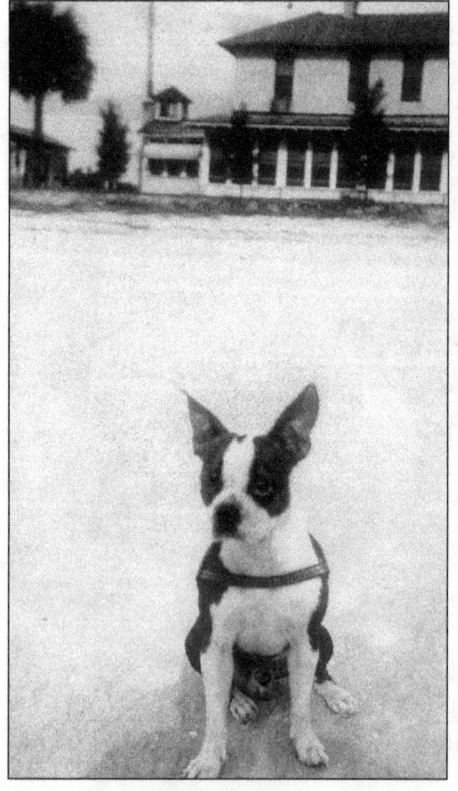

This bull terrier, Jiggs, greeted guests at the Indian Rocks Inn.

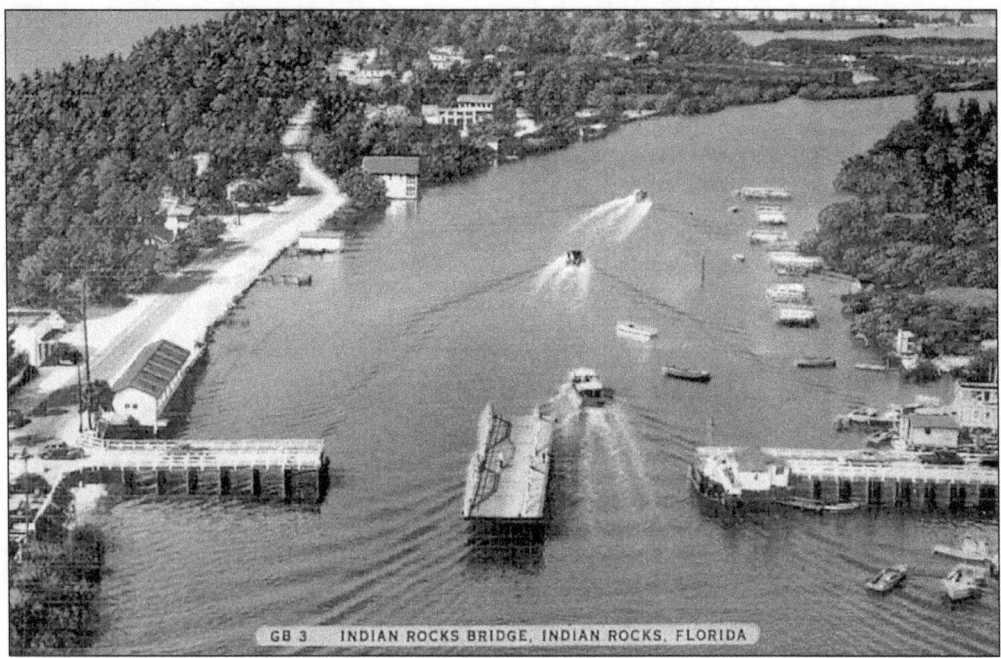

This aerial view shows the Indian Rocks bridge fully open, creating a wide channel for boats to pass through. Note the increased development on the beach side, including the Bie boathouse (upper left) on the waterway.

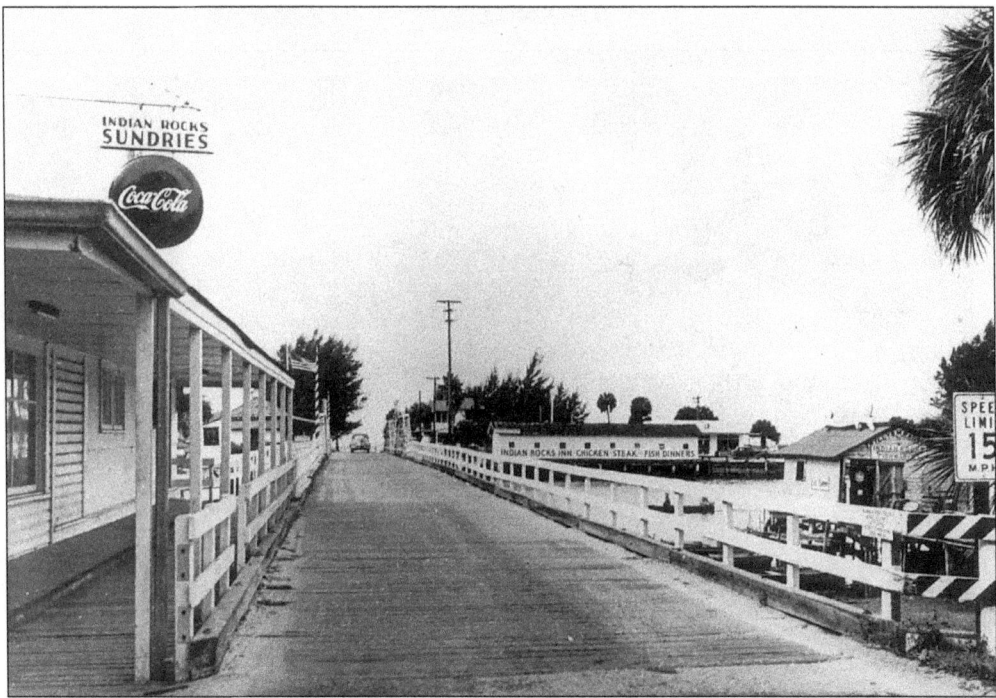

Development clustered around the bridges, as services such as sundries and restaurants rose up to accommodate the visitor influx. The Indian Rocks Bridge was known as the Rickety Bridge for its uneven wooden surface that caused many a bumpy ride.

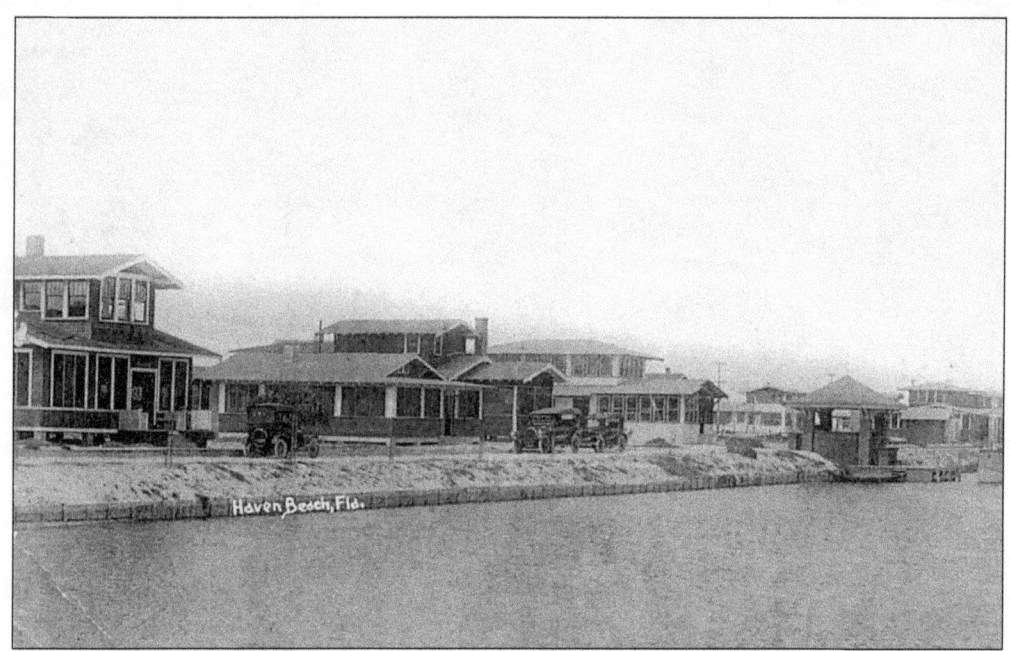

These houses, in the Haven Beach development that blossomed in the mid-1920s, are facing the Yacht Basin along Gulf Blvd. The boathouse on the water's edge is at Sixth Avenue, a block north of where the Texaco stands today. Several houses in this picture still exist. The Wesson family, known for Wesson Oil, lived in the large house on the left.

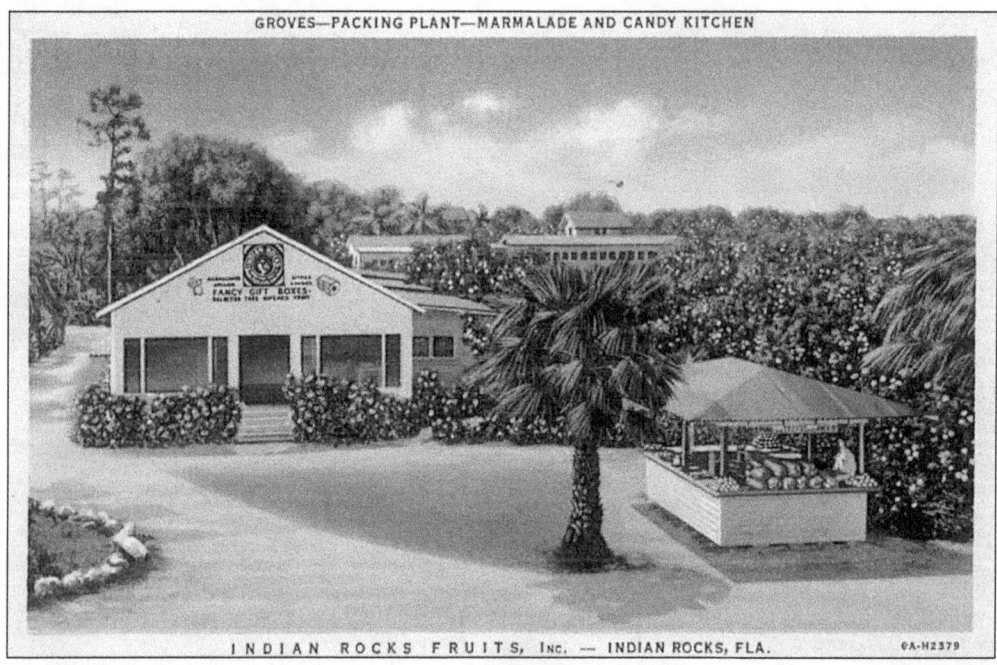

GROVES—PACKING PLANT—MARMALADE AND CANDY KITCHEN

INDIAN ROCKS FRUITS, Inc. — INDIAN ROCKS, FLA.

Oranges have long been the signature fruit of Florida, and groves were plentiful in the area. The Indian Rocks Fruits groves offered "Fancy gift boxes of tree ripened fruit," along with juice, marmalade, and candies.

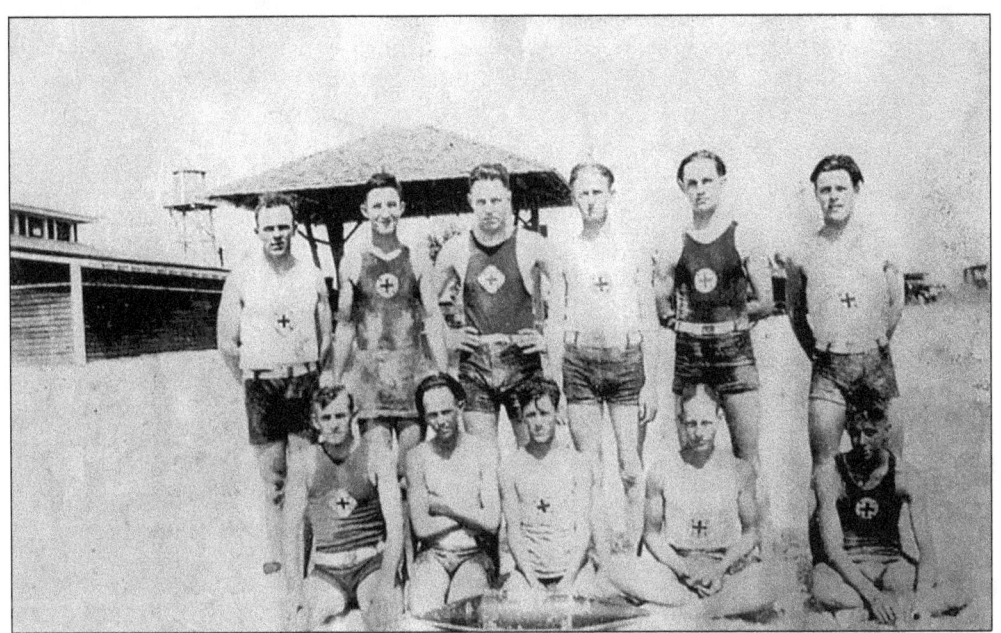

A team of lifeguards assures the safety of the beachgoers at Indian Rocks Beach.

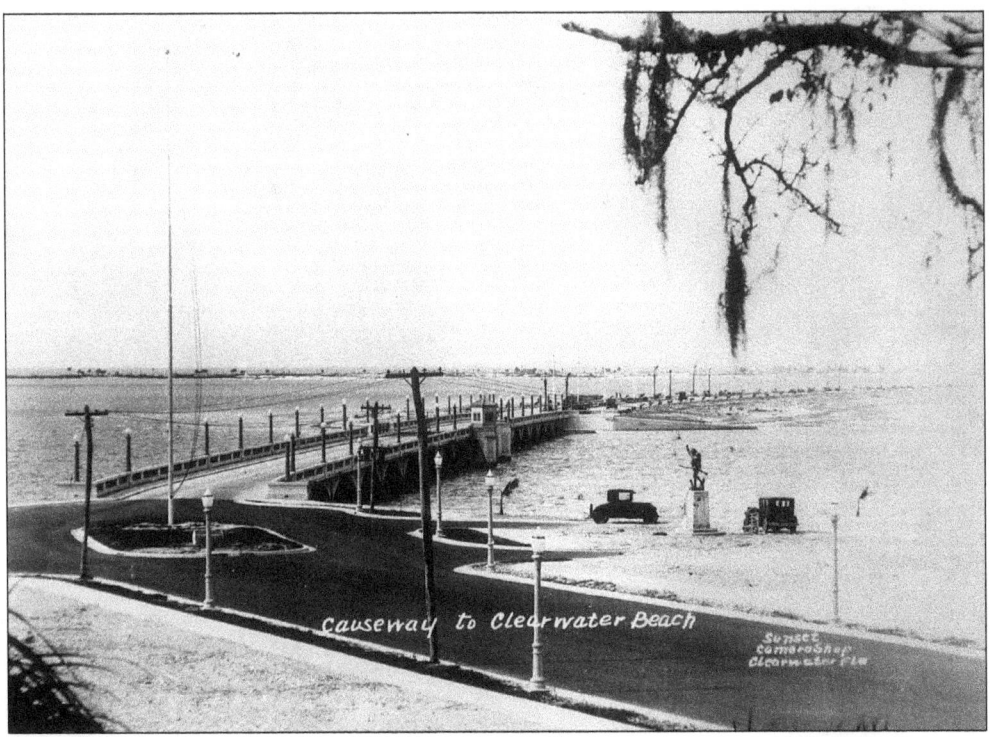

By the 1920s, auto travel had become common and the Clearwater Causeway funneled thousands of visitors to the beach.

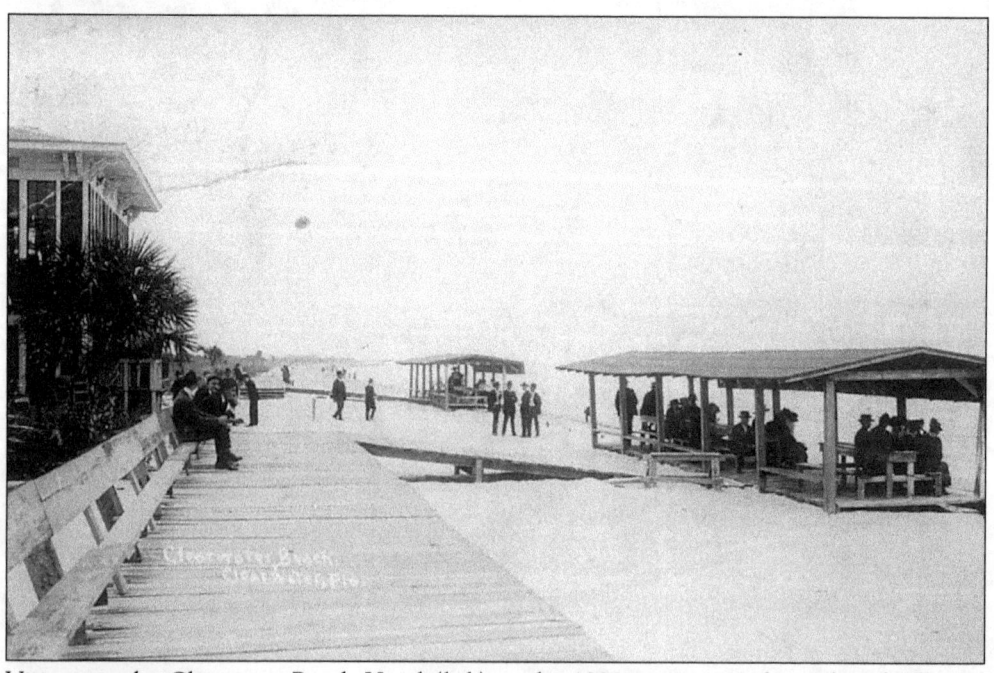

Roads such as this one in the Mandalay section were constructed in Clearwater Beach to accommodate the influx of automobiles.

Visitors to the Clearwater Beach Hotel (left) in the 1920s were treated to a boardwalk and beach "cabanas."

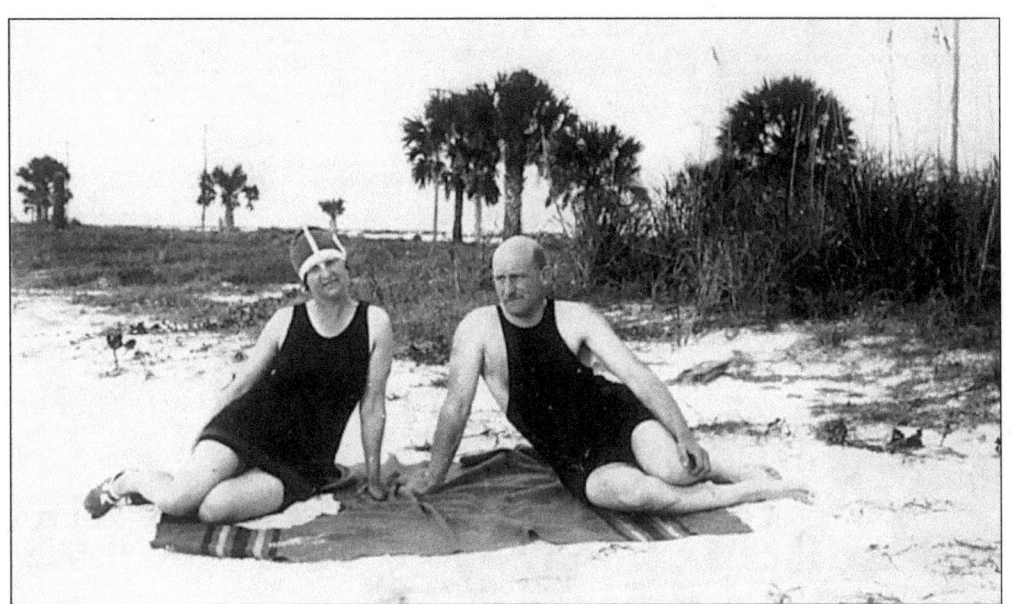
This pair sports matching body suits, 1928-style.

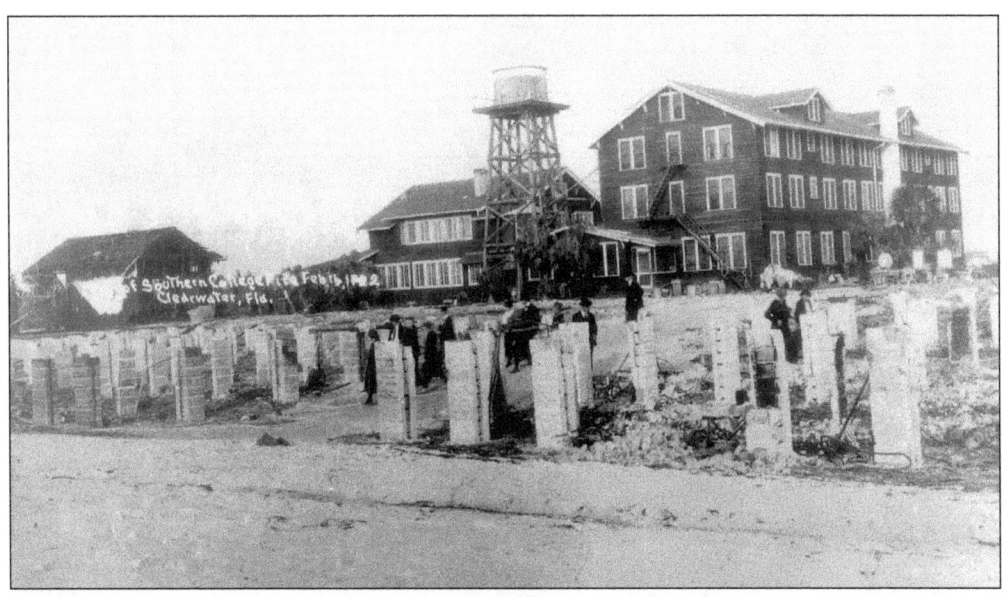
Florida Southern College, which was located adjacent to the Clearwater Beach Hotel, was destroyed in a devastating fire in 1921. Ruins of the barrack buildings which housed the college can be seen in the foreground (hotel in back) of this 1922 photo.

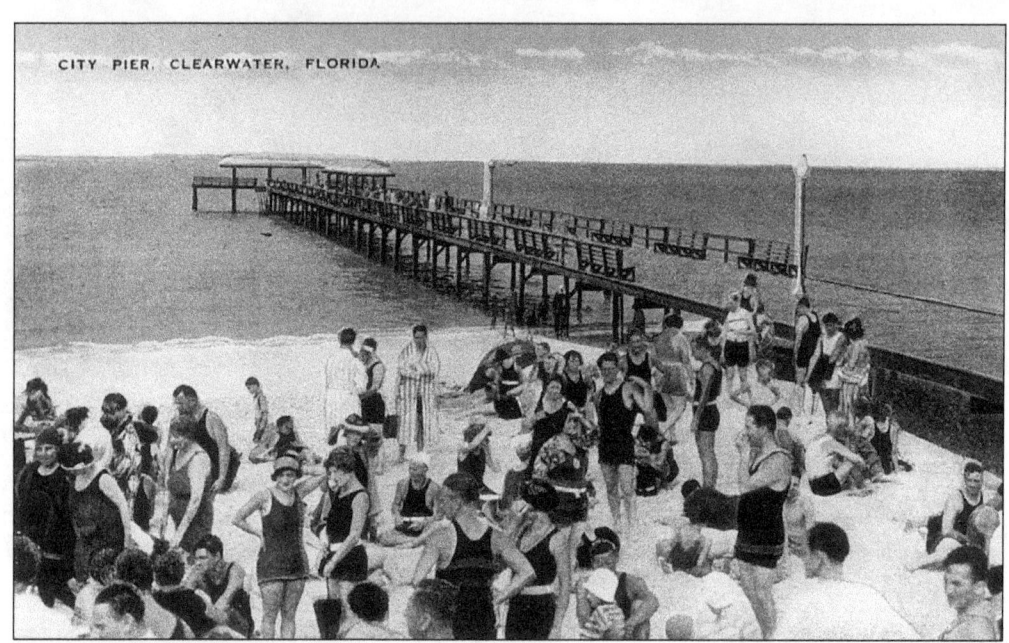

Clearwater Beach, with the City Pier in the background, is crowded with bathers on this sunny day in 1921.

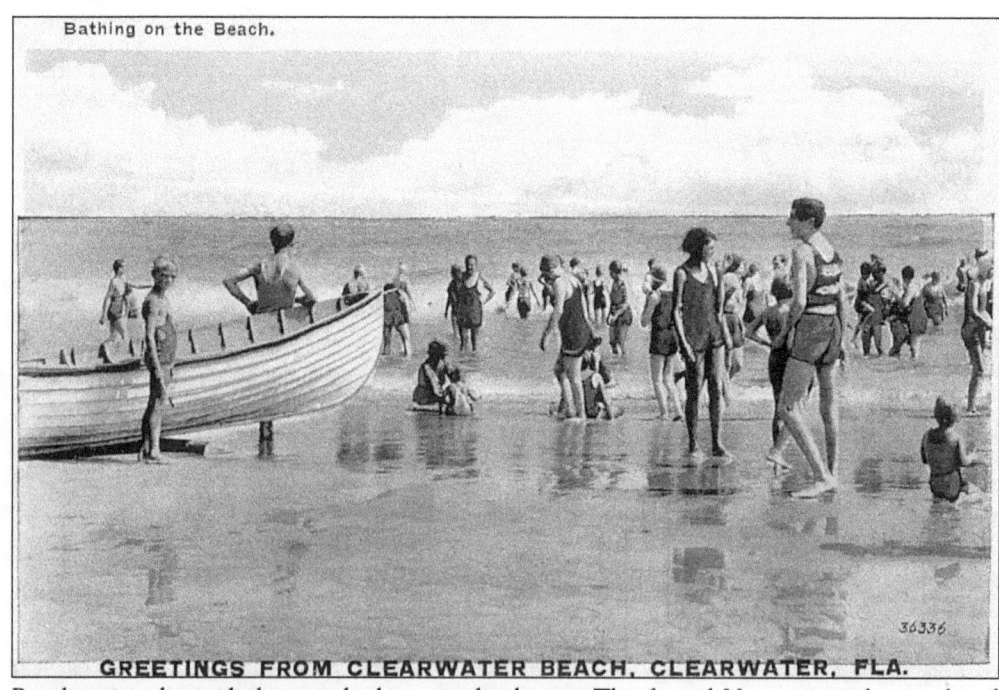

Bathing on the Beach.

GREETINGS FROM CLEARWATER BEACH, CLEARWATER, FLA.

Beach attire changed along with the attitude change. The formal Victorian garb is replaced with the more casual one-piece outfits better suited to bathing and frolicking.

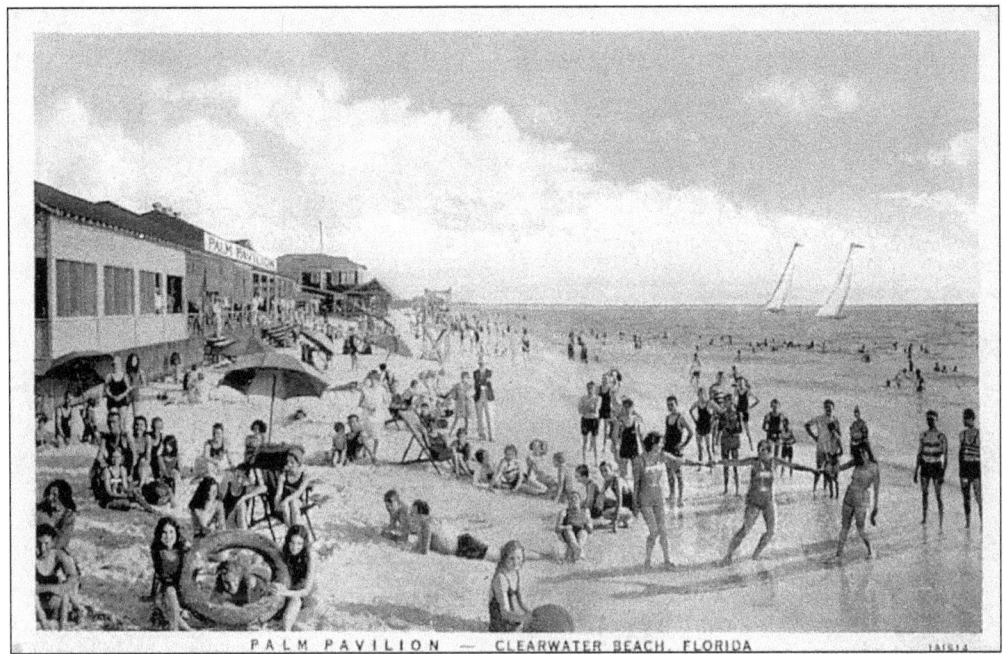

Beach pavilions, where bathers could change, buy beach accessories, and sometimes dance and eat, sprang up along the shore. Palm Pavilion at Clearwater Beach served many a beachgoer during its heyday as a bathhouse in the 1930s and 1940s. The Clearwater Beach Hotel can be seen in the background to the right of the pavilion.

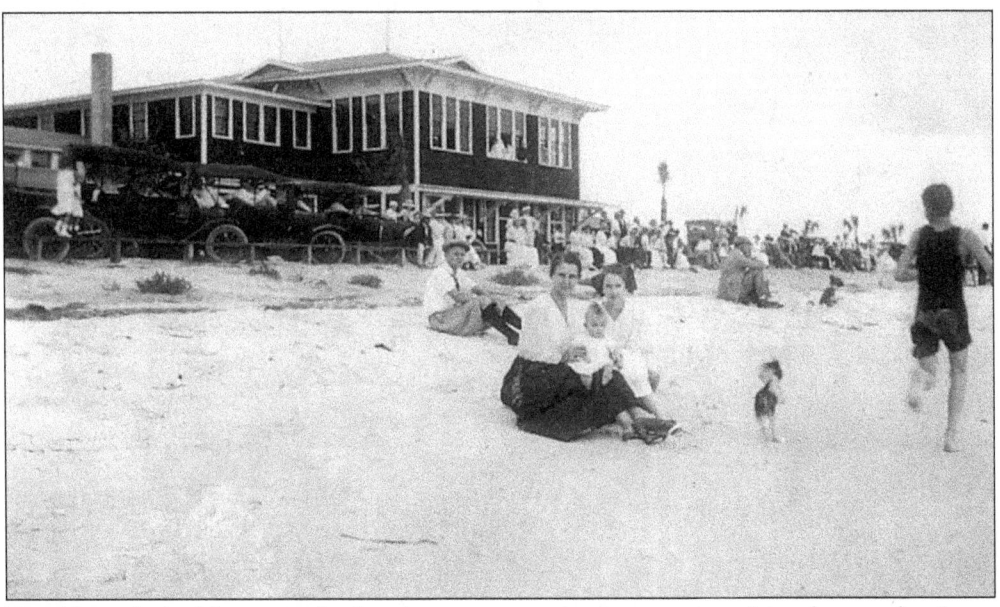

Notable early buildings on the beaches were commonly constructed in the wooden-frame shingle style usually associated with northern climes. The Clearwater Beach Pavilion shown here was the largest of the bathhouses on the island. After the 1921 hurricane undermined the foundation of the structure, its second story was moved across Mandalay Avenue and became the Clearwater Yacht Club.

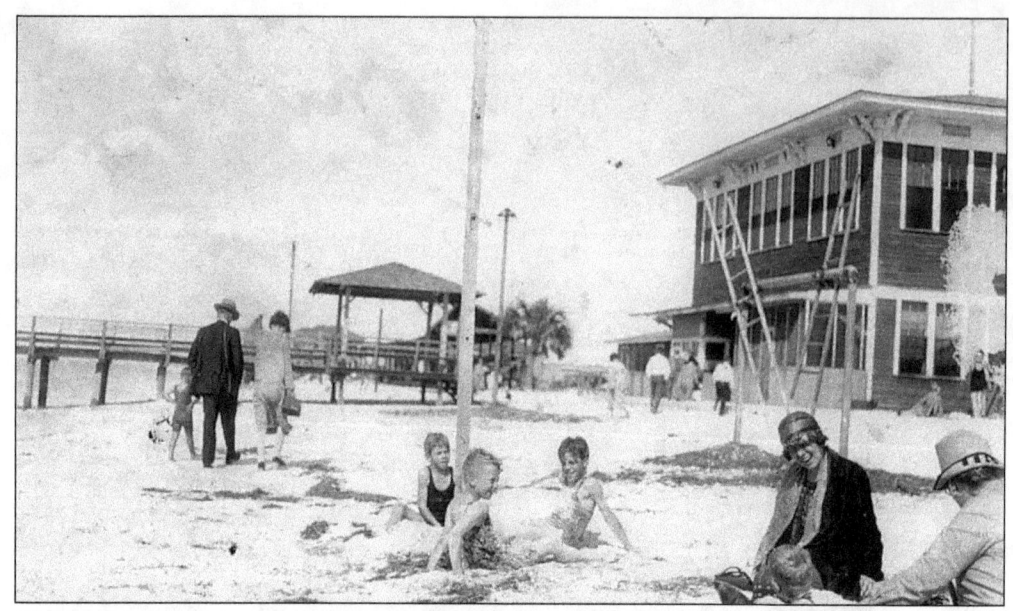

Children play in the sand outside the Clearwater Beach Pavilion.

Evringham's Pavilion was another famous Clearwater Beach landmark during the 1920s and 1930s. It was torn down in 1950 to make way for the Pier 60 development.

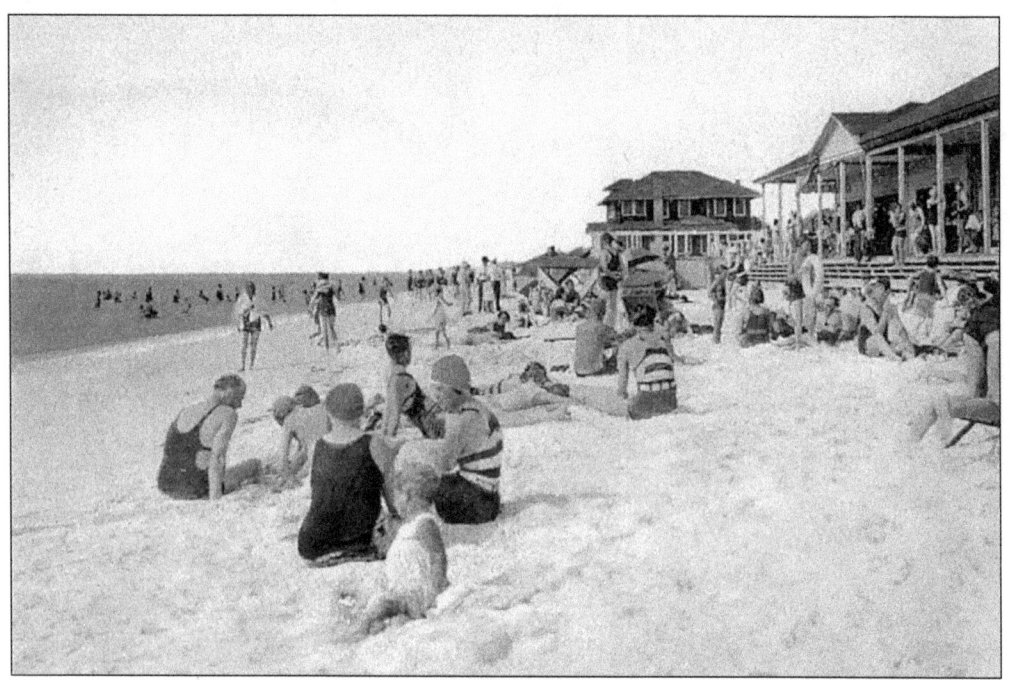

Beachgoers relax in the sand and surf along Clearwater Beach in front of Palm Pavilion. In the background is one of the oldest houses on the beach.

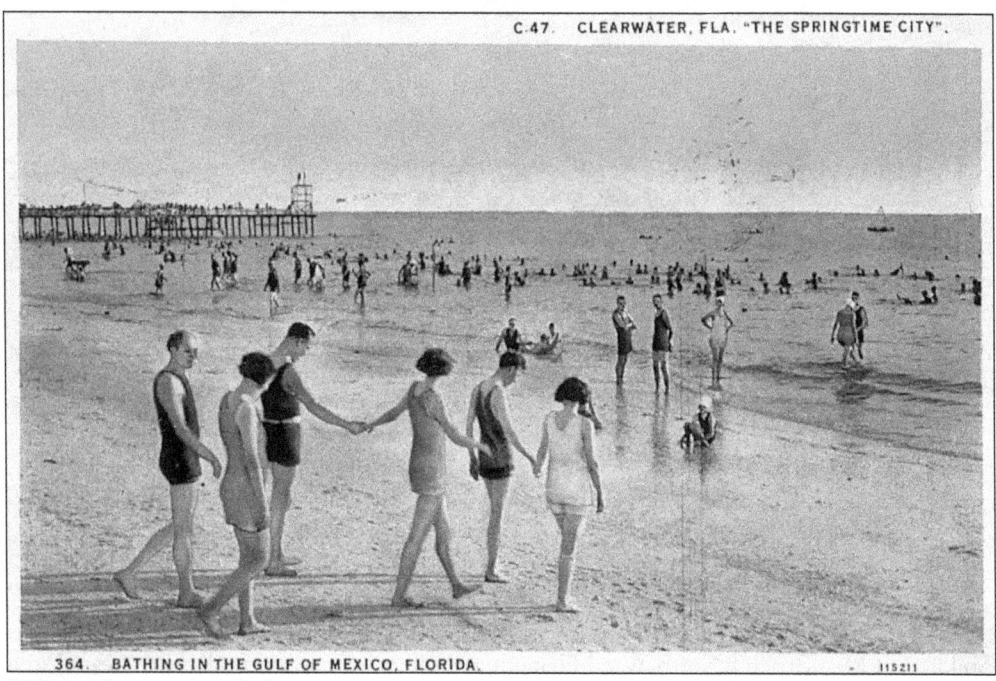

C-47. CLEARWATER, FLA. "THE SPRINGTIME CITY".

364. BATHING IN THE GULF OF MEXICO, FLORIDA. 115211

Walking hand in hand, these couples appear to be enjoying the sand between their toes.

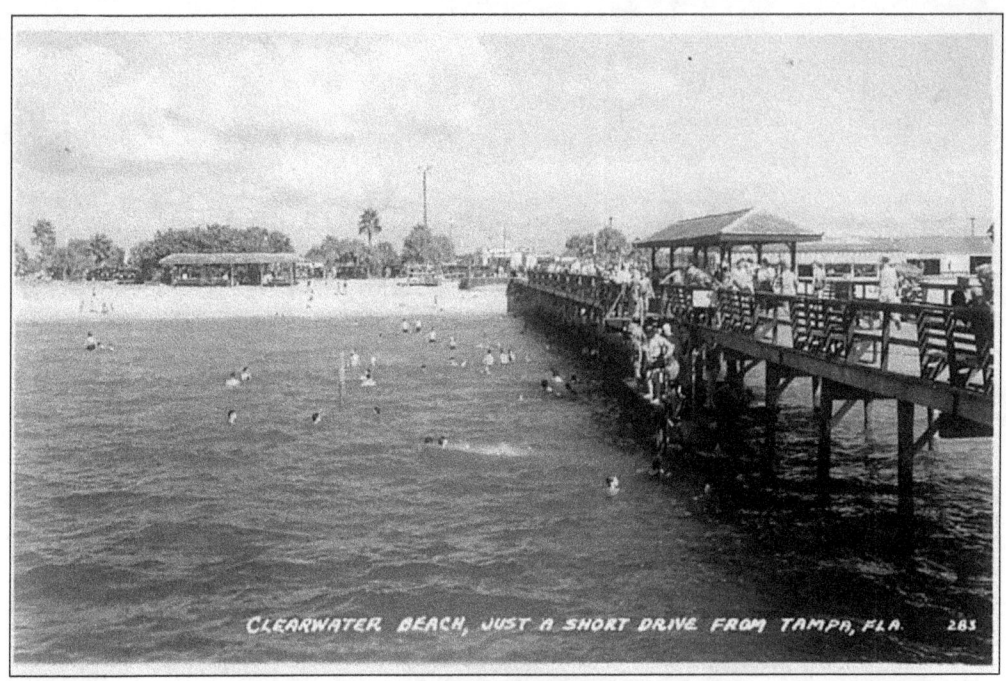

The pier was a popular "jumping off point" for swimmers. Evidently, this photograph was made for promotional purposes—note the comment "Clearwater Beach, just a short drive from Tampa, Fla."

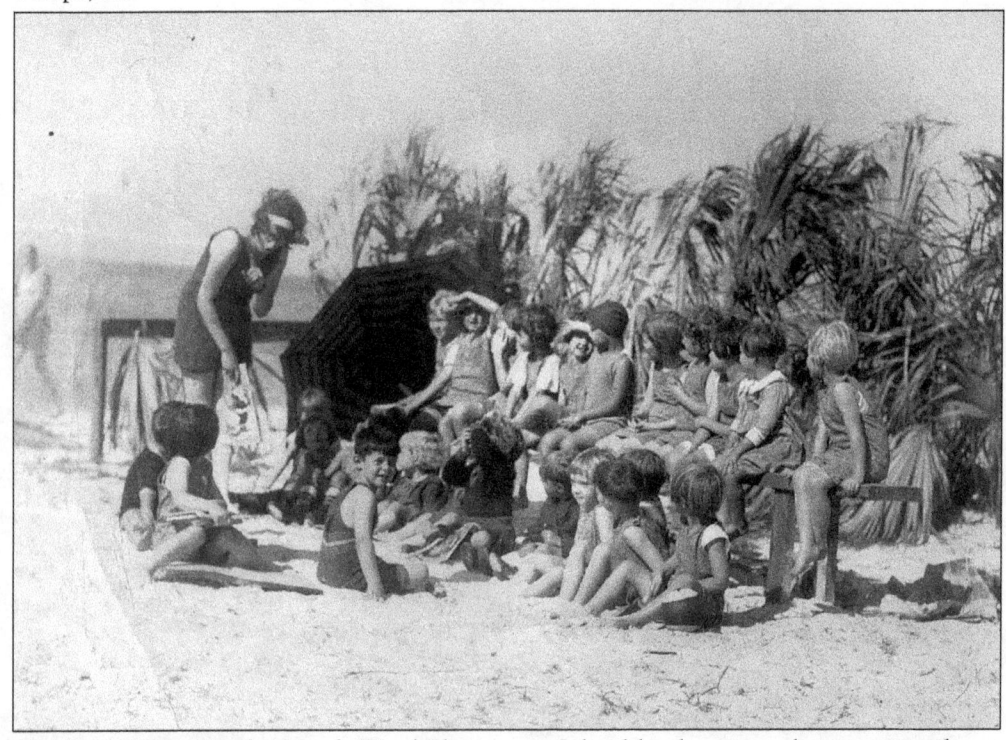

Children of Miss Strich's North Ward Elementary School kindergarten class are treated to a beach excursion in this 1925 vintage view.

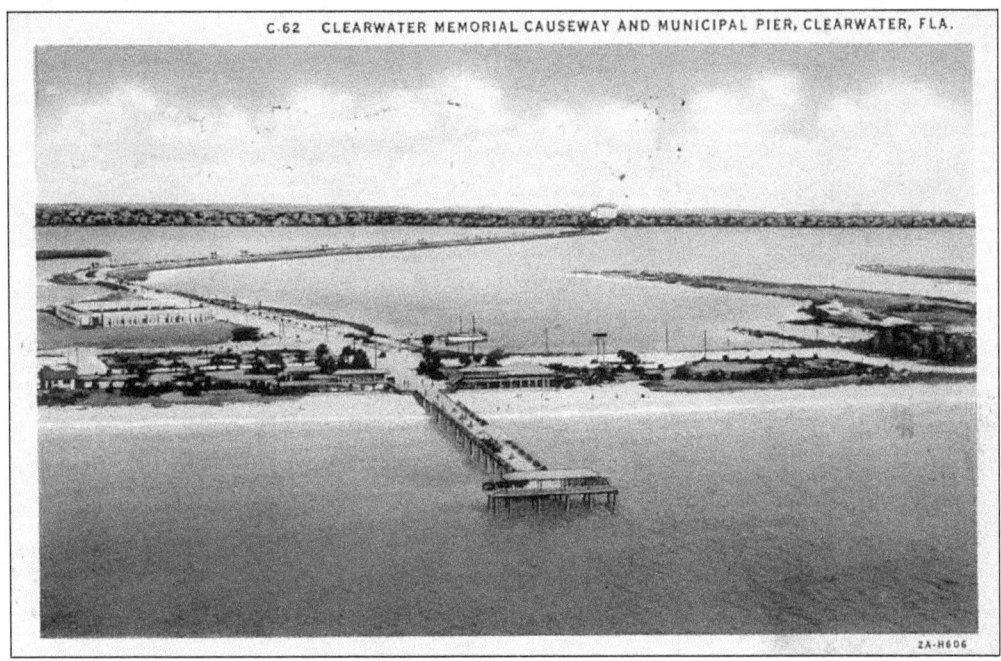

The kids play "bat the ball" with Miss Strich in this photo, taken December 14, 1925.

This aerial view from the early 1930s shows the pier and causeway, with Clearwater's Fort Harrison Hotel across the bay in the background.

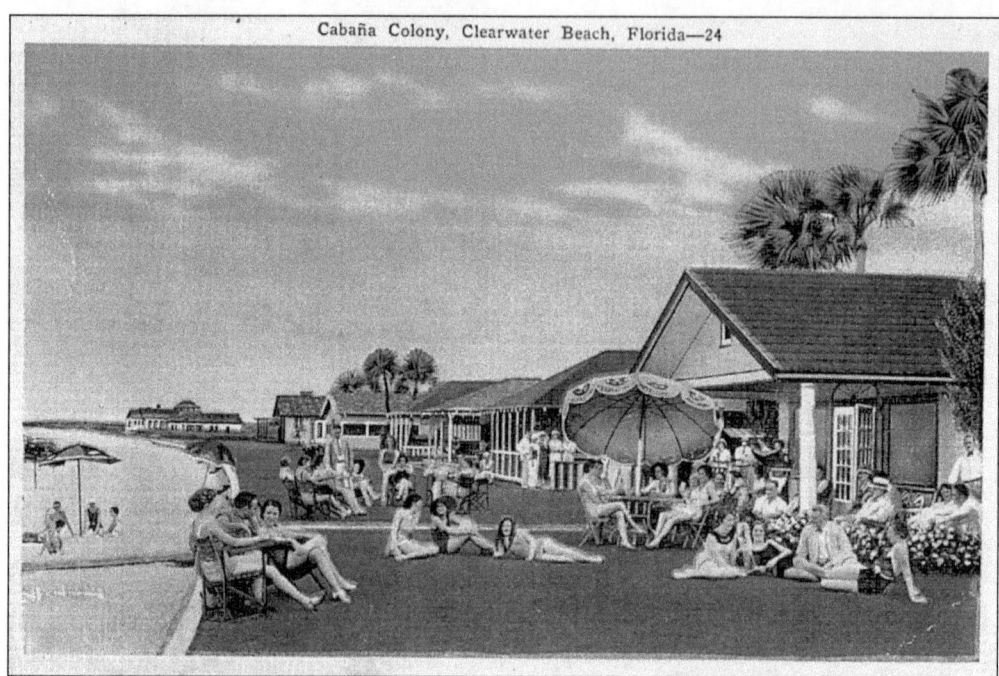

The Cabana Colony was a cottage community on Clearwater Beach in the 1930s.

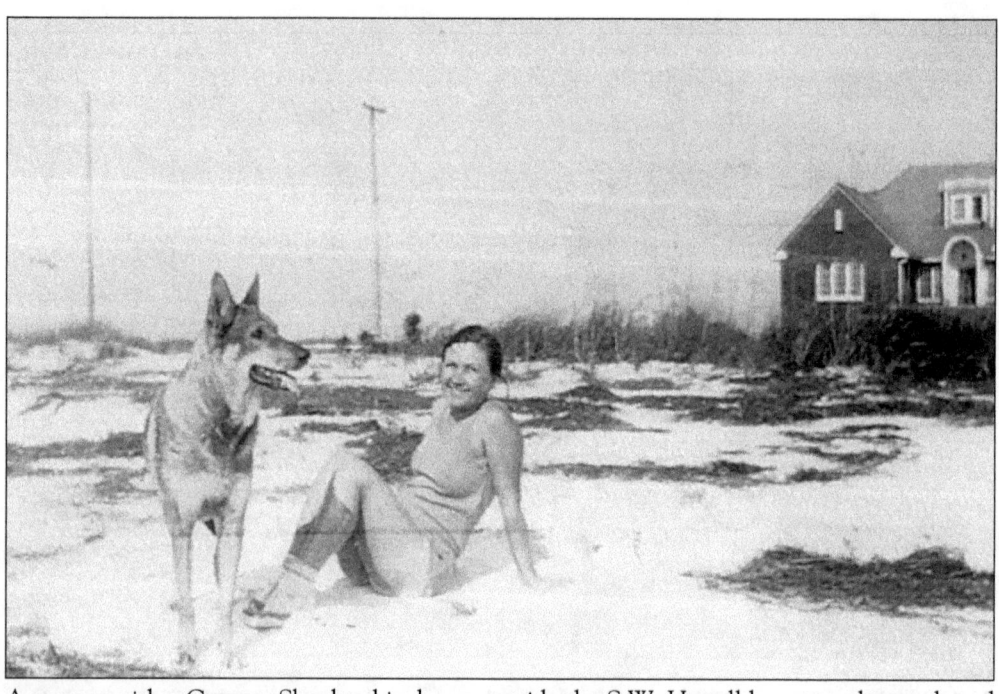

A woman with a German Shepherd is shown outside the S.W. Hassell home on the south end of Clearwater Beach around 1927.

Four

THE BEACH
AS A DESTINATION
1940s–1950s

The prosperity following World War II coupled with the Baby Boom ushered in the era of the family vacation. For the first time, middle-income families had the means and desire to travel on extended— usually summer—vacations and the beach was a natural destination.

The late 1940s through the 1950s became the "age of the motels." A construction boom along the Gulf Beaches saw most open spaces, especially along St. Petersburg Beach, Treasure Island, Madeira Beach, and Redington Beach fill in with mid-size motels with amenities like swimming pools, TV, and later air conditioning, that appealed to families with children.

The rush was on to the beach and, while the condominium era was yet to come, wall-to-wall development, except for set-aside natural areas, became the rule during the peace and prosperity days of the mid-20th century.

The post-war era saw tourist emphasis shift from St. Petersburg to the beaches. With malaria and other water-associated diseases conquered and the jungles mostly cleared, the pristine Gulf Beaches were ready for visitors and war-weary families eager for a vacation were ready for the attractions of the beach.

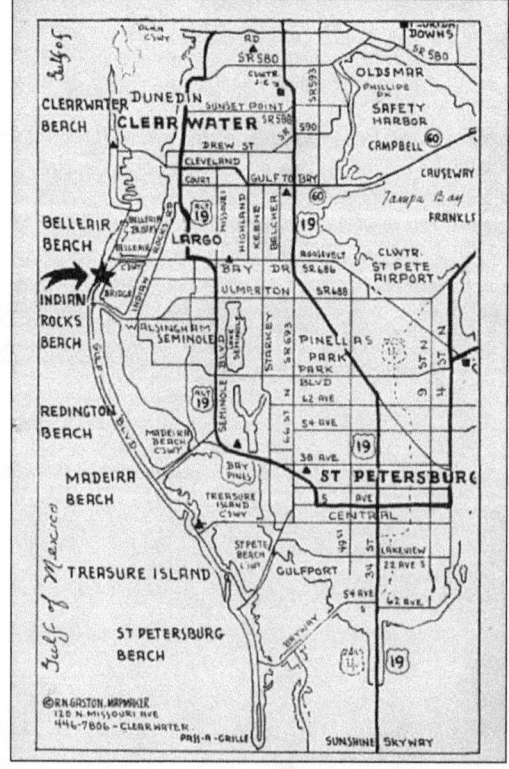

Newly incorporated towns of Treasure Island, Madeira Beach, and Redington Beach joined the older settlements in developing motels, restaurants, and other amenities to compete for the attention of the newly prosperous family vacationers.

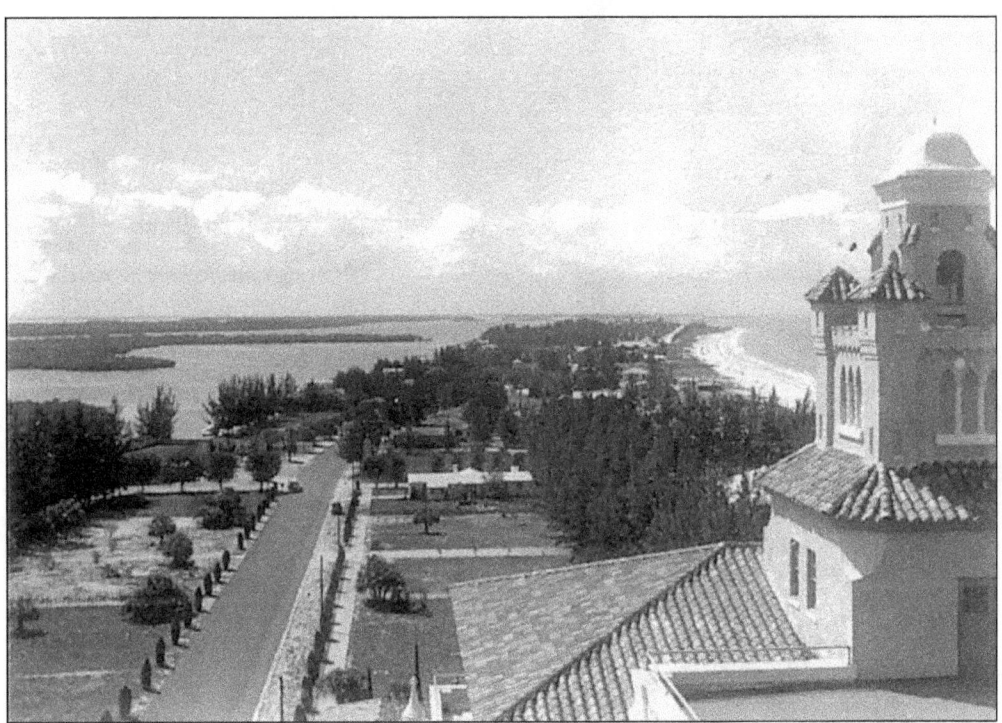

This view looks south from the Don CeSar Hotel toward Pass-a-Grille.

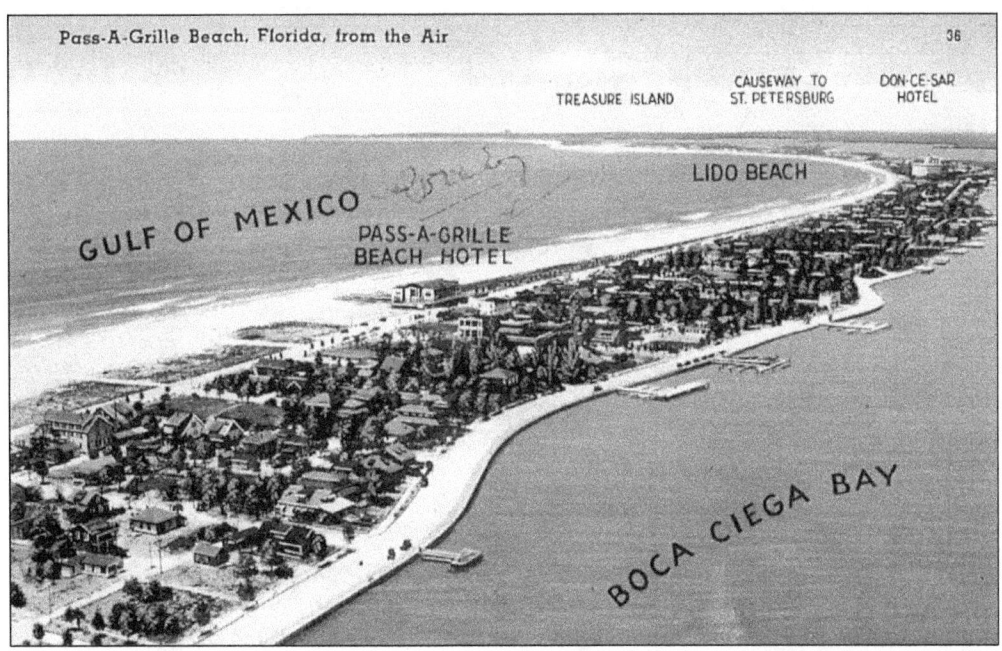

The town of Pass-a-Grille, mostly built out by the 1920s, showed little change during the post-war boom days. Today, the village remains a quaint and lovely reminder of early Florida.

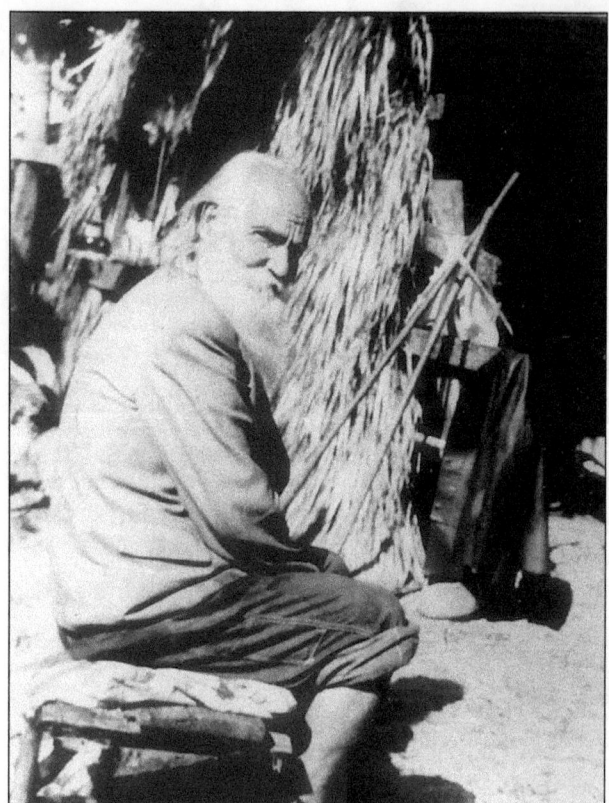

The legendary Silas Dent (shown on page 30 as a young man) continued to embrace the pioneer ways even into the modern 1940s. With his long white beard and love for children he made a perfect Santa Claus, and was a favorite of two generations of islanders until his passing on Christmas Eve 1952 at the age of 76.

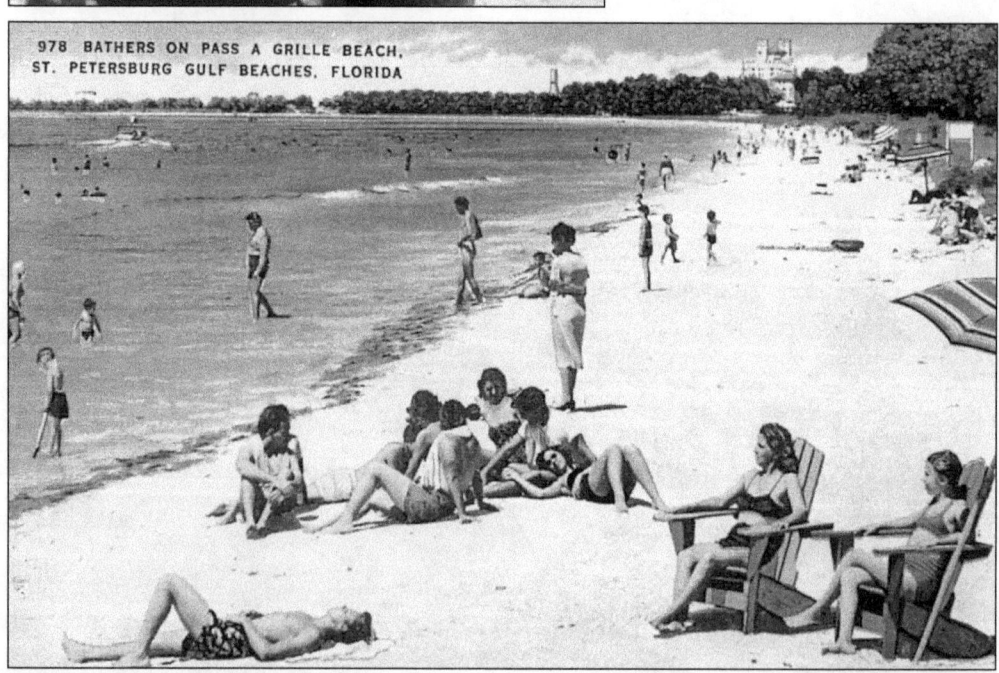

978 BATHERS ON PASS A GRILLE BEACH, ST. PETERSBURG GULF BEACHES, FLORIDA

In the post-war decade, sedate Pass-a-Grille Beach was crowded with sun-worshippers and the one-piece women's bathing suit was largely discarded in favor of more daring and tan-friendly two-piece models. Note the Don CeSar Hotel pictured in the background.

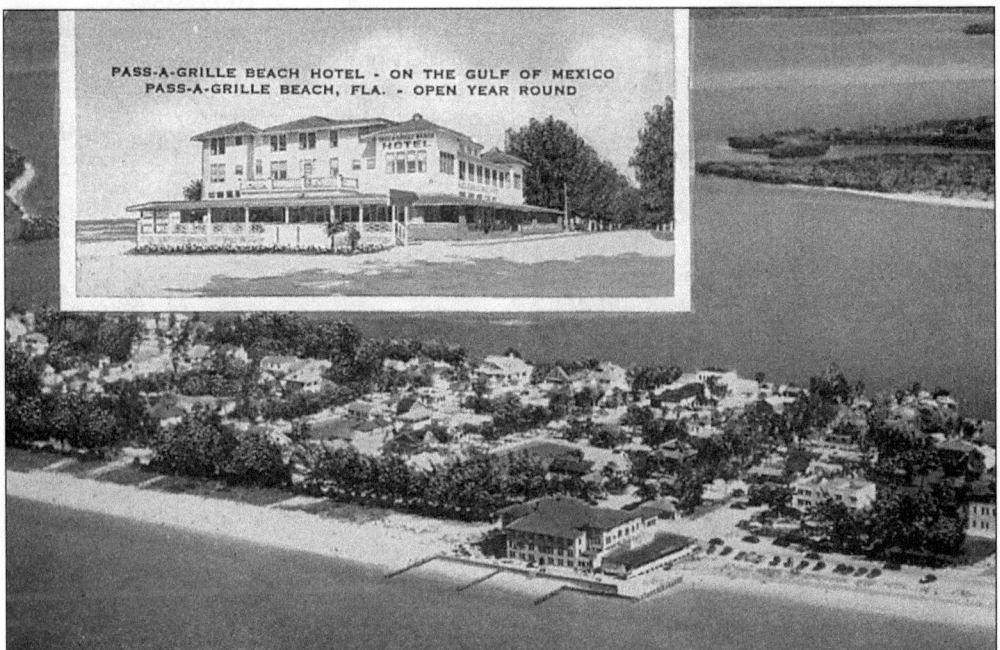

The Pass-a-Grille Hotel name, with "Beach" added, was passed on to the casino, which was renovated to become the Pass-a-Grille Beach Hotel and Casino in the early 1920s. The hotel served guests for several decades until it succumbed to fire in 1967.

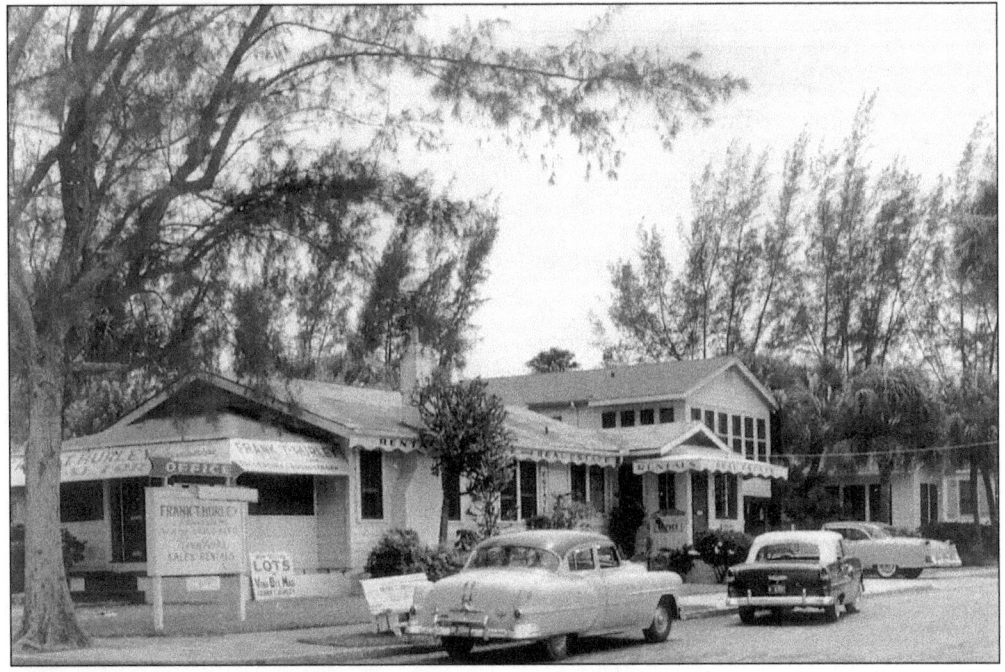

Frank T. Hurley Associates, Realtors of Pass-a-Grille, is the oldest continuing business on the beaches, tracing its origins to 1918 when Mr. and Mrs. Billy Mitchell of Boston opened a business to rent beach houses. The firm was bought by the Hurley family in 1947 and continues to be operated by second- and third-generation Hurleys.

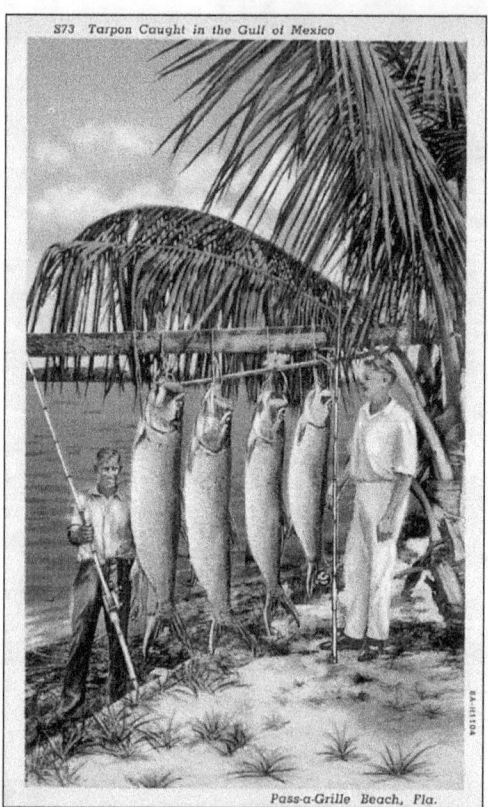

S73 Tarpon Caught in the Gulf of Mexico

Pass-a-Grille Beach, Fla.

The Gulf waters continued to teem with a variety of sport fish and fishermen were eager for their share, as this catch of prize tarpon attests.

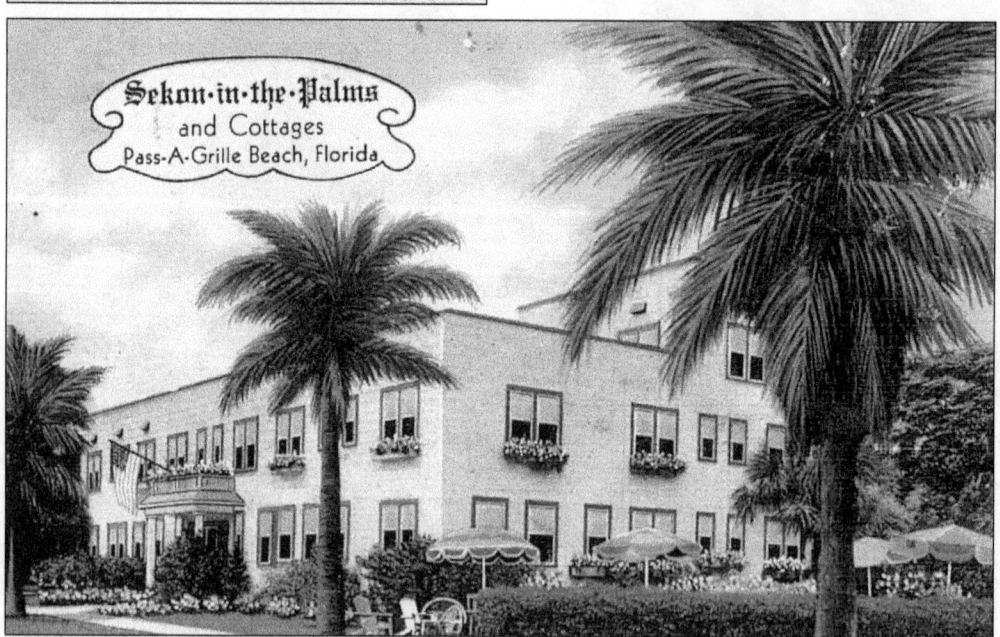

Sekon-in-the-Palms
and Cottages
Pass-A-Grille Beach, Florida

The Sekon-in-the-Palms, which bills itself on this card as Pass-a-Grille's "newest and largest hotel," featured a location "30 seconds from the beach" and an orchestra that played "nightly for dinner and concerts." Owner Ralph Dellevie also operated Sekon Lodge in Upper Saranac Lake, New York, and the reservation office is listed at 630 Fifth Avenue, New York City.

A first-class system of paved highways further enhanced Florida's appeal as a tourist destination in the decades following the war. Major tourist attractions sprang up in all parts of the state and most were easily accessible day trips from the Tampa Bay area.

Corey Causeway replaced the wooden McAdoo Bridge in the late 1920s. It was well established as the link between St. Petersburg and its beach by the time this aerial photo was shot around 1950.

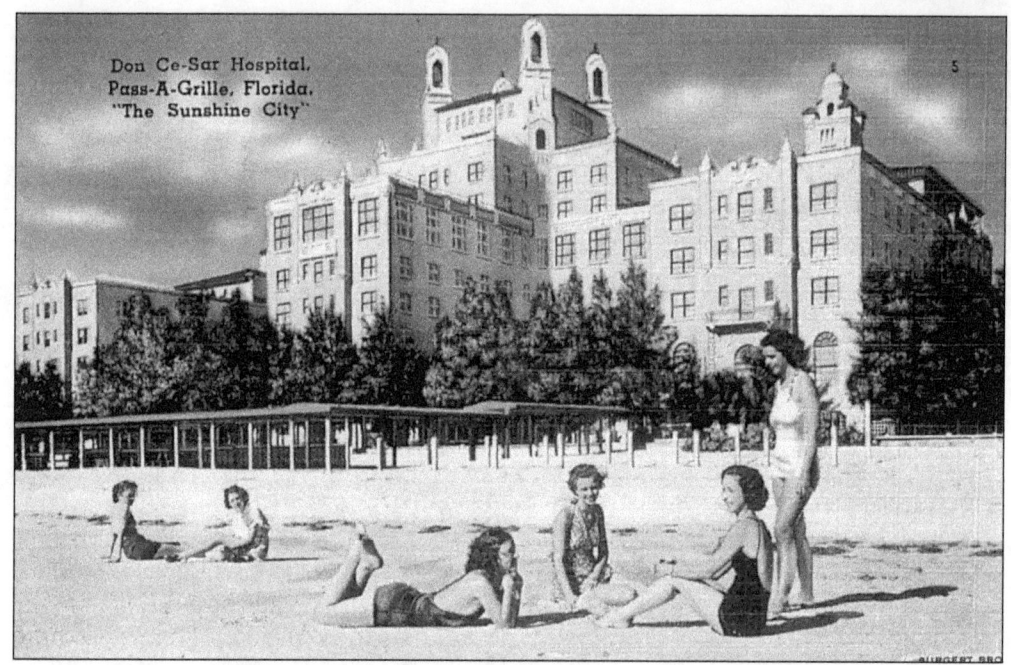

The Don CeSar fell on hard times during the depression and was used as a military hospital during the war years. While these sunbathers were gaily enjoying the beach, the serious business of lifesaving and rehabilitation was being carried on inside the Don's walls.

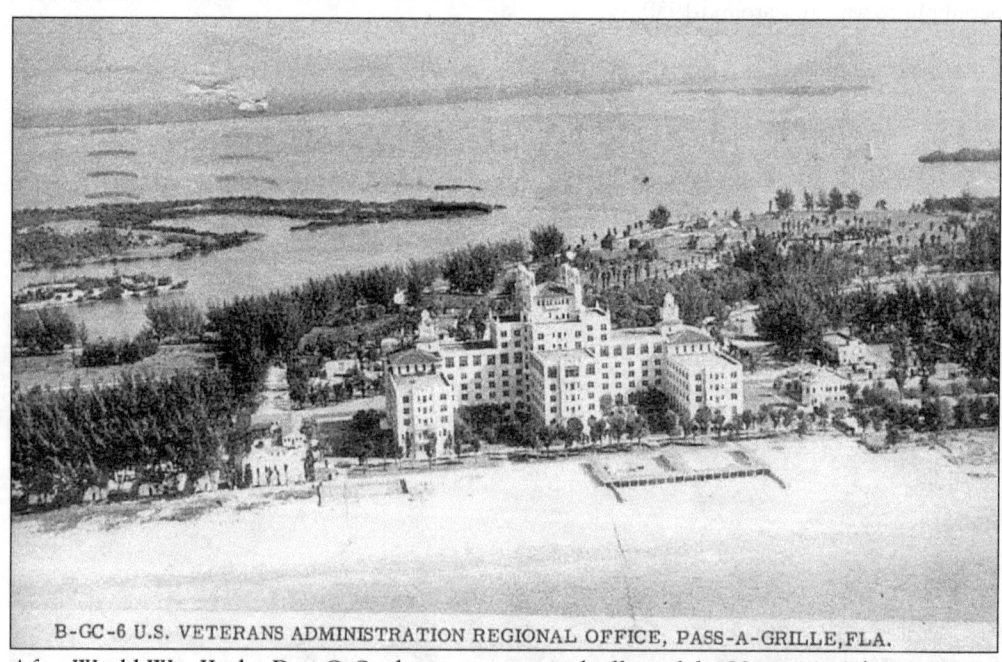

B-GC-6 U.S. VETERANS ADMINISTRATION REGIONAL OFFICE, PASS-A-GRILLE, FLA.

After World War II, the Don CeSar became a regional office of the Veteran's Administration before closing in 1969. Abandoned, but fortunately not lost to demolition, the Don was restored to its original splendor in the mid-1970s and remains today the most elegant hostelry on the beaches.

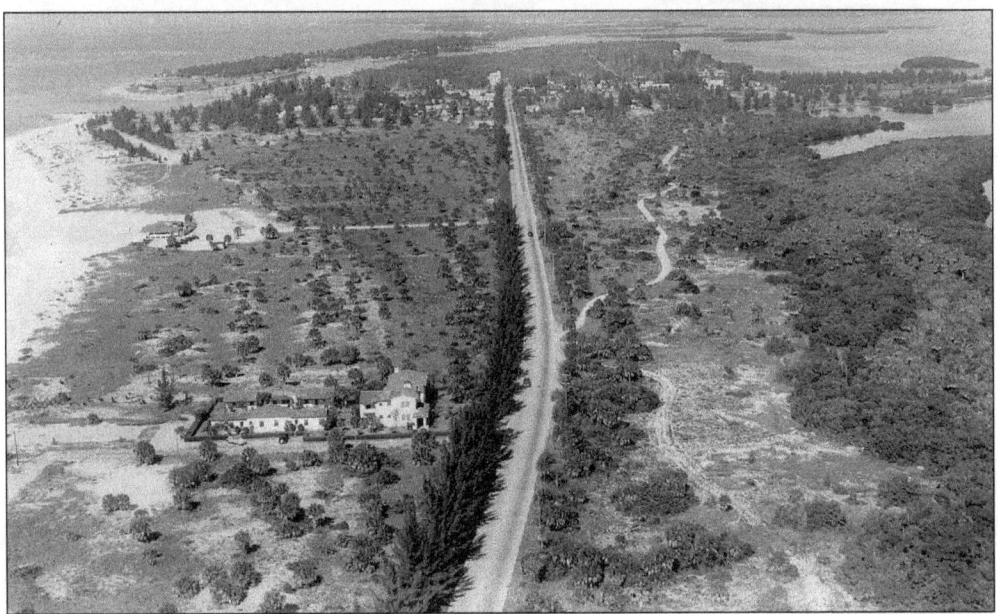

This 1948 shot of the St. Petersburg Beach business district shows the postwar boom in full bloom. Buildings or cleared lots occupy most of the area. The street crossing the center of the picture with the large buildings is Gulf Boulevard, while Corey Causeway is in the upper right.

This view, also 1948, shows development increasing, though still sparse, along Blind Pass Road looking north.

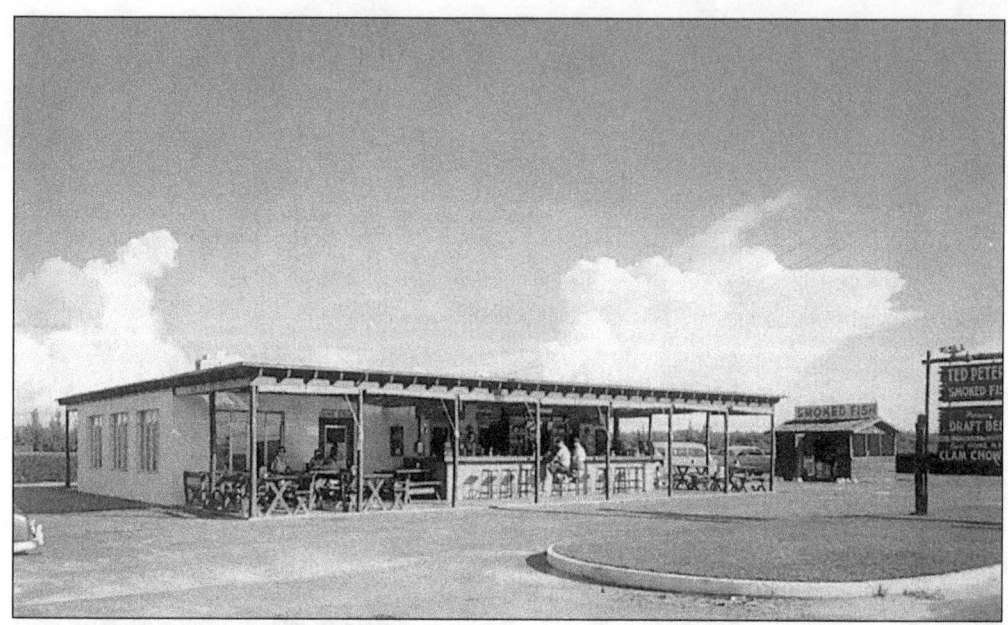

Ted Peters Smoked Fish, a St. Petersburg institution then as now, was a quick jaunt across the causeway for hungry tourists. The Pasadena Avenue location of the restaurant was described in the 1950s as "a peaceful setting at the gateway to the Gulf Beaches." At the time, Ted's was already boasting "over 100,000 lbs. of fish handled annually."

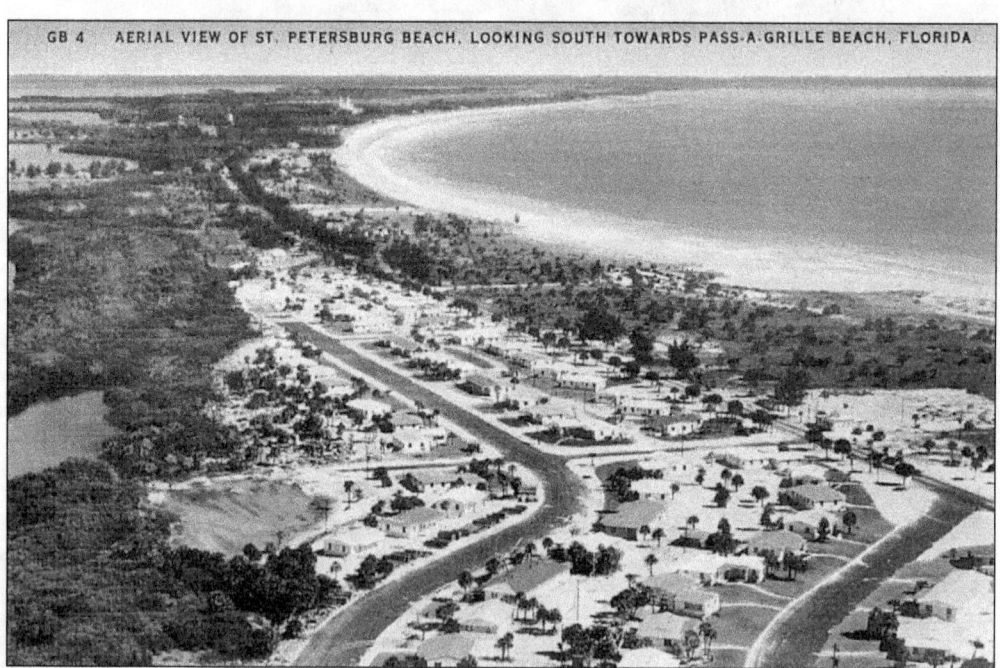

Residential development is apparent in this view showing St. Petersburg Beach, looking south toward the Don CeSar and Pass-a-Grille. The City of St. Petersburg Beach (now St. Pete Beach) as it exists today was formed on July 11, 1957 with a consolidation of the city of St. Petersburg Beach and the towns of Belle Vista Beach, Don CeSar Place, and Pass-a-Grille Beach.

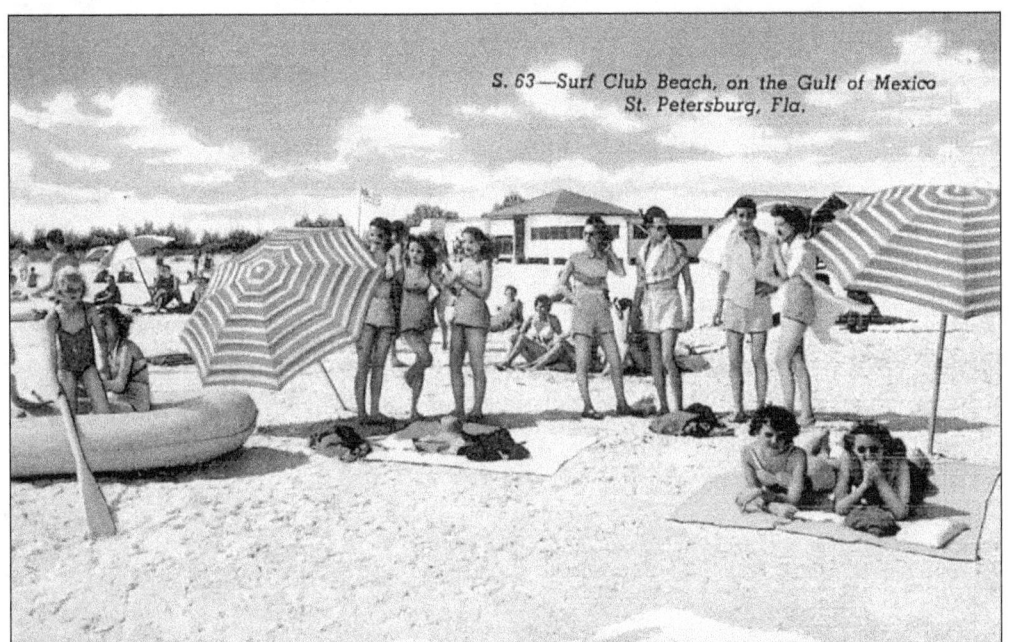

Surf Club Beach was a popular spot to hang out in 1950s-era St. Petersburg Beach.

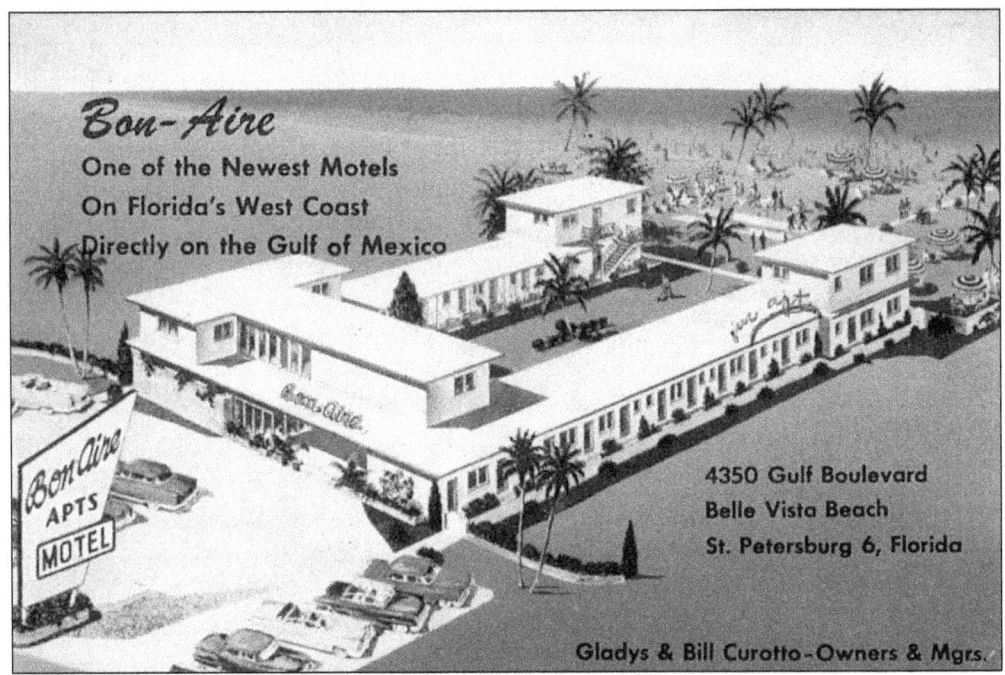

By the 1950s, the motel, often called an apartment-motel, had become the preferred vacation accommodation for growing baby boom families. Most available beachfront property along Tampa Bay's Gulf Beaches was quickly gobbled up for motel sites. The Bon-Aire, with its wings and courtyard facing the Gulf, was typical of early motel construction in the area. The only thing lacking was a swimming pool. Belle Vista Beach was part of St. Petersburg Beach, and this motel still operates today.

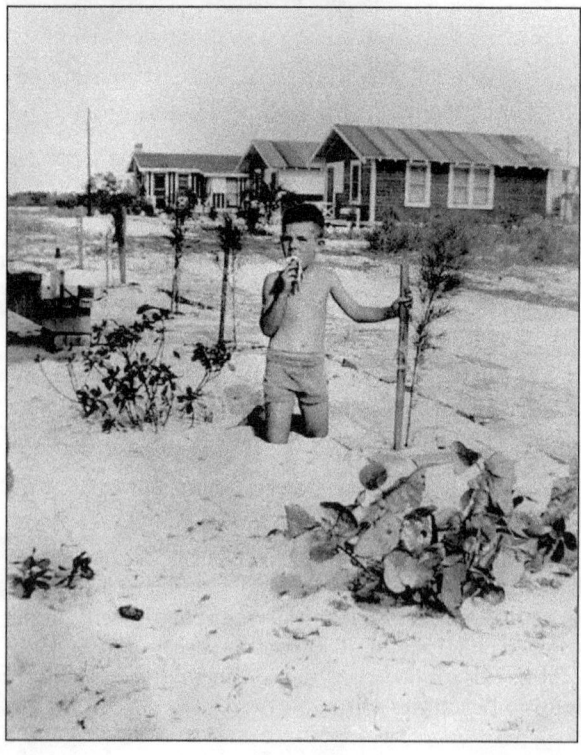

The town of Sunset Beach (the peninsula, left) is now part of Treasure Island.

The cottages on Sunset Beach were the perfect spot for a family vacation. At the time of this photo, the newly-planted trees on 90th Avenue fail to provide much shade for this boy eating a banana.

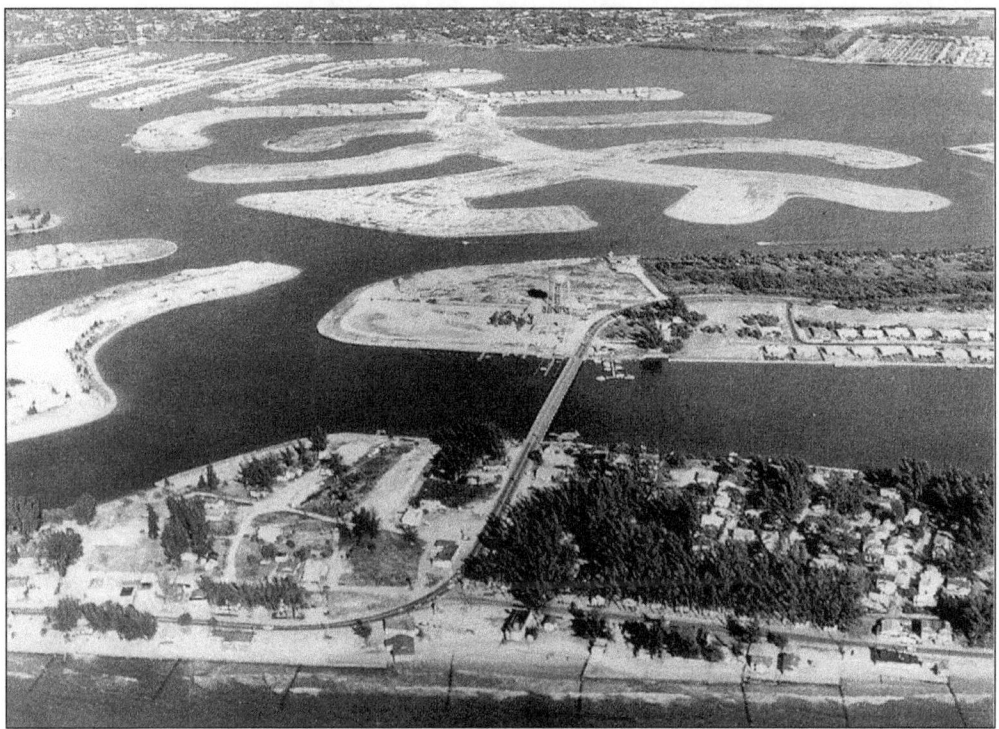

Sunset Beach (foreground), which became part of Treasure Island in 1955, was opened to development with the bridging of Blind Pass in 1940. The land jutting out into Boca Ciega Bay in the background is Yacht Club Estates in St. Petersburg, which had been dredged and plotted as a residential area when this aerial photo was taken in 1945.

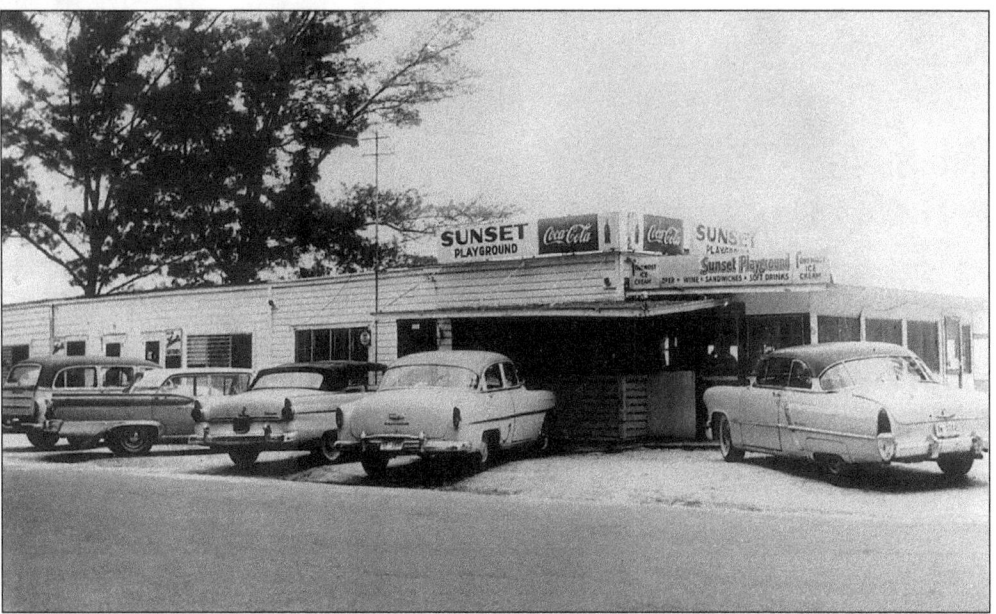

The Sunset Playground was a convenient place for Sunset Beach residents to stop for a sandwich and a beer or cola.

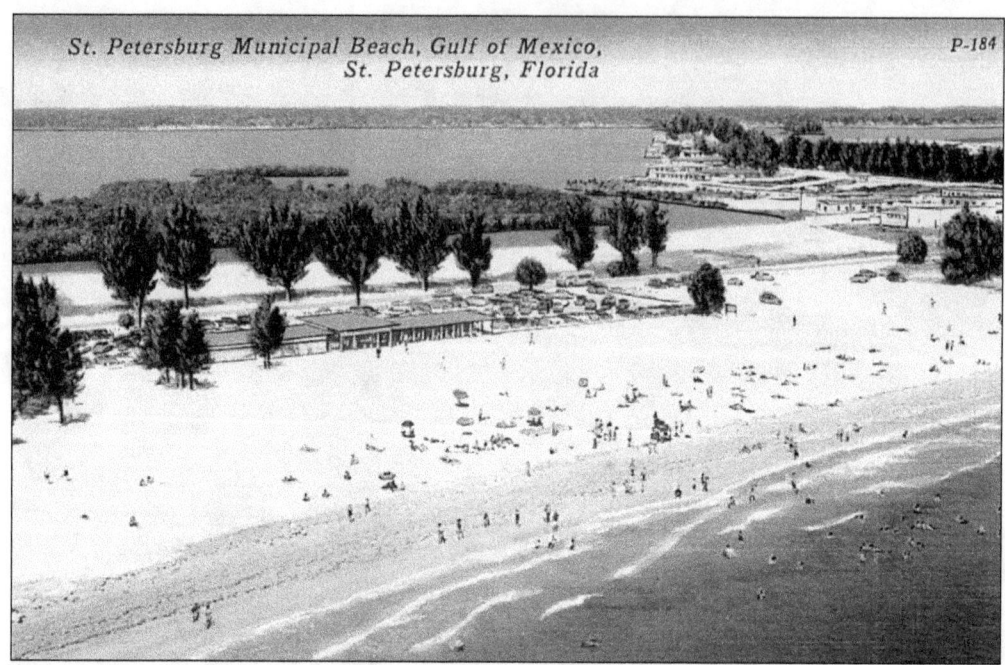

St. Petersburg Municipal Beach, Gulf of Mexico, St. Petersburg, Florida

P-184

The St. Petersburg Municipal Beach is the city of St. Petersburg's beach on the Gulf and is actually on Treasure Island. The pavilion today is little changed from this 1940s view.

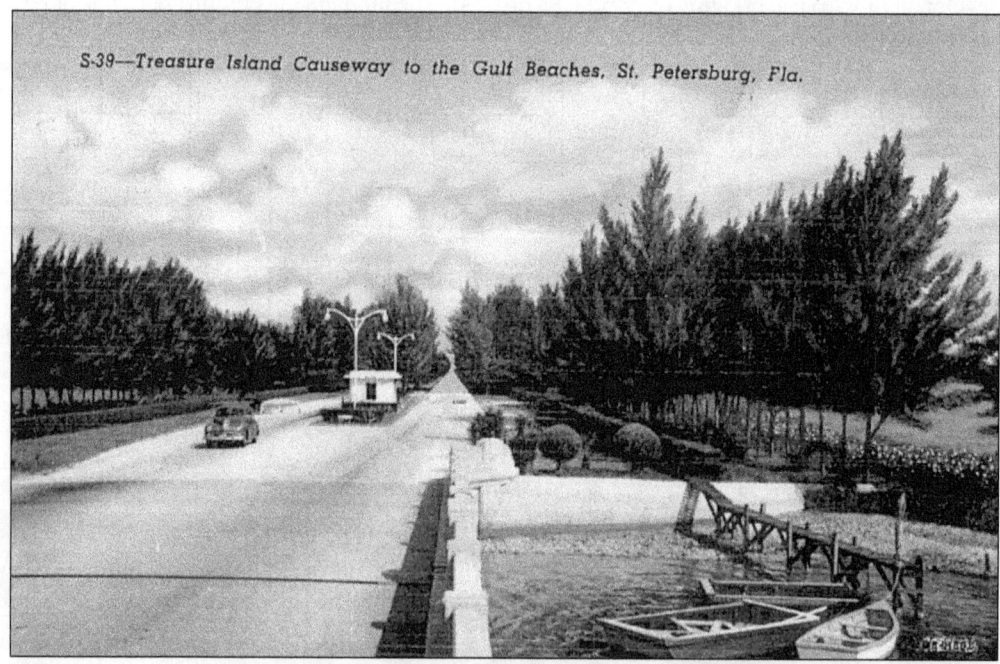

S-39—Treasure Island Causeway to the Gulf Beaches, St. Petersburg, Fla.

The coming of the Treasure Island Causeway in 1939 set the stage for the development boom in that area. The City of Treasure Island had been established a year before. The attractive span, lined with the now-taboo Australian Pines, gave motorists a straight shot to the island's wide sandy Gulf beaches, and an era of feverish motel construction began in the postwar period.

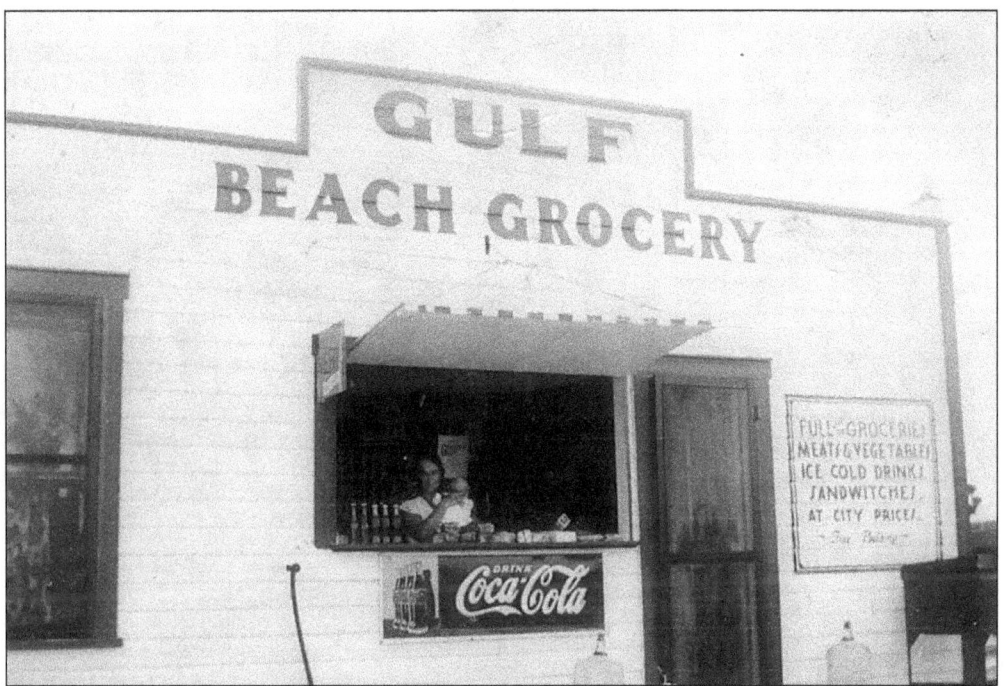

The Gulf Beach Grocery, a small, mom-and-pop outfit, predated the causeway and served the Treasure Island community with basic needs during the 1930s and 1940s. Note the spelling of "sandwitches."

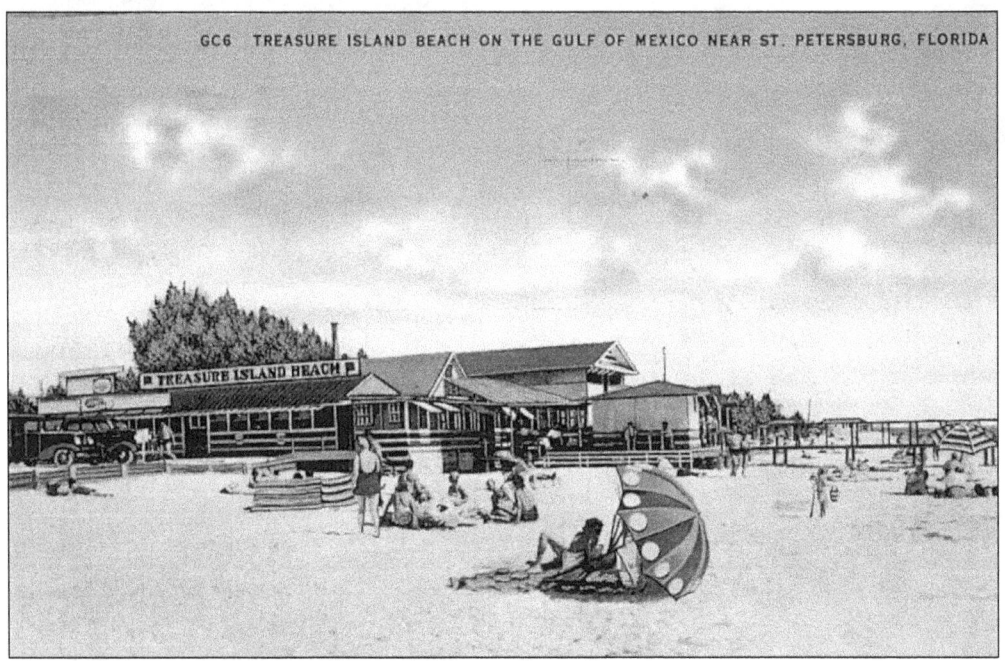

This mid-1940s view shows Treasure Island Beach before the postwar development push. The wooden pavilion had been an institution since the 1920s.

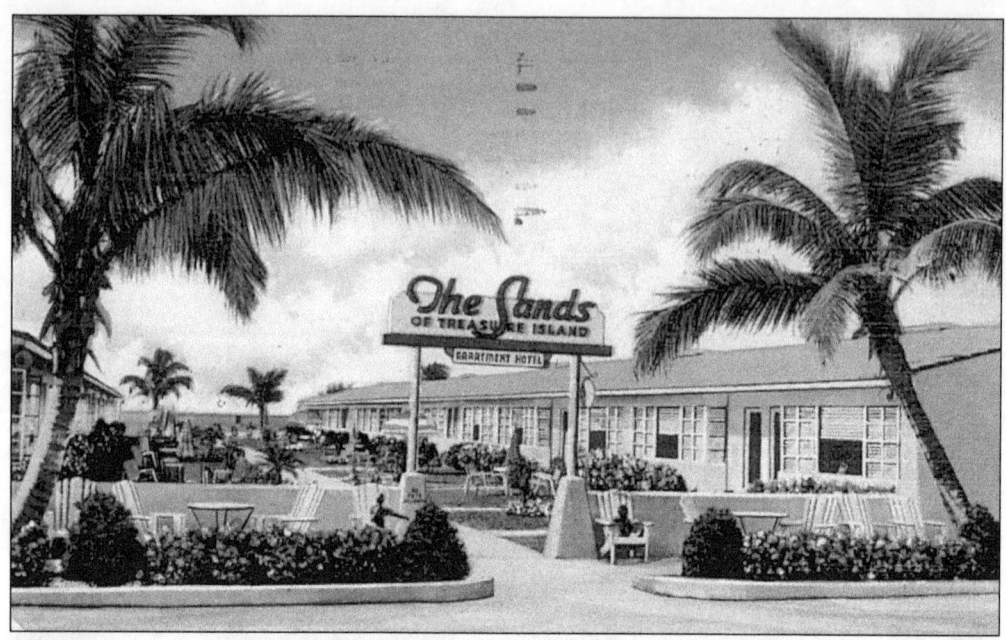

The construction of the Sands in 1948 followed shortly by the Surf ushered in the motel boom that transformed Treasure Island in the early 1950s into one of Florida's hottest vacation destinations. Both the Sands (above) at 11800 Gulf Boulevard, and the Surf (below) at 11040 Gulf Boulevard, are still welcoming guests today.

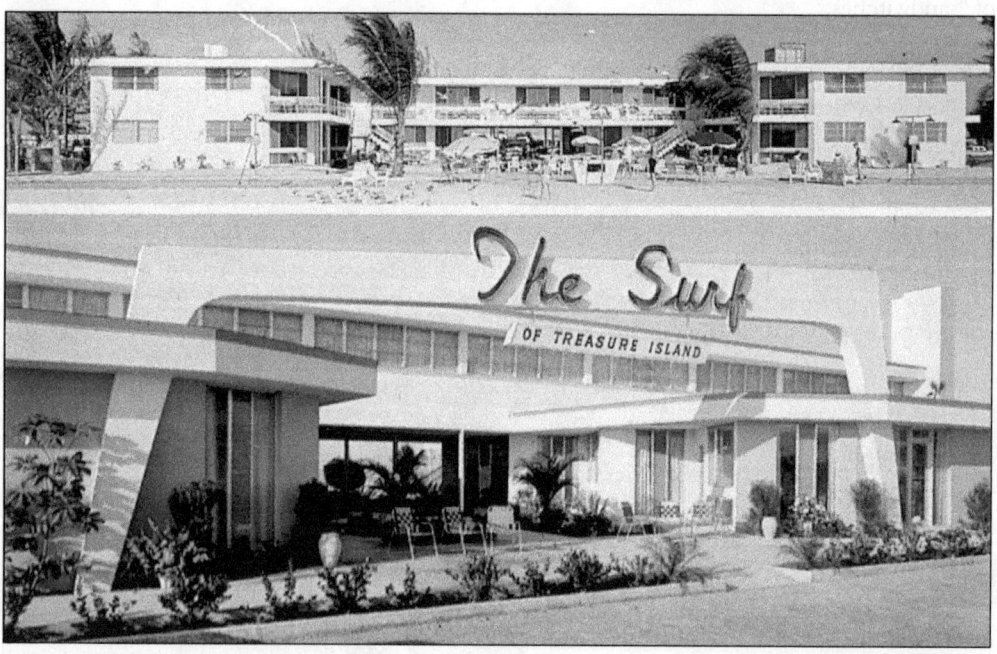

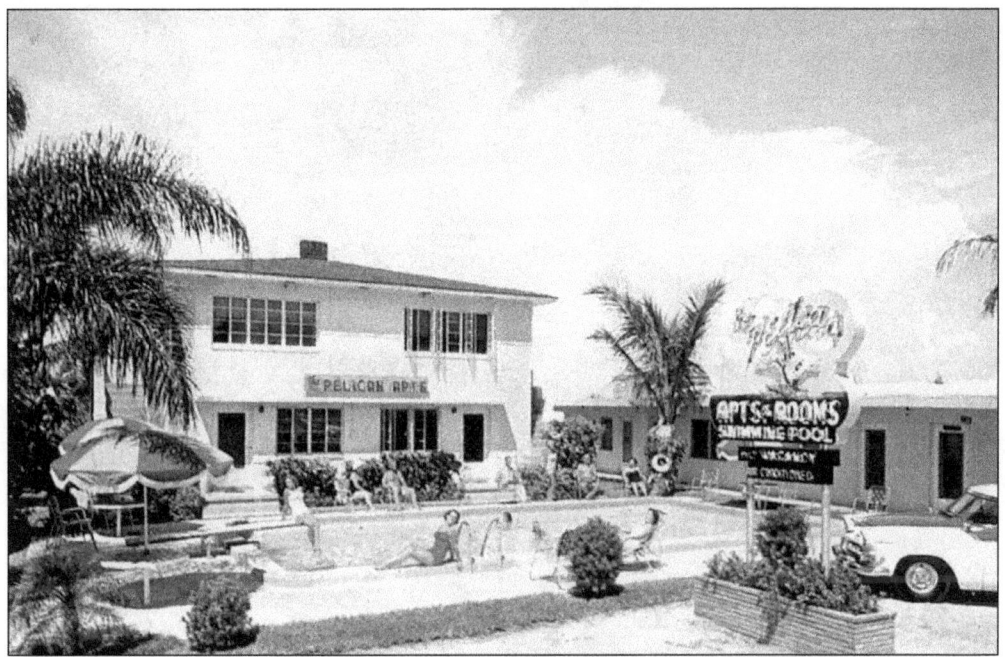

A bright neon sign and large swimming pool beckoned 1950s travelers to the Pelican (today's Roadside Inn), across the street from the beach on Treasure Island.

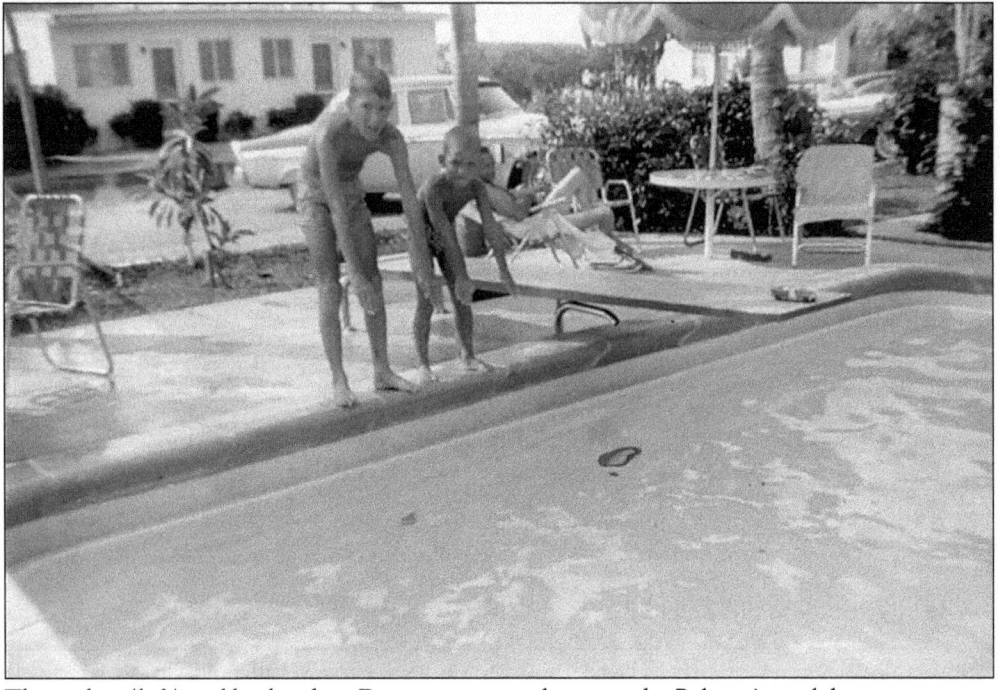

The author (left) and his brother, Dave, prepare to dive into the Pelican's pool during a summer vacation in 1957.

105

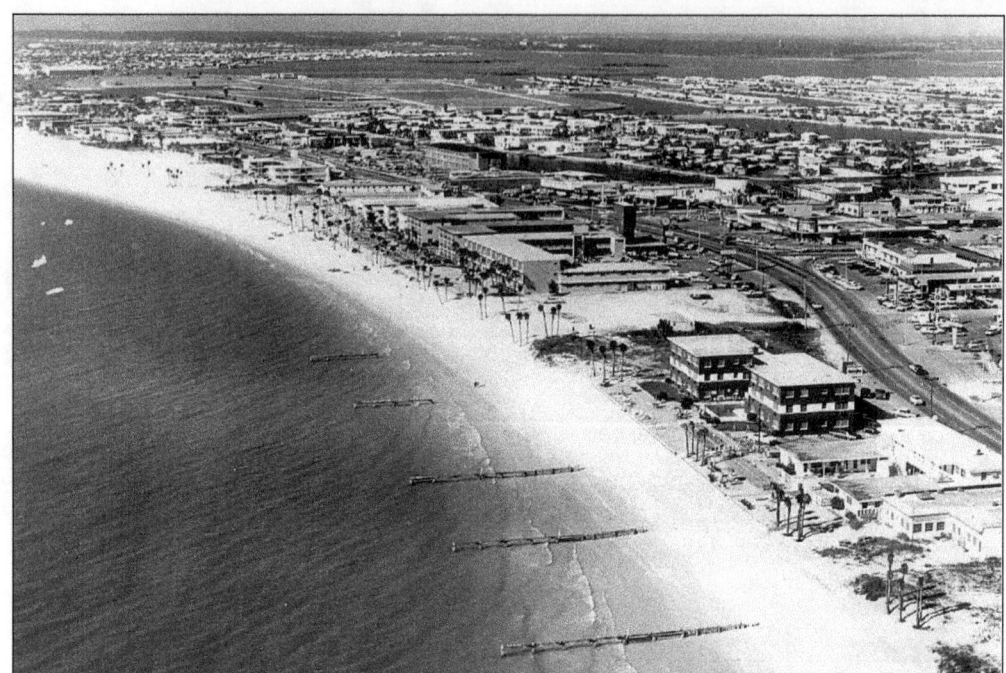

Treasure Island, seen here in a 1950s aerial along Gulf Boulevard near 107th Street (Treasure Island Causeway), emerged from a sleepy hamlet with a few beach pavilions to a booming beach resort of modern, sprawling motels and beach services.

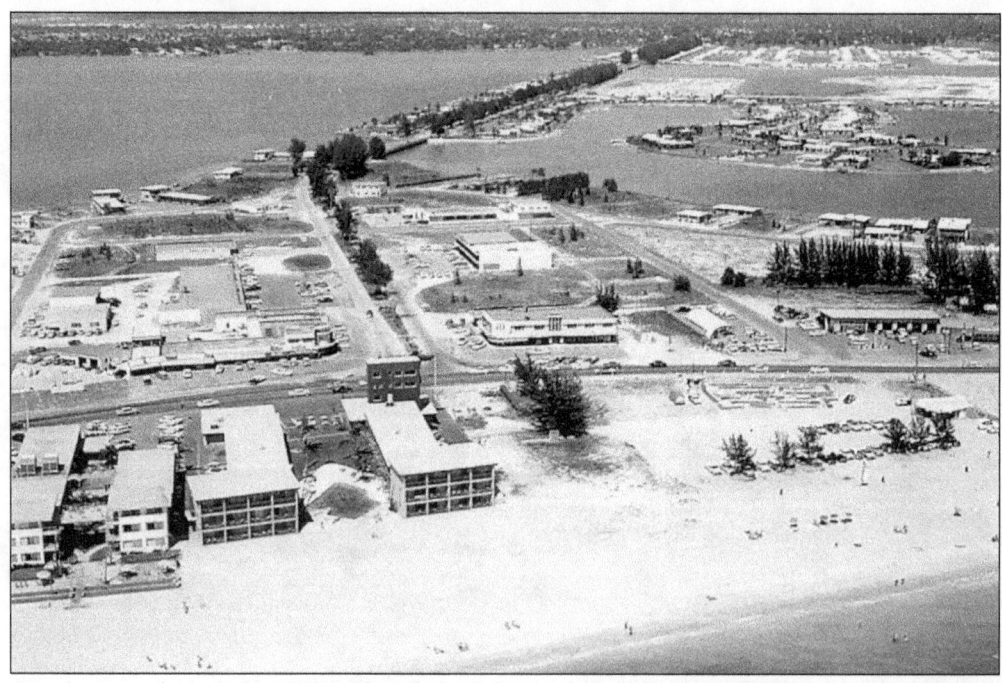

Another aerial view shows the Thunderbird Motel, which today still holds its commanding position at the busy causeway intersection. Vacant land, even on the beachfront, was plentiful in downtown Treasure Island as this photograph taken in the 1950s shows.

These 1950 beauties sport one-piece backless bathing suits, another style reflecting a more adventurous look popular in the years following World War II.

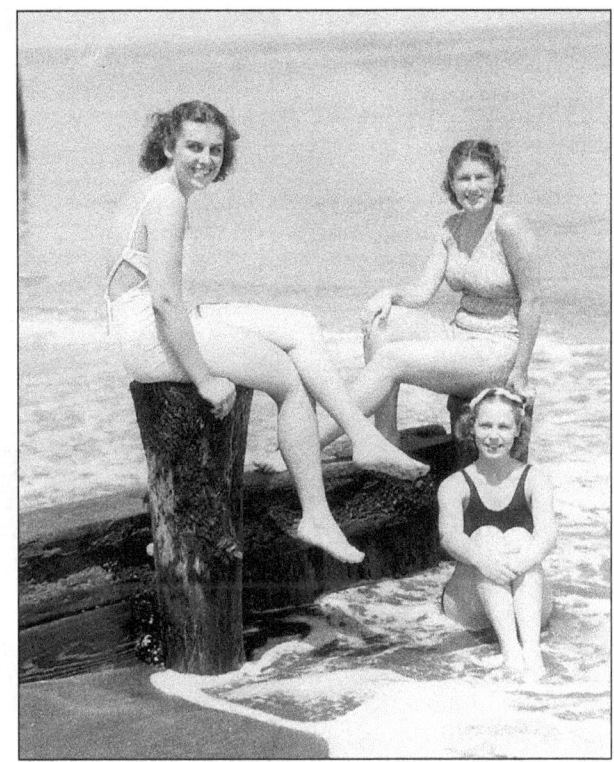

The John's Pass Bridge, connecting Treasure Island with Madeira Beach, shows the impact of the post-war boom, as newer pursuits such as scuba diving vie for space with perennially popular deep-sea fishing.

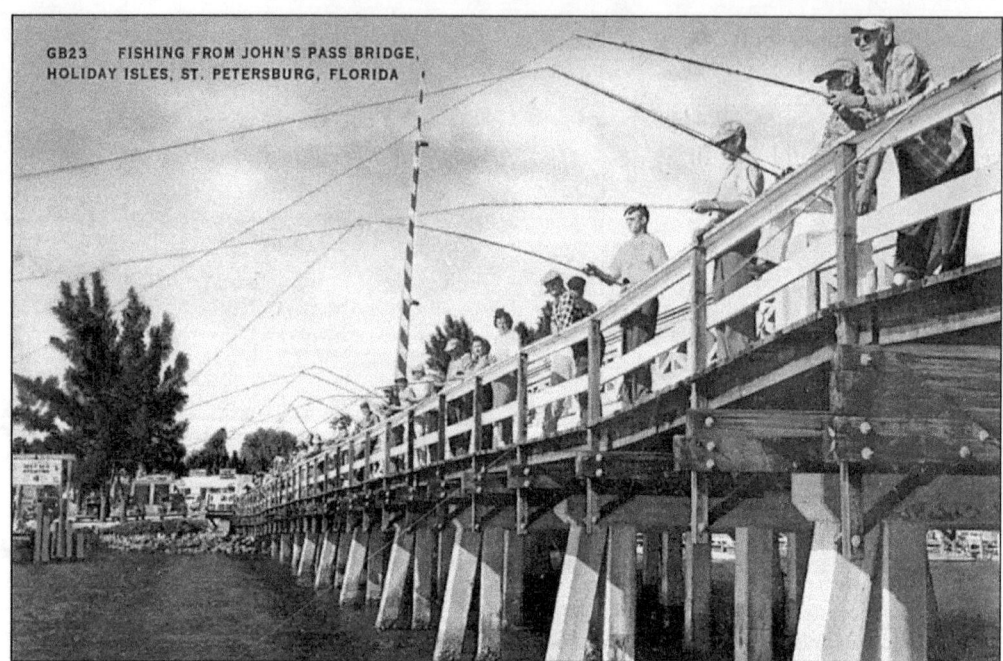

Long known as "the place where the fish are," the John's Pass Bridge often attracted wall-to-wall fishermen eager to snag the red snapper, flounder, mullet, and other delicacies that swam in the channel waters.

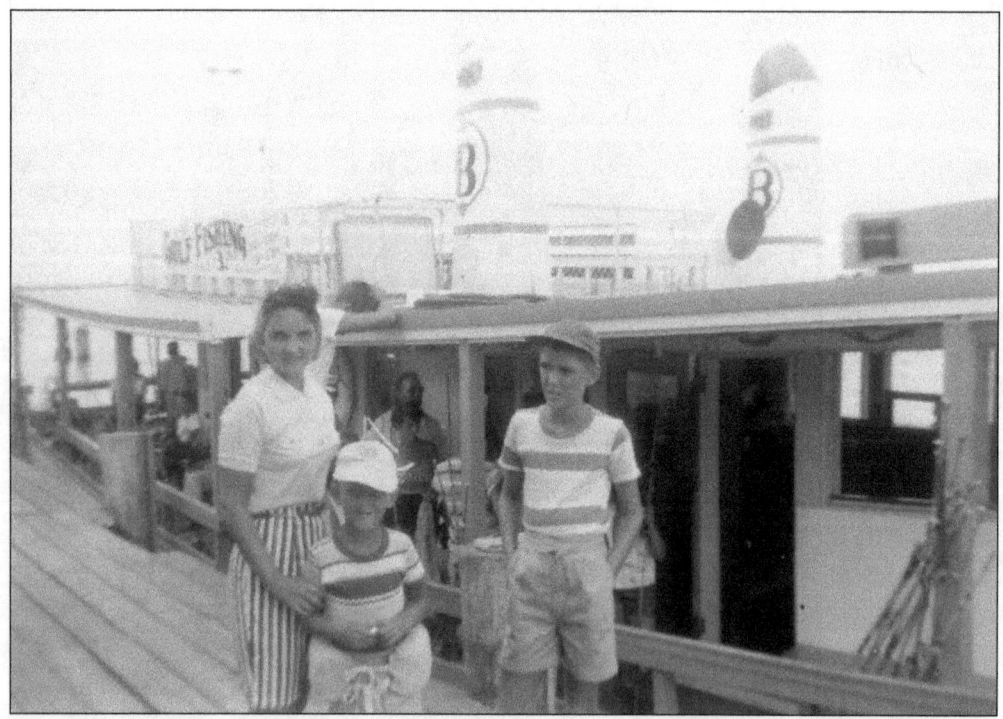

The author and his family (Dad is taking the picture) prepare for a day of fishing in the Gulf during a vacation in Treasure Island in 1957.

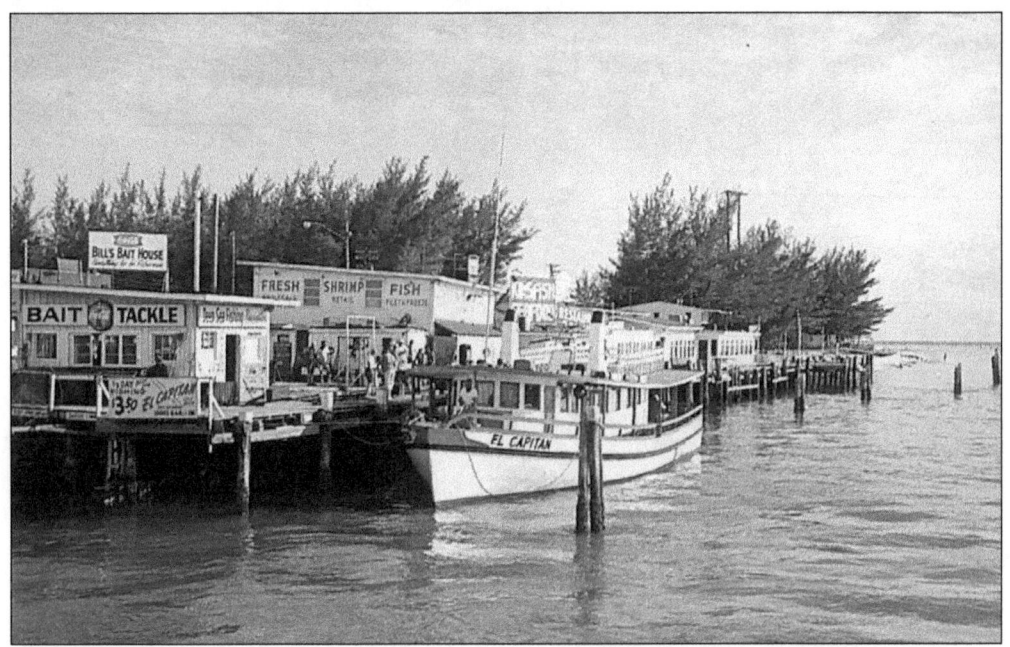

Deep sea fishing boats, such as *El Capitan* shown here, commonly docked at John's Pass during the 1950s. *El Capitan* and the *Kingfisher* brought in fresh fish to the Kingfish Seafood Restaurant (which can be seen between the trees in the background). The restaurant was located right on the bridge approach in its early years.

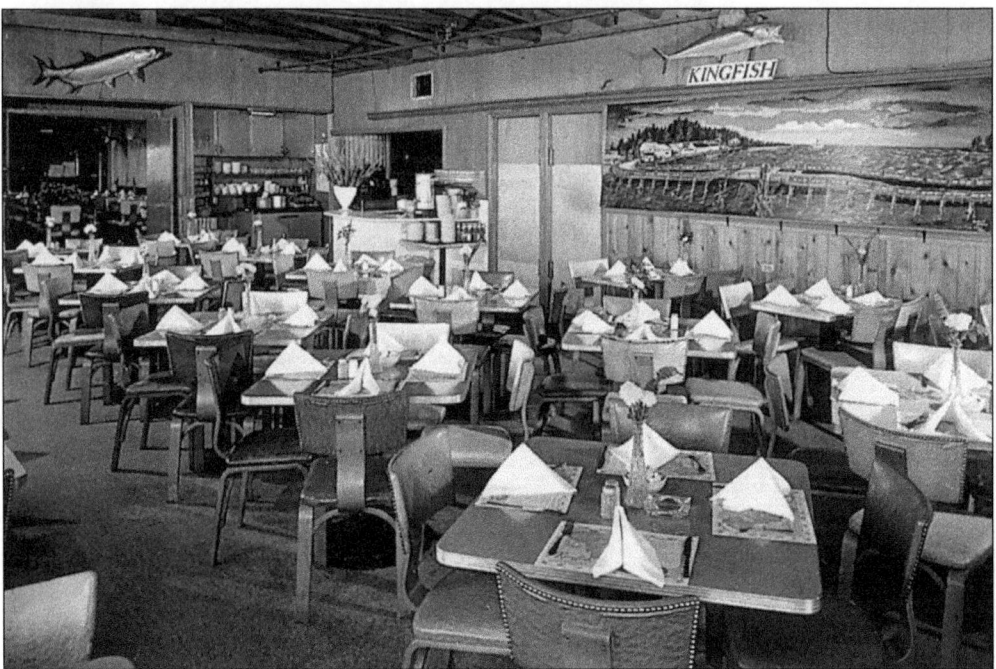

Updated versions of the ever-popular shore dinners were available at the Kingfish Restaurant. The restaurant, now reopened on Gulf Boulevard in Madeira Beach and still owned by the Rice family, continues to do a brisk business with both new and longtime customers.

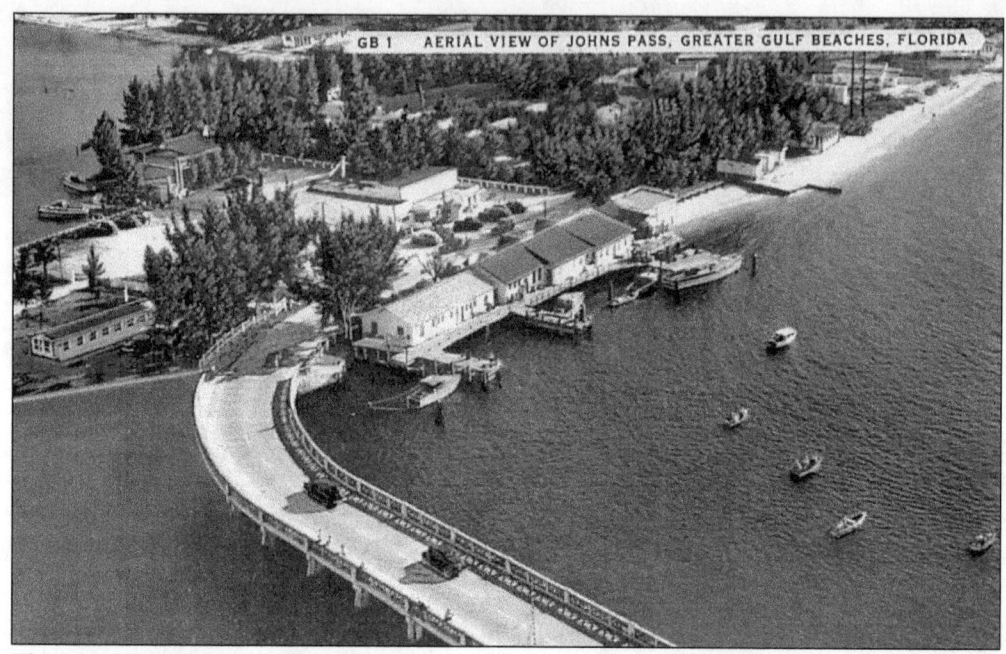

This aerial shot shows the businesses clustered along the Treasure Island entry of the bridge.

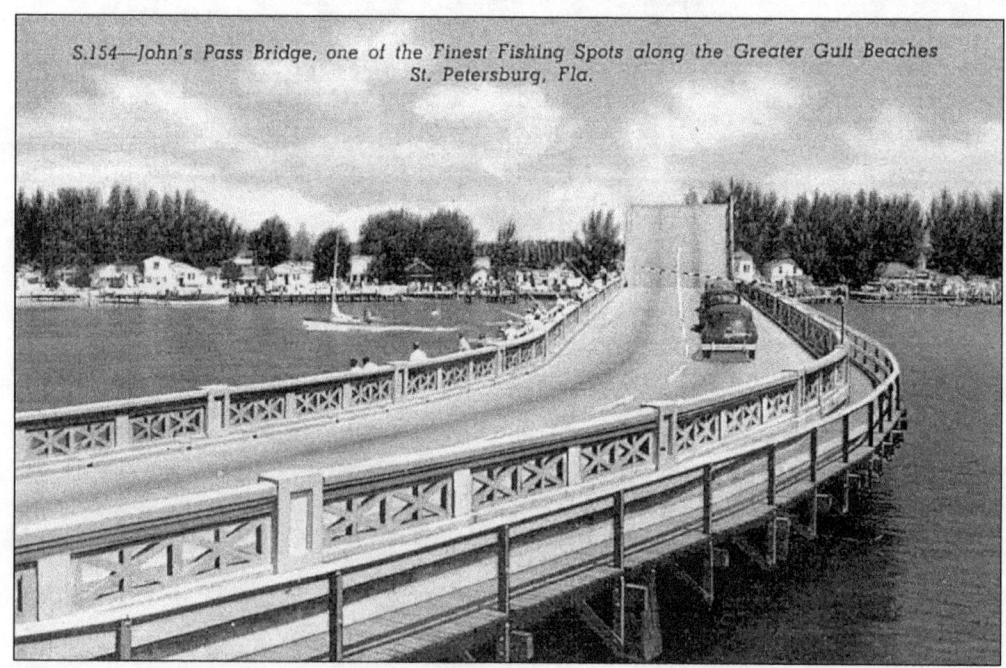

"Bridge up" was a common sight, in the 1950s as now, allowing boaters to head to and from the Gulf for fishing and pleasure runs.

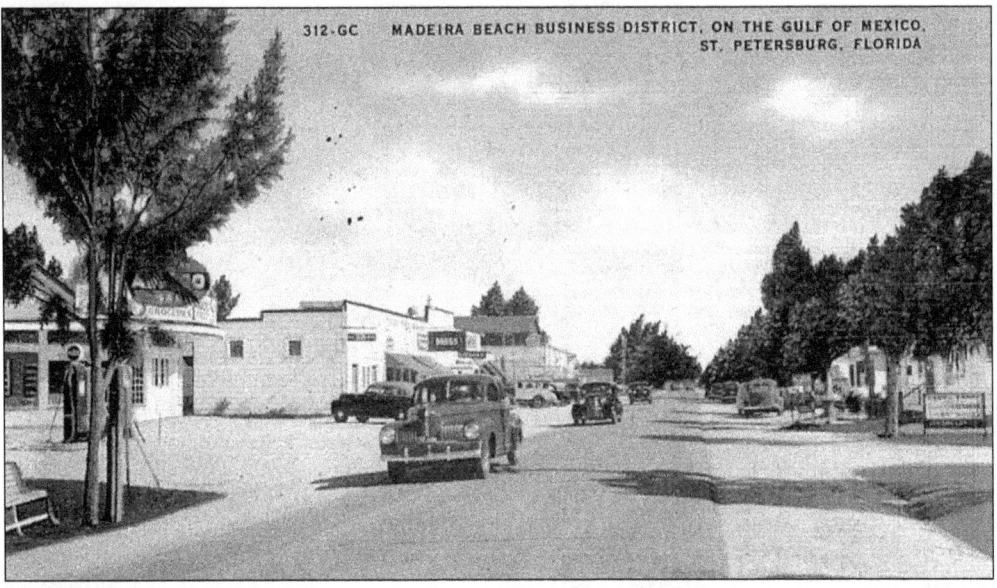

This 1949 view of the area surrounding John's Pass shows post-war development gobbling up remaining green areas in Madeira Beach.

312-GC MADEIRA BEACH BUSINESS DISTRICT, ON THE GULF OF MEXICO, ST. PETERSBURG, FLORIDA

Though Madeira Beach began to grow in the 1920s and 1930s with the building of the Welch Causeway to the mainland, the post-war tourist boom that hit Treasure Island spread across John's Pass, and Madeira Beach was booming when it was incorporated as a town in 1947.

Luxuriously shaded by Australian Pines and cooled by Gulf breezes, Madeira Beach—promoted as one of the "Holiday Isles"—became a popular Suncoast tourist destination.

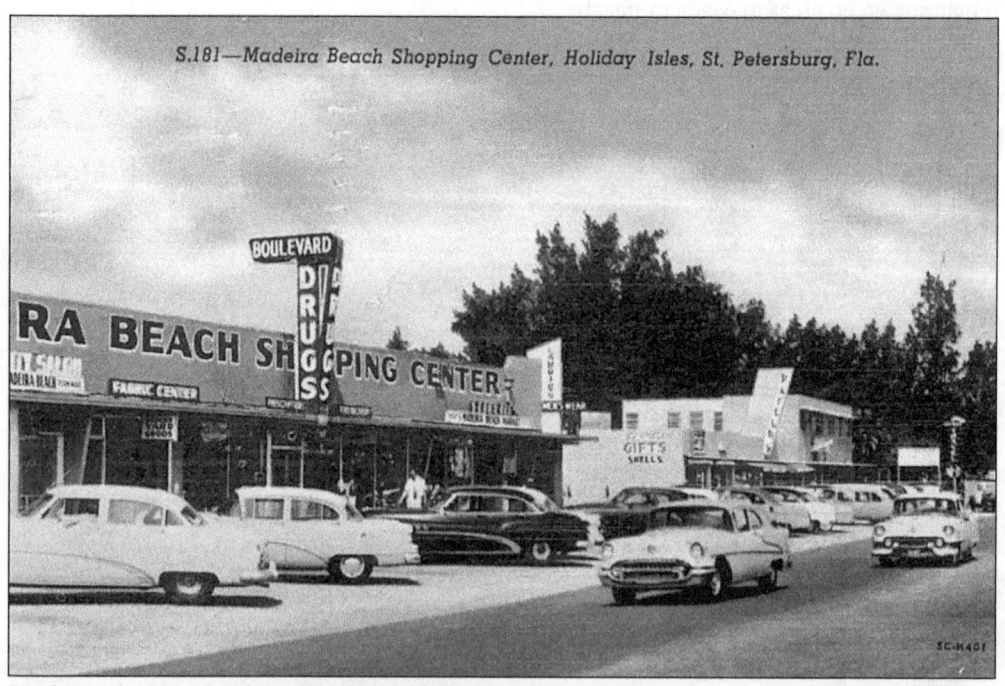

By the mid-1950s, Madeira Beach could claim a thriving downtown along Gulf Boulevard, its shops catering to tourists as well as the large resident population.

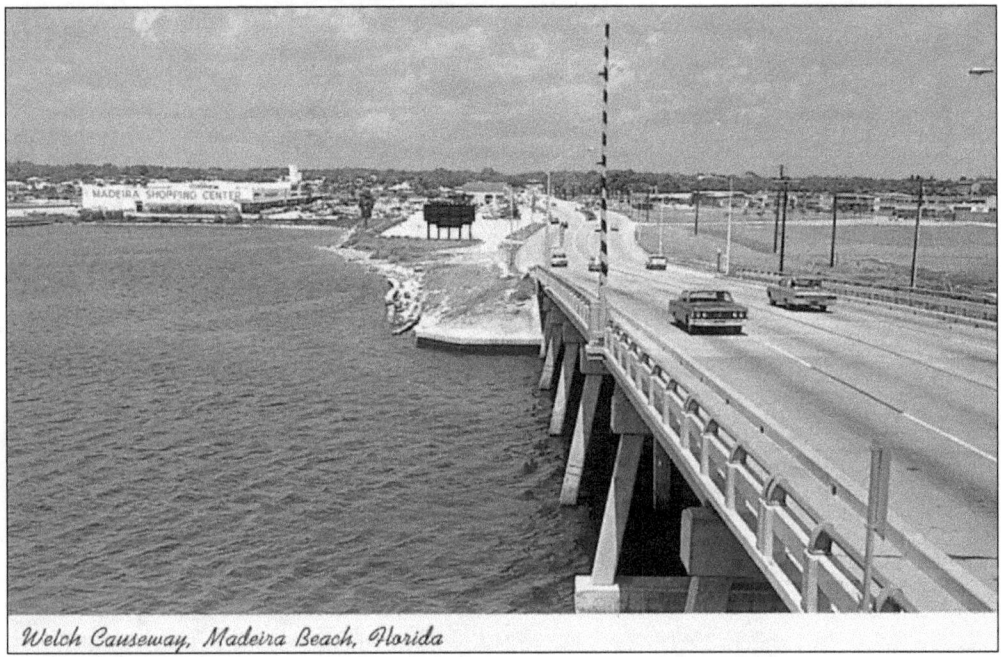

Welch Causeway, Madeira Beach, Florida

An updated Welch Causeway provided a dramatic entry to Madeira Beach from the mainland. This scene today includes a McDonald's.

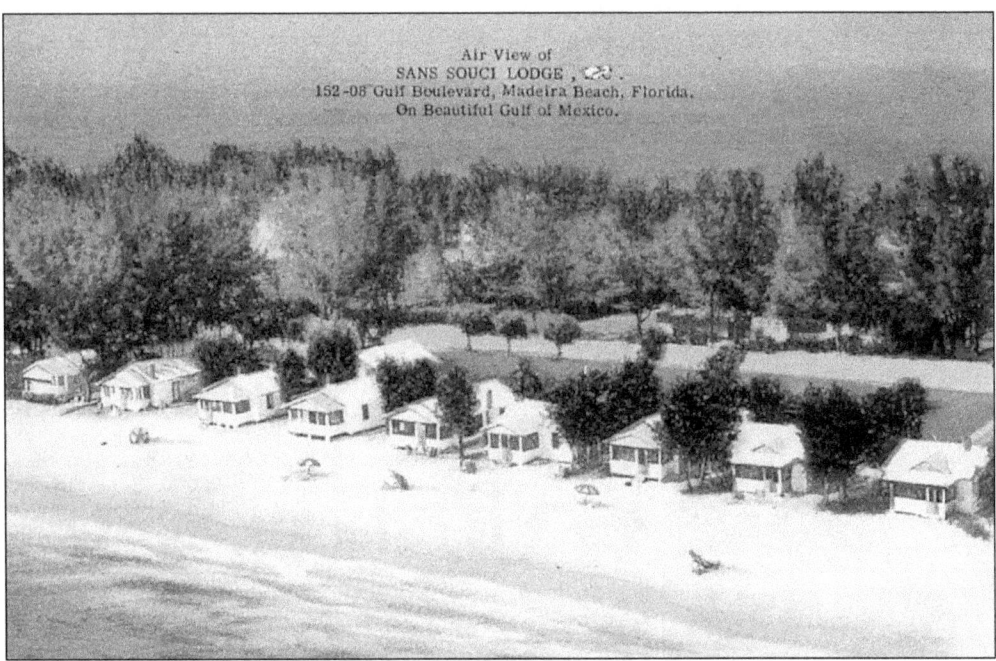

Air View of
SANS SOUCI LODGE,
152-08 Gulf Boulevard, Madeira Beach, Florida.
On Beautiful Gulf of Mexico.

Madeira's beachfront in the 1950s featured more of the homey cottage-style and apartment-motel developments than the large motels favored by neighboring Treasure Island. The Sans Souci Lodge at 15208 Gulf Blvd. featured "four and five room cottages and complete electric kitchens."

113

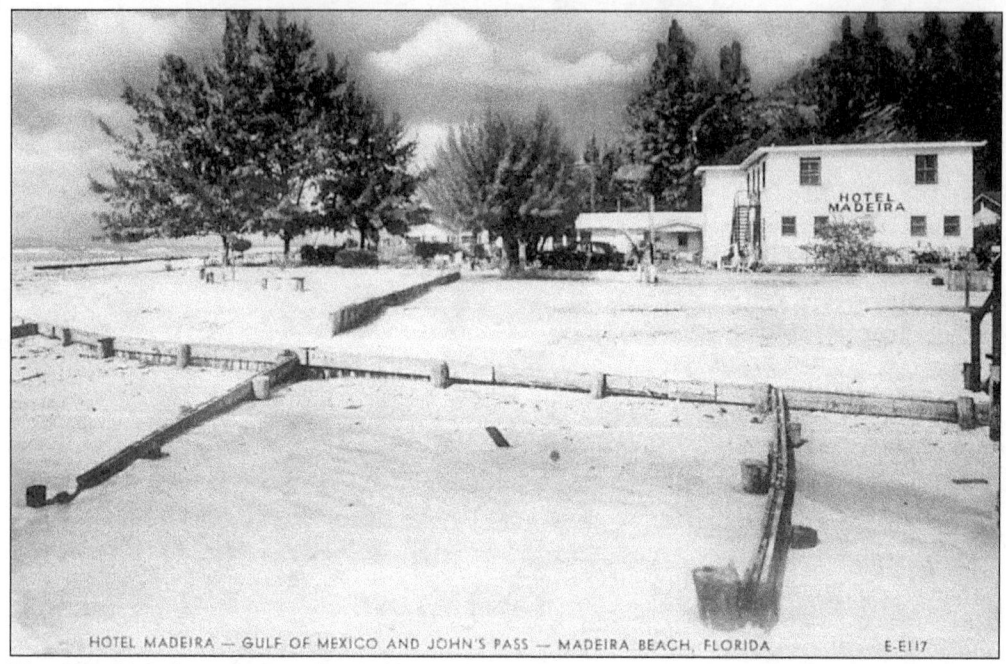

HOTEL MADEIRA — GULF OF MEXICO AND JOHN'S PASS — MADEIRA BEACH, FLORIDA E-E117

The Hotel Madeira was on the Gulf near John's Pass. Note the use of pilings to slow beach erosion dates to this era.

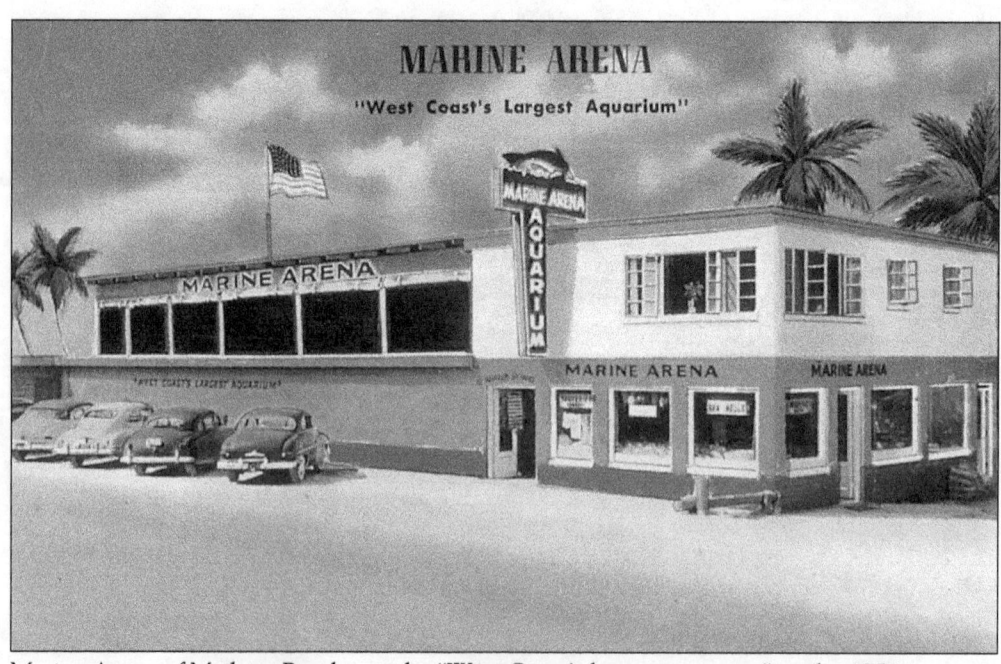

Marine Arena of Madeira Beach was the "West Coast's largest aquarium" in the 1950s.

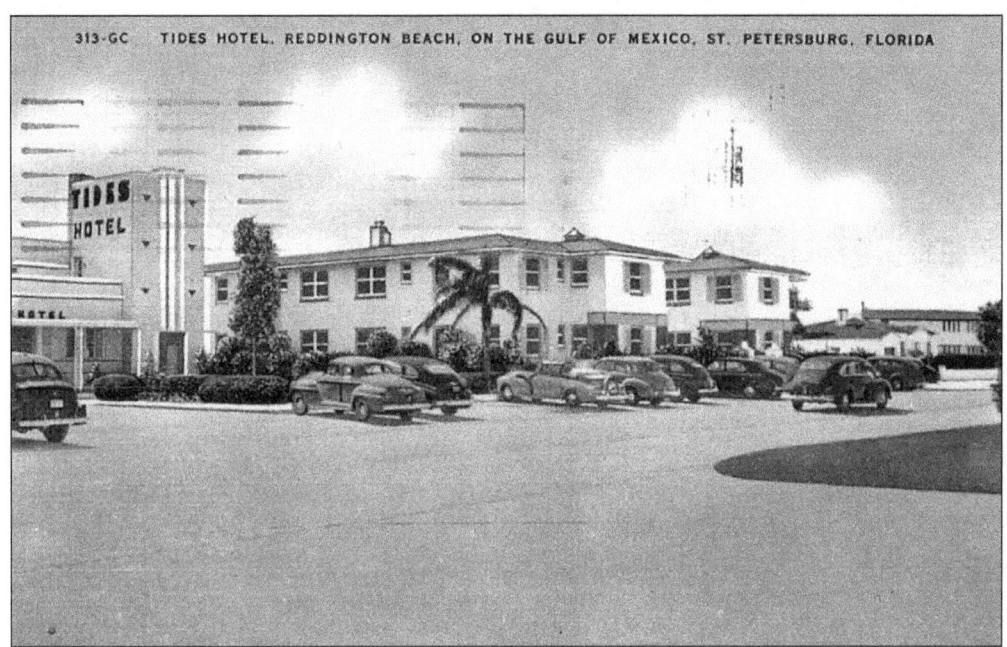

313-GC TIDES HOTEL, REDDINGTON BEACH, ON THE GULF OF MEXICO, ST. PETERSBURG, FLORIDA

Redington Beach was named after Charles Redington, who built the first home there in 1935. The Tides Resort came in 1939 and helped spur tourist interest in the area.

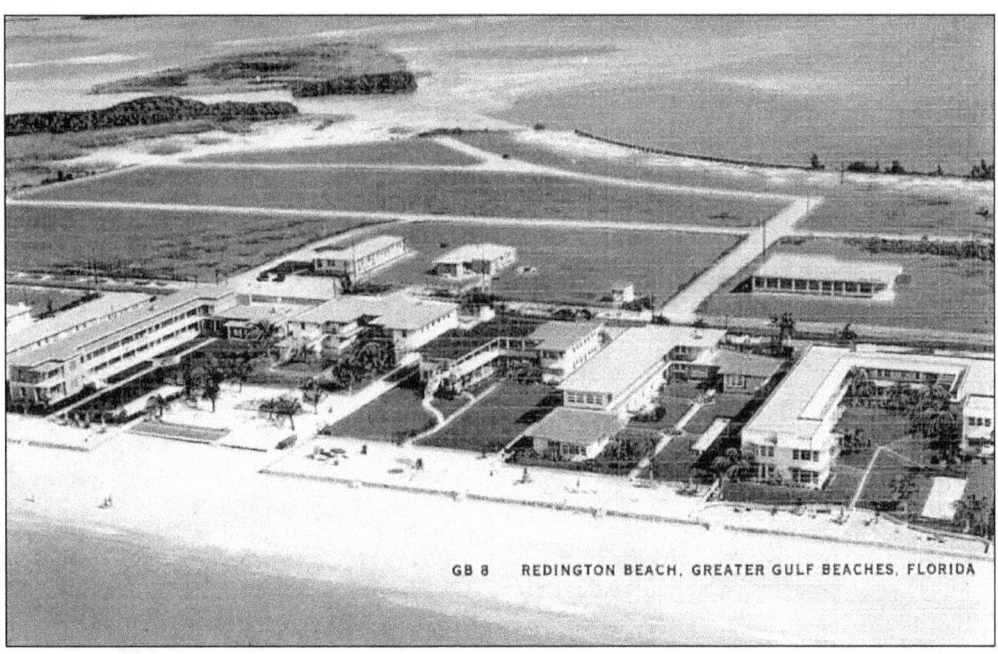

GB 8 REDINGTON BEACH, GREATER GULF BEACHES, FLORIDA

The town of Redington Beach (now divided into the Redingtons) was established in 1947 and by the 1950s beachfront property began to fill in with motels. This aerial view shows the large amount of land still vacant on the bay side of Gulf Boulevard.

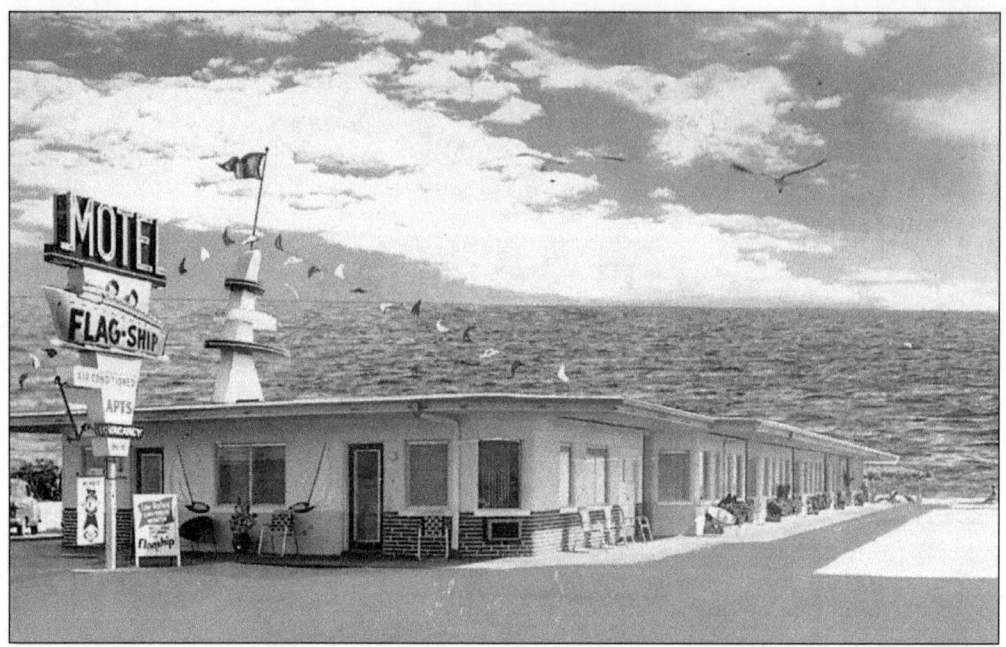

The Flagship Motel at 17040 Gulf Boulevard in Redington Beach typifies the 1950s style with its streamlined look and jalousie windows. It was built perpendicular to the Gulf to allow views from all rooms. Larger motels had two stories and were often built around a green courtyard area.

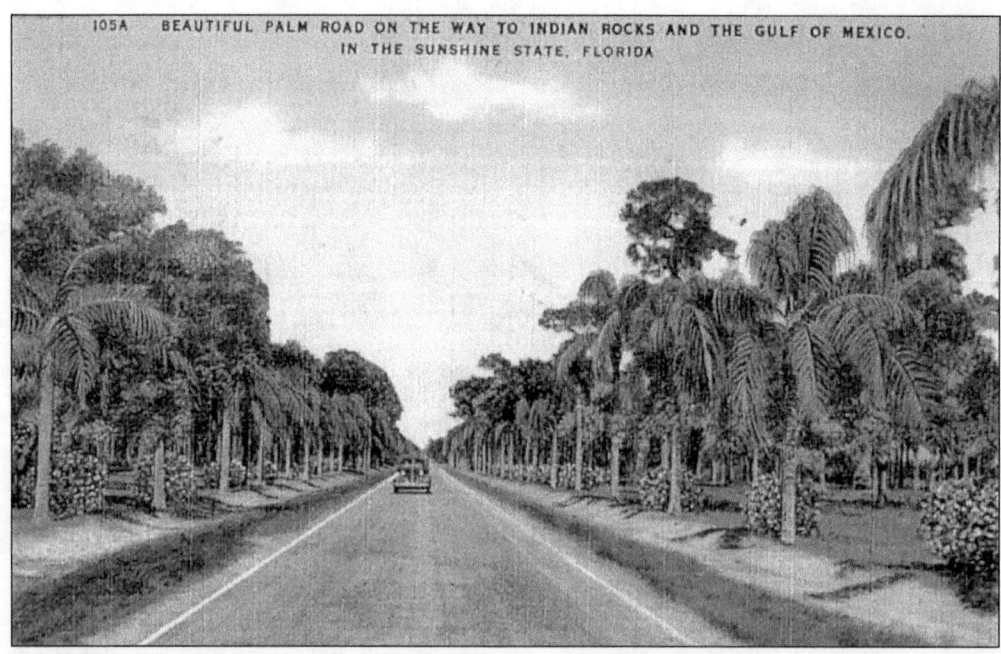

Improved roads and beautiful scenery along the way lured tourists to Indian Rocks and other Gulf Beach locations.

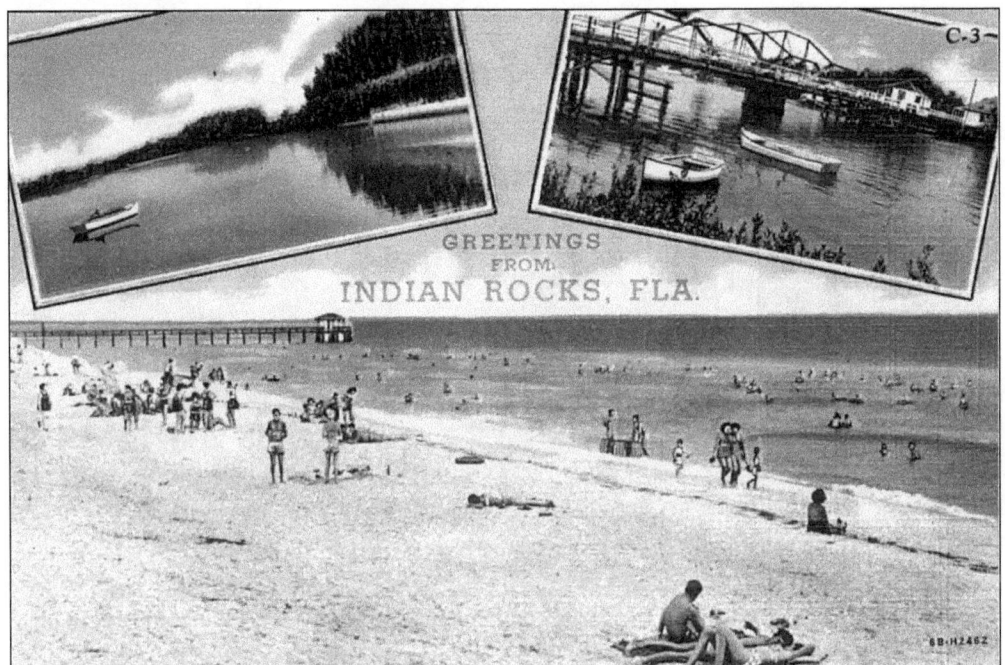

The older town of Indian Rocks had little available land by the time the motel boom hit in the 1950s. As a result, Indian Rocks Beach maintained much of its original cottage character until condominium construction began in the 1970s. Even today, the city probably retains more of its original look than any other location on the beach strip with the exception of Pass-a-Grille.

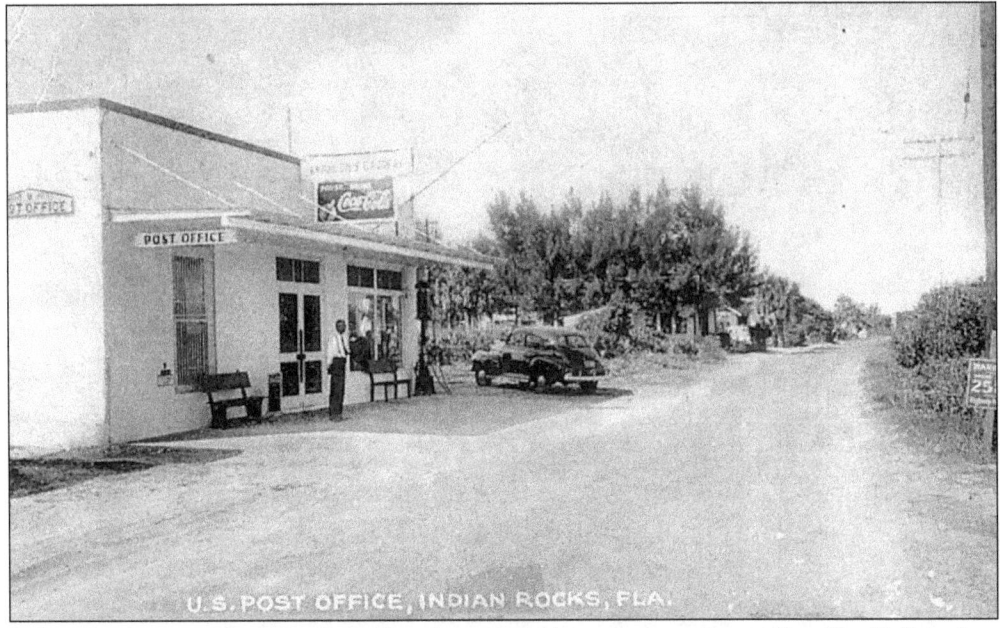

Indian Rocks postmaster Frank C. Brandon, son of longtime postmaster Camillus B. Brandon, operated a grocery along with the post office in the Hamlin Building on the east end of the bridge from 1941 until the post office moved to its present location on Fourth Avenue in 1960. The city officially added "Beach" to its name and became Indian Rocks Beach in 1949.

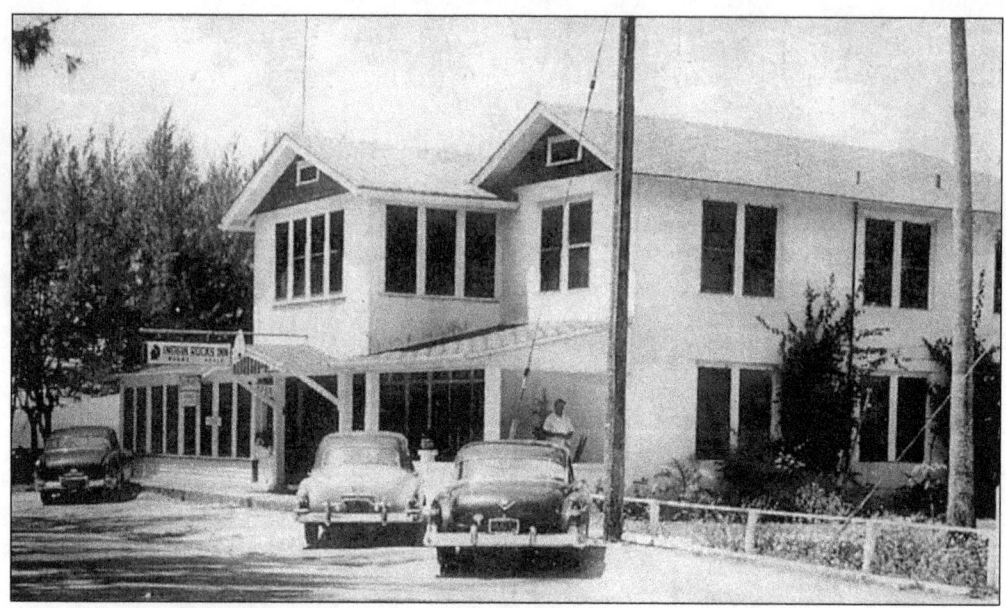

The inn was renovated and continued to accommodate guests during the 1940s and 1950s until the vintage structure was destroyed by fire in 1963.

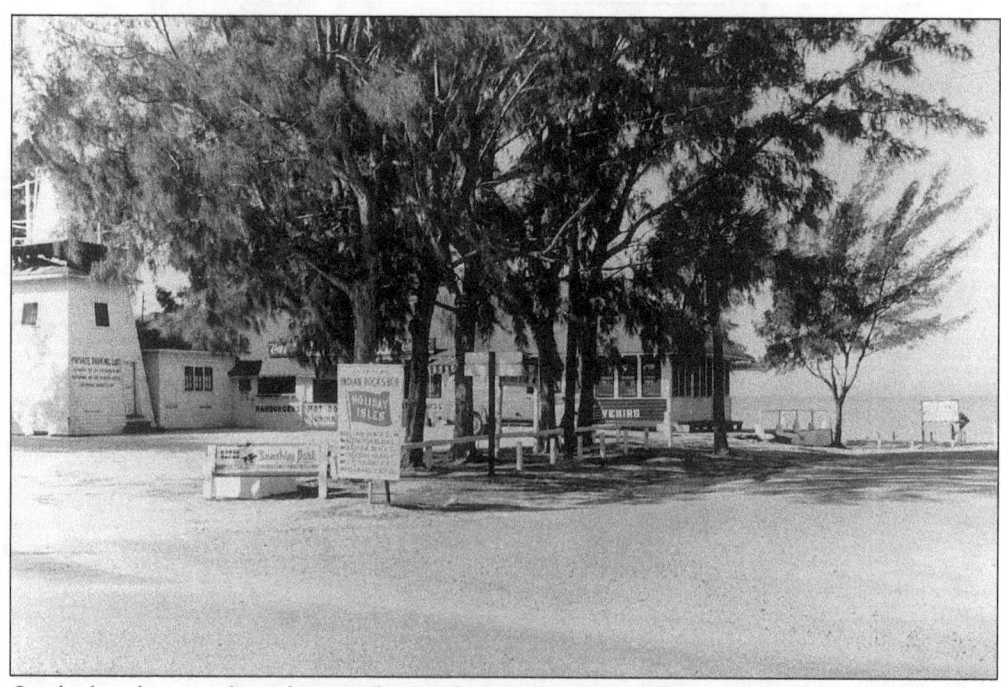

On the beach across from the inn, the Pavilion was a community institution, where beachgoers could stop for snacks and sundries, from the early 1900s until it burned in 1968.

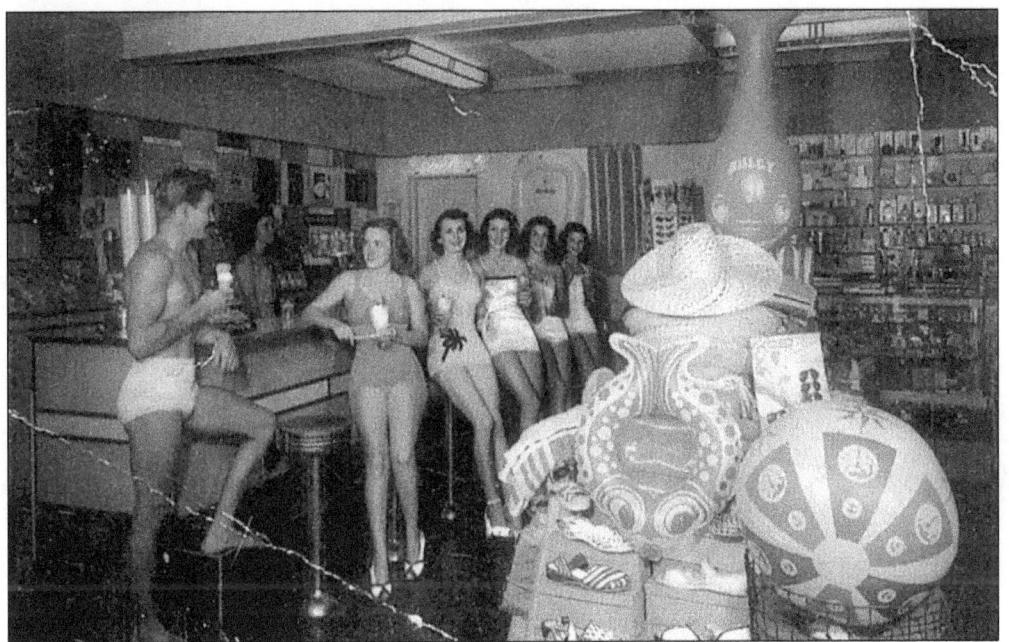

Moodies Drug Sundries featured a soda fountain and touted itself as "your vacation headquarters" in Indian Rocks Beach.

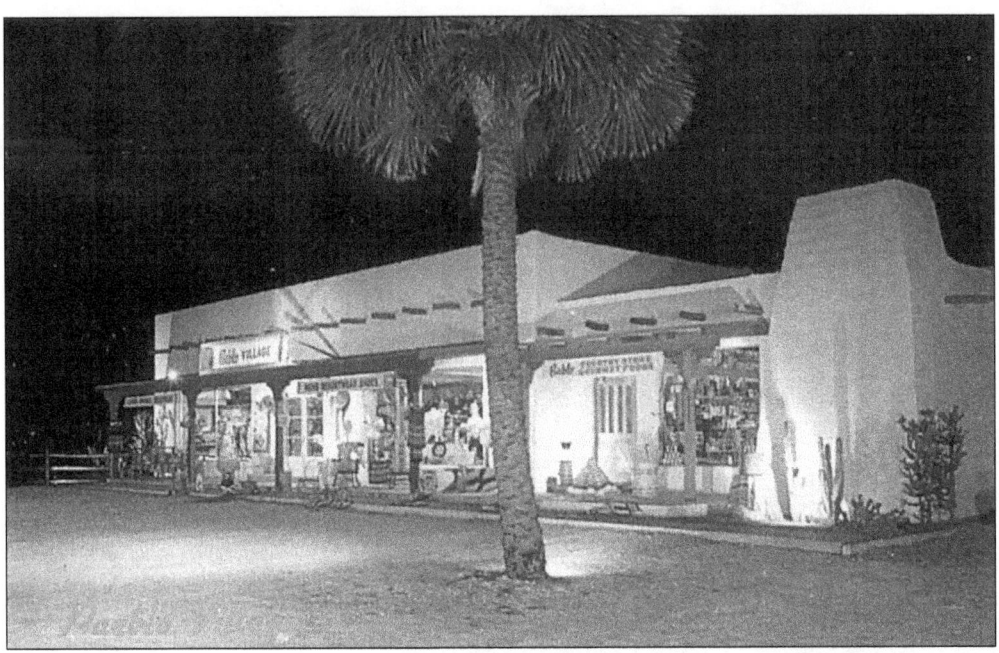

Pueblo Village on Gulf Boulevard at Fifteenth Avenue offered an "Old West" atmosphere and carried everything from apparel to barbeque under one roof. The landmark business, built by the McNally brothers in 1956, was enlarged in 1963 and operated until the early 1990s.

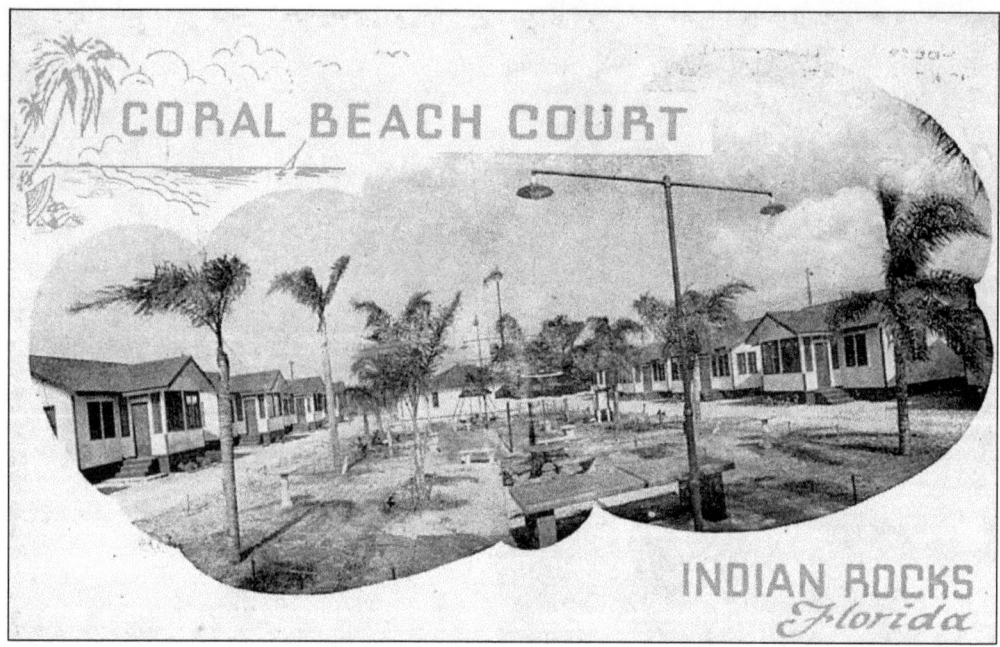

"Clean and simple" cottage developments such as Coral Beach Court were common along the Indian Rocks Beach waterfront in the postwar years. Attic fans and screened porches kept residents cool.

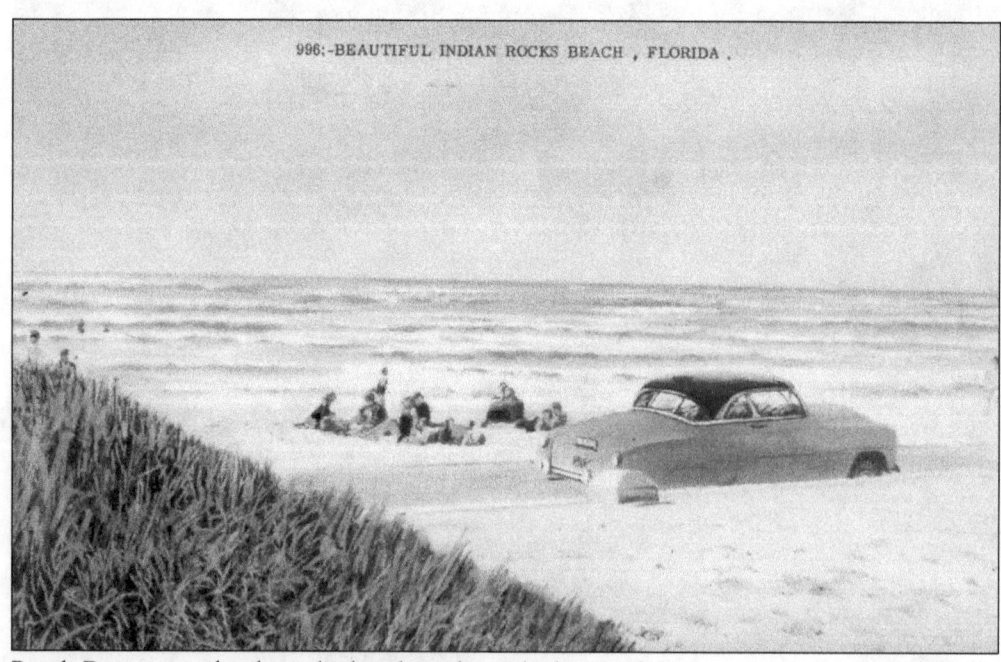

Beach Drive ran right along the beach in the early days, and these sunbathers at Indian Rocks Beach could hop from their car to the surf.

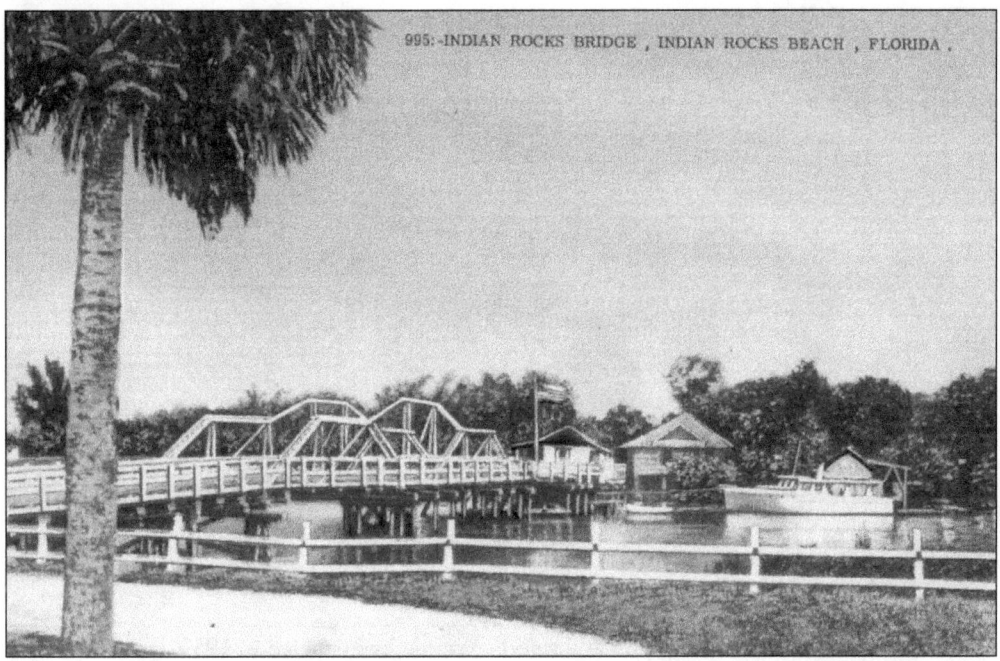

The rickety Indian Rocks Bridge across to the mainland at the Narrows continued to serve motorists and boaters through the 1940s and 1950s.

This aerial view shows both the old wooden bridge (foreground) and the new bridge built in 1958 (background) at Walsingham Road. Today a historical plaque marks the spot of the original bridge.

The Indian Rocks Beach fishing pier at Twelfth Avenue, constructed in 1959, was the longest in Florida. The popular attraction lasted only 26 years before succumbing to the winds of Hurricane Elena in 1985.

These cabanas on Belleair Beach were owned by the Belleview Biltmore Hotel across the bay.

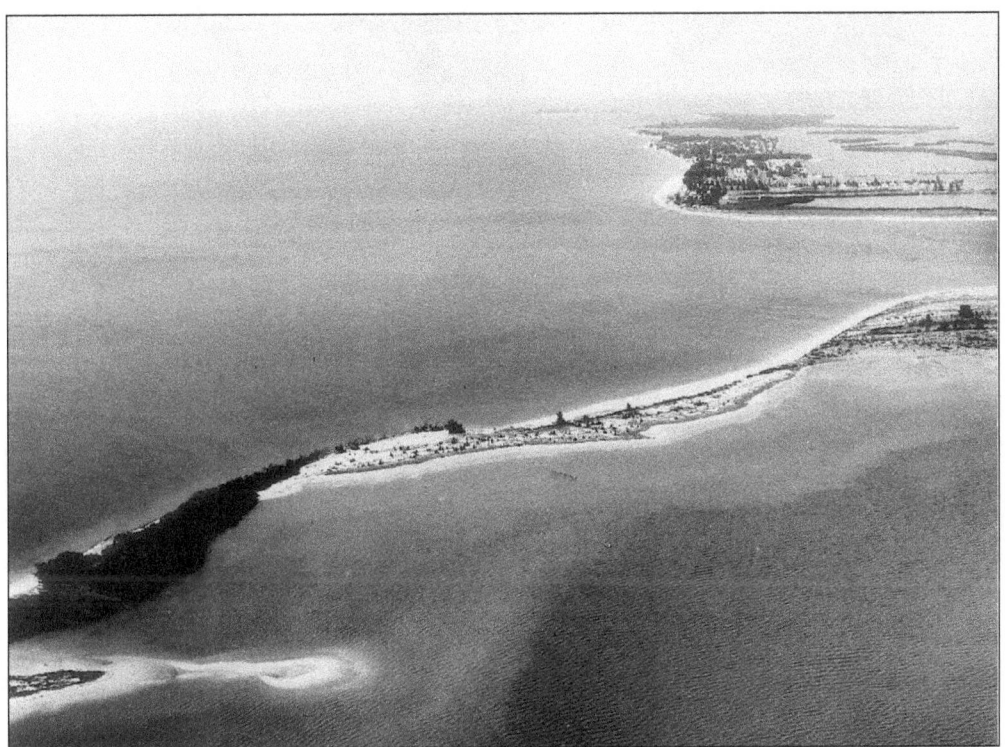

Sand Key in 1950 was truly a *sand* key.

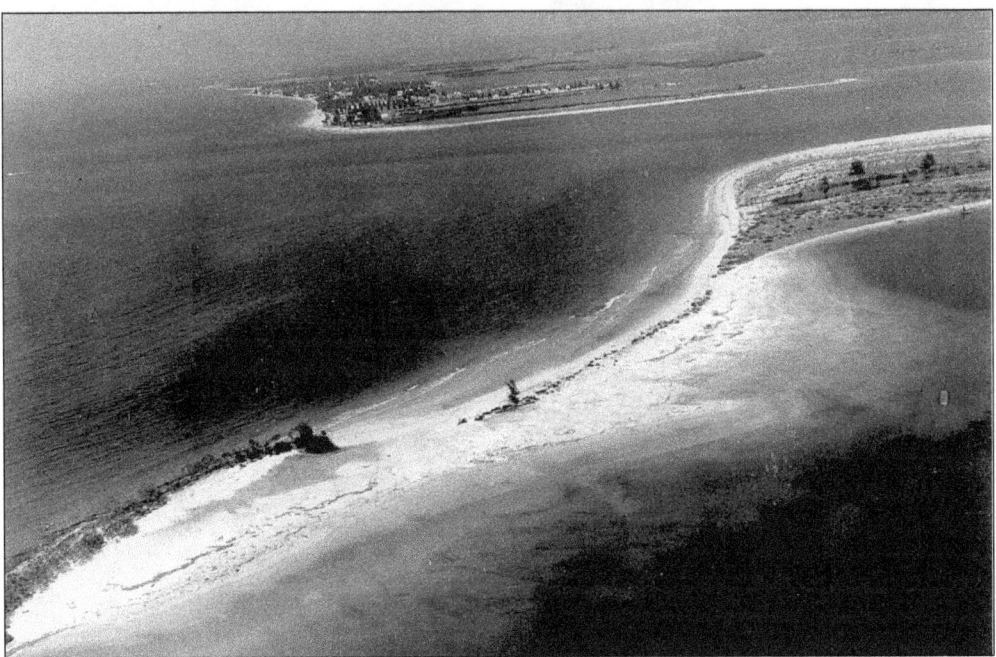

This 1950 view shows the north end of Sand Key, the area where Sheraton Sand Key, the Grande and Meridian Condominiums, and the Sand Key Shoppes (on the Bay side) are located today.

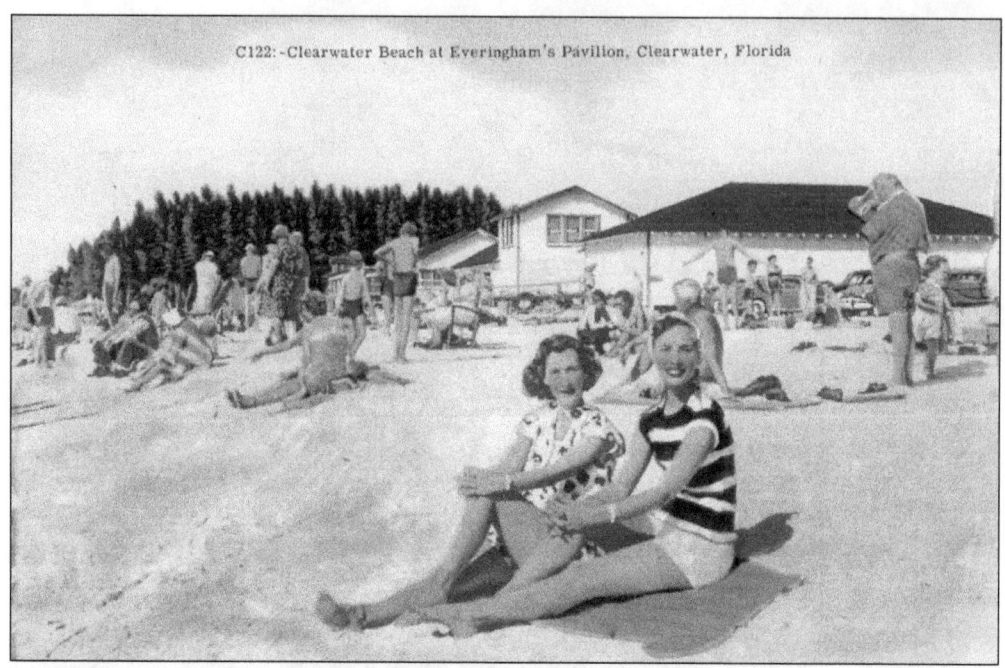

C122:-Clearwater Beach at Everingham's Pavilion, Clearwater, Florida

Evringham's Pavilion continued as a center of Clearwater Beach social life until it was torn down in 1950 to make way for the pier development.

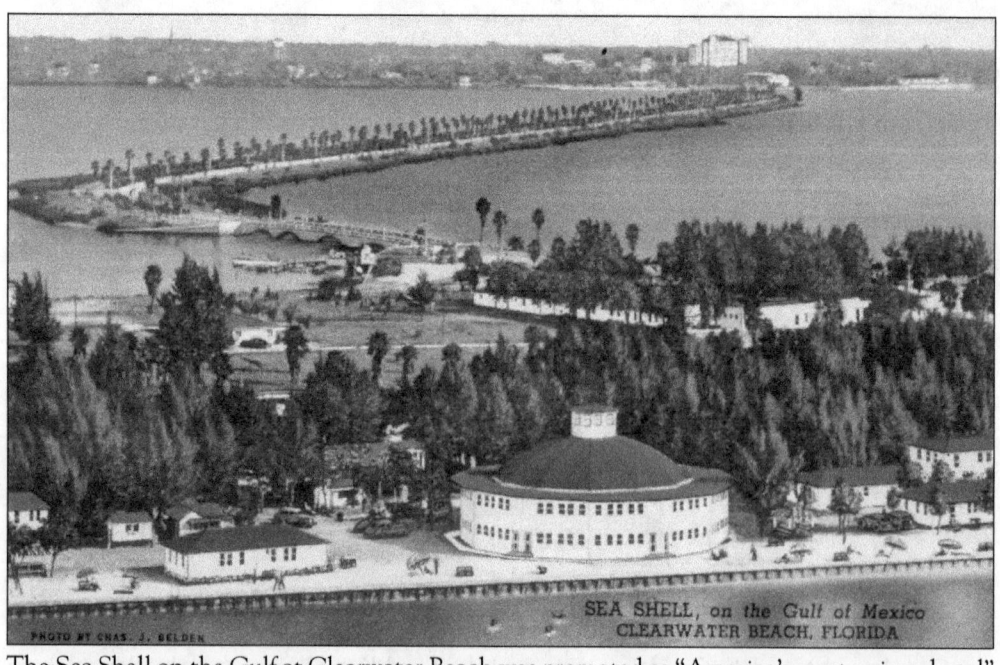

SEA SHELL, on the Gulf of Mexico
CLEARWATER BEACH, FLORIDA

The Sea Shell on the Gulf at Clearwater Beach was promoted as "America's most unique hotel" during the 1940s and 1950s. The causeway can be seen in the background.

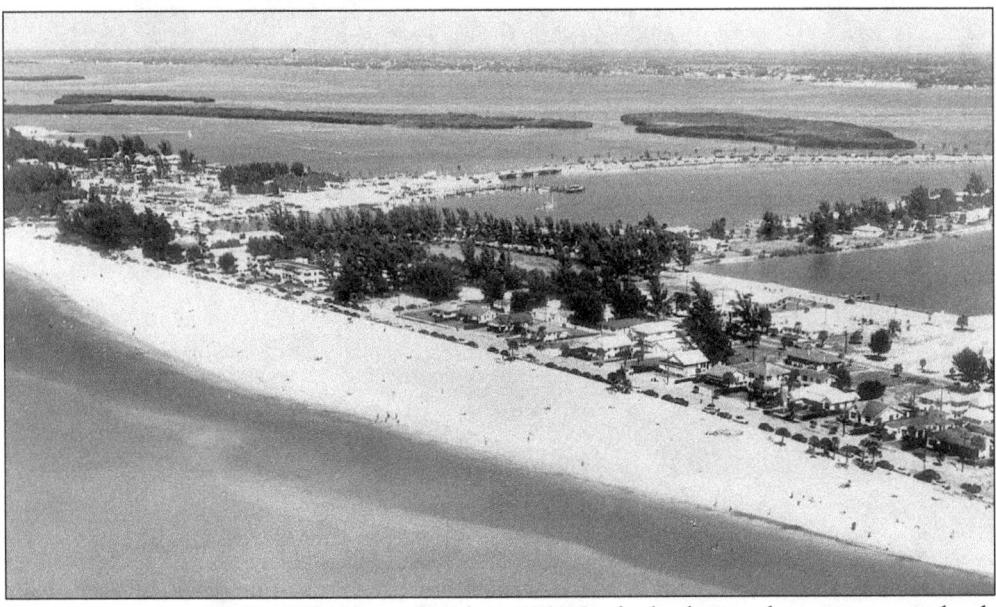

This 1950s aerial photo shows the causeway with the Ft. Harrison Hotel in the foreground and the south end of Clearwater Beach at the top of the picture.

Residences and motels line Clearwater Beach in 1951. In the background are mangrove islands where today the Island Estates development is located.

This aerial sketch shows Clearwater Beach, the mainland, and the Davis Causeway Bridge to Tampa. The studios and towers of pioneer radio station WFLA can be seen at the foot of the causeway. To the right is the Belleview Hotel. Note much of the area is still undeveloped in the post–World War II view.

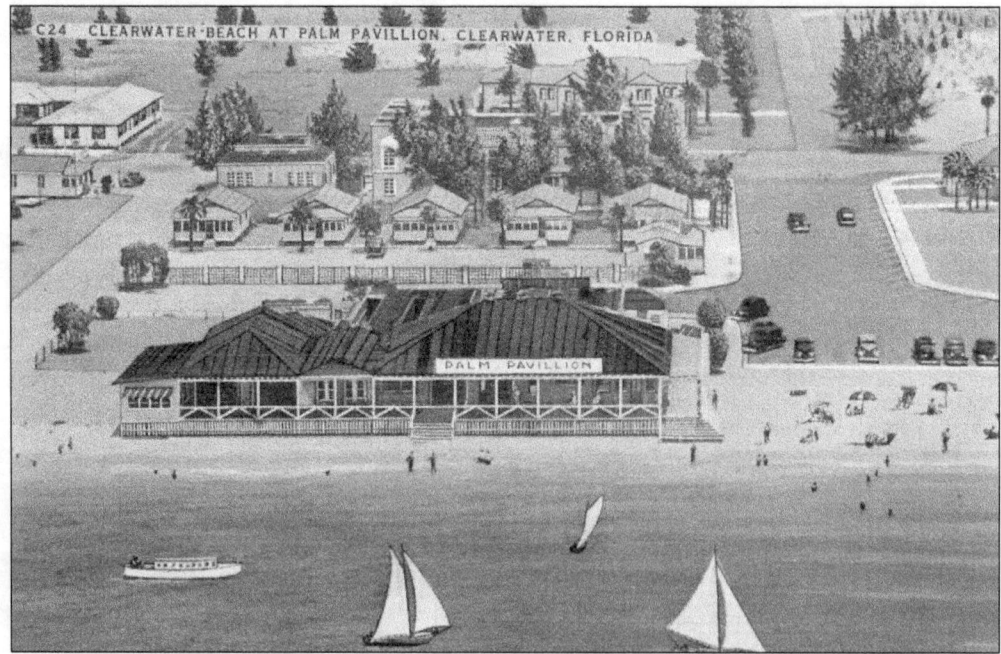

Clearwater Beach's Palm Pavilion has welcomed beachgoers since its debut in 1926. Now a popular restaurant, it is the oldest continually operating beach concession in the state of Florida.

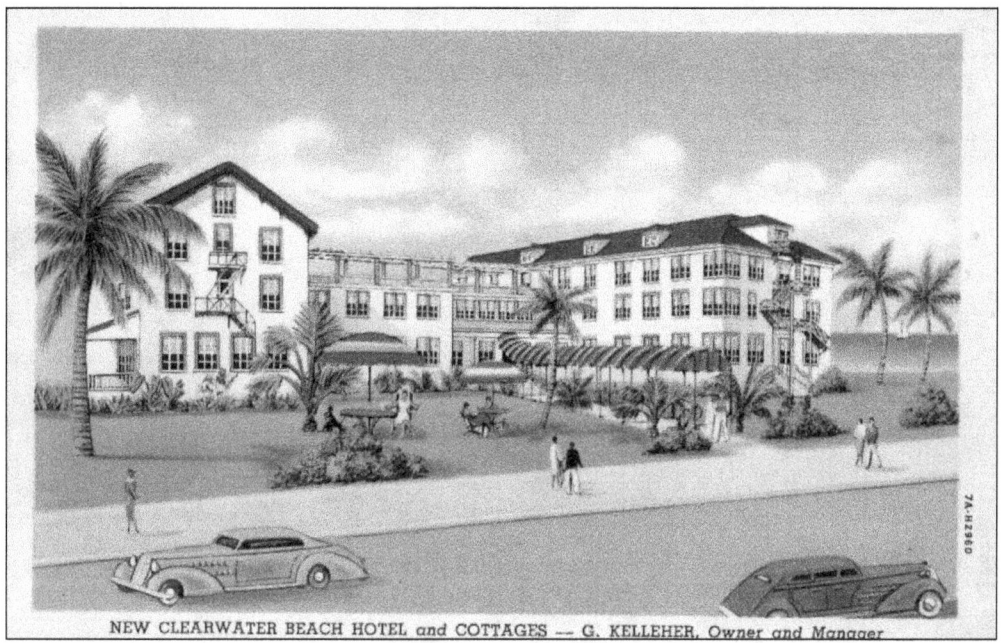

NEW CLEARWATER BEACH HOTEL and COTTAGES — G. KELLEHER, Owner and Manager

The Clearwater Beach Hotel, depicted here in the 1940s, has been a beach landmark since 1917.

PELICAN GUIDE...

MILAGE FROM CLEARWATER

St. Petersburg	21
Tampa	22
Tarpon Springs	14
Sarasota	43
Lakeland	55
Homosassa Fish Bowl	65
Cyprus Gardens	76
Winter Haven	75
Lake Wales (Bok Tower)	82
Gainesville (Univ. of Fla.)	146
Daytona Beach	182
Marineland	216
Tallahessee (State Capital)	241
Palm Beach	242
Miami	291
Key West	403

DOG RACING —
 Derby Lane, St. Petersburg
 Sulphur Springs, Tampa
INFORMATION—Beach Civic Center
 Mrs. Lynn Watkins in charge

PELICAN MENU...

We enjoyed a wonderful lunch ☐
 dinner ☑

here today. This is what we ordered
an was it GOOD . . . YES!

☐ True N. Y. Cut Sirloin Steak

☐ Broiled Stuffed Flounder

☐ Saute'd Green Turtle Steak

☐ French Fried Scallops

☐ Broiled Gulf Mullet
 (chicken of the sea)

☐ Broiled Florida Lobster

☐ The PELICAN'S Feature:
 French Fried Shrimp

☐ .

Restaurants such as the Pelican at Clearwater Beach featured the delicacies of the sea, including green turtle steak, mullet, and Florida lobster. Mileage charts like the one shown above were common during the days before interstate highways, when travel was a time-consuming event on roads ranging from two-lane highways to unimproved gravel and dirt tracks.

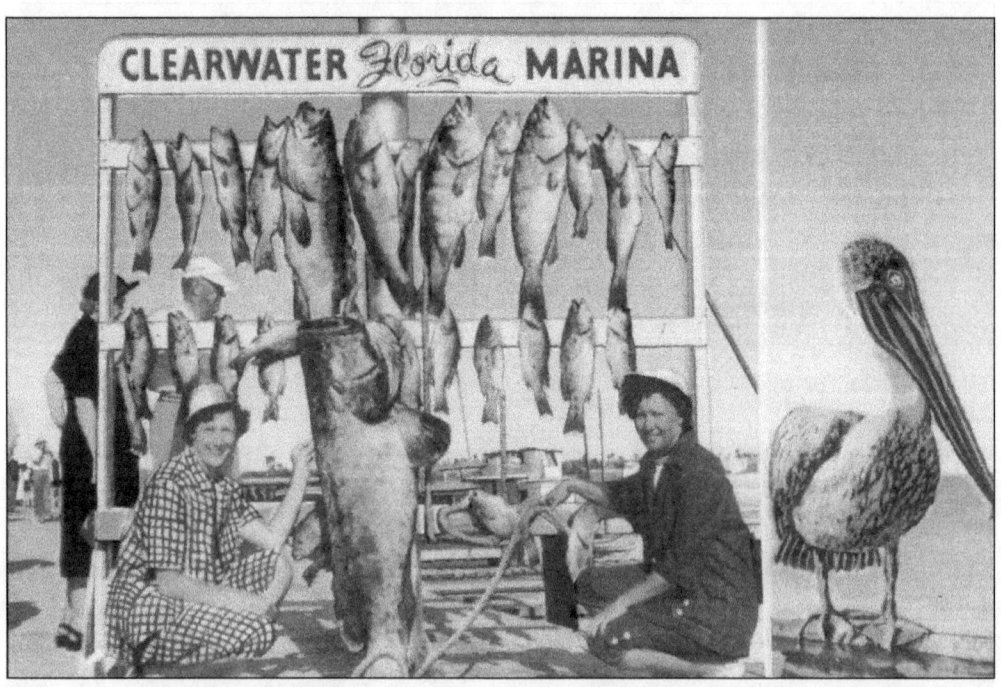

The *Dixie Queen*, c. 1950, is crowded with fishing enthusiasts as it departs Clearwater Harbor.

Fisherwomen display a day's catch from the bountiful Gulf waters off Clearwater Beach. At right, a hungry pelican waits for a handout.

Visit us at
arcadiapublishing.com

www.ingramcontent.com/pod-product-compliance
Lightning Source LLC
Chambersburg PA
CBHW050601110426
42813CB00008B/2422